MOVIE MAGIC

JOHN BROSNAN

The story of special effects in the cinema

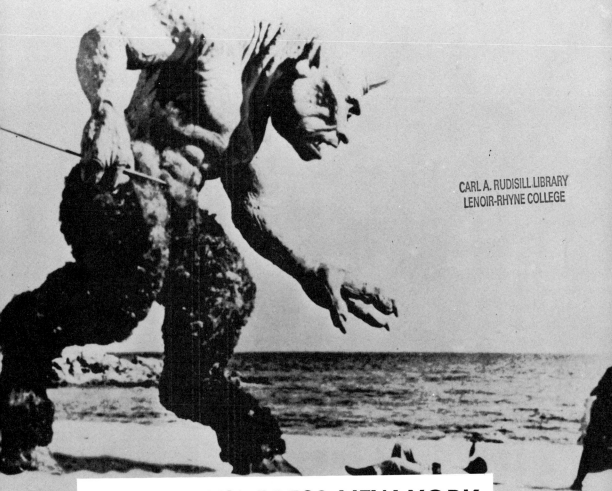

ST MARTIN'S PRESS-NEW YORK

ACKNOWLEDGEMENTS

I wish to thank the following people for their assistance in the preparation of this volume: Cliff Richardson, John Richardson, Les Bowie, Bill Warrington, Wally Veevers, Tom Howard, L. B. Abbott, Lee Zavitz, Ray Harryhausen, A. Arnold Gillespie, Eustace Lycett, Alex Weldon, Mrs John Fulton, Ted Samuels, William Rotsler, Peter Saunders, Stan Nicholls, Steve Moore, and Shepperton Studios. I am indebted to Mark Frank for granting permission to reprint portions of his interview with Jim Danforth which originally appeared in issue number 20 of Mr Frank's magazine *Photon*. I must also thank John Baxter for his many valuable suggestions and the loan of certain materials, and Jack Marsh who performed the unappealing task of typing the manuscript. In addition I would like to thank the staff of the British Film Institute's reference library for their patient and courteous help.

CONTENTS

Introduction
What are Special Effects?

(Left) *Technicians at work on one of the more standard forms of special effects – building a large model ship for a sequence (subsequently not used) in* The Private Life of Sherlock Holmes

According to Danny Lee, a veteran who has supervised the effects in many films, including *It's a Mad, Mad, Mad, Mad World* (Stanley Kramer, 1963), you explain special effects this way:

Script writers have no limits on their imagination. What we do is make photographable anything they can come up with. All it takes is mechanical ability, a knowledge of hydraulics, pneumatics, electronics, engineering, construction, ballistics, explosives and no acquaintance with the word *impossible*.[1]

Which is reasonable enough providing one remembers that Mr Lee is referring only to *mechanical* effects, one half of the effects field, and does not mention anything about optical effects. Technically though, the term 'special effects' does apply only to physical or mechanical effects. Optical effects are usually denoted in film credits as 'special photographic effects', but most people tend to lump both categories together under the blanket term of 'special effects'.

Basically, special effects, whether optical or physical, are concerned with creating illusions on the screen – such as the illusion that two actors are travelling in a car when in reality they have been filmed inside a studio, or the illusion that a giant ape is climbing up the Empire State Building. Of course there are times when the work of an effects man is anything but an illusion, such as when he really does blow up a building or really sends a train crashing through a bridge.

Optical effects, 'trick photography' and so on, are as old as the motion-picture industry itself. Older, in fact, because many of the techniques, such as in-the-camera mattes (see page 24), were originally developed by still photographers in the nineteenth century. Optical effects include such visual devices as fades, dissolves, superimpositions, all the various types of matte work, rear projection, front projection and so on. Today these effects are achieved with all kinds of complicated laboratory processes but in the early days of motion pictures most of them were created by the cameraman himself.

The term 'special effects', according to expert Lee Zavitz (now retired), was introduced by Louis Witte at the old Fox Film Company to denote

mechanical effects. It was first used as a credit on a picture called *What Price Glory?* (Raoul Walsh) which was released in 1926 (Zavitz worked under Witte at Fox until 1935). Mechanical effects are really a continuation of stage effects – such things as trapdoors, flash powder and wires to simulate flying, that have been used in the live theatre for generations – but, of course, on a much bigger and wider scale. They involve a combination of the skills of an art director with the skills of a prop maker and, as Danny Lee said, a great number of other skills as well. Many prop makers become special effects men and some effects men become art directors. All of these various fields overlap in some way, and most effects men also have to acquire a good deal of photographic knowledge along the way.

Just where do these multi-skilled wizards come from? How does one become a special effects man? Lee Zavitz reckons he qualified because he had experience in mining, ships, and logging camps, as well as knowing Lou Witte before he went to Hollywood, which was a big help. Alex Weldon, who was responsible for many of the effects in such films as *El Cid* (Anthony Mann, 1961), *55 Days in Peking* (Nicholas Ray, 1962), *Battle of the Bulge* (Ken Annakin, 1965) and *Lost Horizon* (Charles Jarrot, 1972), said:

'I actually got into the motion picture business through my father who was in charge of the property department and special effects for Douglas Fairbanks Snr. Originally I was going to be either a baseball or basketball coach, then I decided to go into subtropical horticulture . . . but finally ended up in motion pictures.'

A. Arnold Gillespie, who was in charge of the effects department at MGM – which included miniatures, rear projection and mechanical effects – from the early 1930s to the late 1960s, has his own ideas on the subject:

'Young people coming up in the industry have often asked me, "What do I do? Where do I go to learn?" And I've never been quite able to advise them. I think people in our profession are a combination of engineer, inventor and dreamer . . . but there's no set course you can take for it. I've always said that to be able to draw, to make working drawings, and to be able to read drawings is very important. Even for optical effects men, because I've gone down to our optical department sometimes and there hasn't been anyone with the foggiest idea on how to read a drawing. With very complicated set-ups I've wasted a lot of time explaining the drawings to them. So that particular training I have always recommended to aspiring youngsters, as well as any training in mechanical engineering, architectural engineering, even naval engineering.

'However, through the years, I've found I would prefer not to get too involved in *how* a thing is done – the method yes, but if we had to build

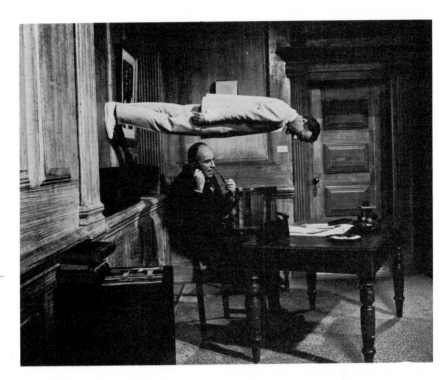

(Right) *The camera often lies—which provides the basis for many special effects. In this case the man in the chair is actually the one doing the battle with gravity – his desk, chair, and even his shoes are nailed to the wall*

a miniature ship which was forty to fifty feet in length and needs to ride properly in the water because of her hull shape – now I wasn't going to worry about that, I would simply hire a naval architect. And that went for explosives too, because I didn't want to get too involved with that either. In my department I had a draughtsman, a constructor, a hydraulic engineer, a processing assistant and another assistant who helped me with the miniatures . . . as well as being able to draw on the entire resources of the studio, such as the wardrobe department, etc.'

Unfortunately such set-ups, as described by Gillespie, are more or less extinct today. The trend has been away from studio production with the result that most departments have been closed down and the effects men themselves have gone free-lance, in both America and Britain. There are over 190 effects men in Hollywood and nearly 100 in Britain. As work is not exactly plentiful in either country at the moment, breaking into the business is somewhat difficult.

Nowadays in Hollywood a would-be special effects man must first train as a prop maker for two years, then spend a further six months learning the basic skills of creating rain, fake snow and making sure that the spears and arrows land in the right places (preferably not in the actors). Since explosives feature in so many films these days it is more or less mandatory that the apprentice should receive training in their use.

To win a Class 3 powderman's licence he must take a state-approved course in explosives and pass an eighty-page examination. Later, after much more experience, he can go on to become a Class 1 and will at last be eligible for a crack at the top money (by then he will have been investigated by the government to ensure that he is politically safe and not liable to do anything embarrassing with his explosives).

In Britain there are also stringent controls on the use of explosives, but the overall training of newcomers is much more haphazard. A large number of young people were hastily inducted into the industry during the 1960s when there was an abundance of work available but they now find themselves ill-equipped to carry on under more competitive conditions.

'What we do is an art – there's no way you can boil it down to a science,'[2] says Universal's effects chief, Roland Chiniqui. While this may sound a little presumptuous, there is a good deal of truth in what he says. Creativity *does* play a very important part in the work of a special effects man, faced as he is with a constant series of new problems each of which demands a new solution. Script writers blithely write in all manner of incredible situations and events, oblivious to any sort of technical limitation, leaving it to the effects man to achieve what often amounts to the impossible. And with finance so scarce in films today the effects man not only has to achieve the impossible but has to do it as cheaply as possible. As a Hollywood director once said – if NASA had employed a team of special effects men they would have reached the moon ten years earlier at half the price.

Although most effects men may moan aloud at the working of the average script writer's mind it is doubtful whether they would really prefer it any other way. If they have one thing in common it is the love of a challenge. Besides, if they were able to choose what effects should or should not be included in a film, the result could be rather dull cinema . . . as has been the case occasionally when this has happened. Like stunt men, the special effects man needs a challenging problem to produce his best work.

A more legitimate complaint of effects men concerns their status within the industry. One would think that such an indispensable unit of the film-making machine would be held in relatively high regard, but this is not so. Unless they happen to belong to that exclusive group which includes such people as Ray Harryhausen and Douglas Trumbull the average special effects man does not seem to receive the attention he deserves. According to Les Bowie, who has been handling effects in British films for nearly thirty years, the situation is worse in Britain.

'Special effects are always underrated in this country. I always say that if you want to find the credit for special effects on a picture made

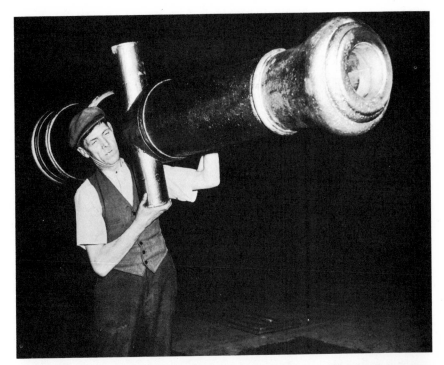

(Right) *Two examples of prop work:* (above) *a studio workman with one of the dummy cannons used in* Captain Horatio Hornblower RN; (below) *one of the impressive models created for* Things to Come

here you have to look under the name of the hairdresser. We're always under the hairdresser. A special effects man is like an army cook . . . they need you but they don't like you. On location an effects man is invariably the one who has to work on while everyone else has broken for lunch . . . and in the evening when they've all gone home. I always find that I get the battery to carry up the mountainside. Oh, the glory of a cameraman compared to a special effects man!'

1/The Pioneers

The beginning of the story of special effects is to be found at the beginning of the film industry itself. Not long after the first images had been successfully projected onto a screen, trick photography, the creating of illusions through the manipulation of camera and film, was born. But one of the most exasperating things about any investigation into the development of the film industry is the difficulty of attempting to determine just who was *first* with any particular technique or device. This is because so many of the early pioneers were working independently, separated by both national boundaries and business competition. There was a certain amount of interaction between them, of course, ideas spread despite the patent laws, but often it was a case of innovations being made simultaneously in different countries. This situation has continued on down through the years; front projection, a relatively new technique, has claimants for its invention in both France and America. Therefore it is more or less impossible to state with any certainty just who invented trick photography, but we can at least group together those who were among the first, and one of these is an Englishman by the name of G. A. Smith.

Smith, originally a portrait photographer in Brighton, became interested in moving pictures as a means of illustrating his lectures on photography. In 1896 he designed and built his own camera and began to make films. Soon he was experimenting with trick photography and, in 1897, had even taken out a patent for double exposure, which he used for a 'vision' in his film *The Corsican Brothers*. It is possible that he preceded both R. W. Paul and Georges Méliès in the use of trick photography.

Robert William Paul was another Englishman. He was an established scientific instrument maker when, in 1894, two Greek showmen commissioned him to make six duplicates of an Edison and Dickson kinetoscope that they owned. There was nothing illegal in this for at that time the patents did not apply to Britain. Paul made the six as requested and during the following year made another sixty. The Edison company was understandably annoyed and refused to supply film for them (the kineto-

scope contained about forty feet of film which moved on an endless belt and was viewed through an eyepiece). Like Smith, Paul simply designed and built his own movie camera. From there he went on to solving the problem of projecting pictures onto a screen. He gave his first demonstration of this technique in London on 20 February 1896. Also in London, on the same night, were the Lumière brothers, Louis and August, who were giving a public demonstration of their version of the same process. (Their first demonstration, which had been attended by Méliès, had been in Paris a couple of months earlier.)

Paul continued to design better and more efficient projectors and some of his innovations are still in use today. Then, in 1897, he bought a field in Muswell Hill where he built Europe's first film studio. W. H. Eccles, D.Sc., F.R.S., writing in a 1943 issue of *Electronic Engineering* shortly after Paul's death, described the studio:

It comprised of a miniature stage, a movable hanging bridge, many trapdoors, a trolley system for running the camera to and fro at speed, and means for turning the camera on its axis. Gradually at this studio the 'trick film' was developed; ghosts, fairies, ogres, dwarfs and giants became every-day products. Deep sea divers found boxes of treasure with live fishes apparently swimming around them. A very great success was a collision between two trains on an embankment beside a lake; this was so realistic that the audience usually screamed. A great authority on the history of the cinema has said, 'Paul's trick films were the first and best of their kind and eclipsed anything produced throughout the world.'

Whoever that 'great authority' was, he might have been wrong about Paul's trick films being the first but he was correct as far as the quality of these was concerned. One of his surviving films, *The ? Motorist*, made in 1905, rivals and, in some people's opinion, even surpasses the best of Méliès' work. In it a motoring couple exceed the speed limit in their car and hurtle off the face of the earth into outer space where they encounter various heavenly bodies before returning safely to the ground. One impressive scene shows them driving around the rings of Saturn.

An interesting sidelight in Paul's career was his association with H. G. Wells. In 1895 the two men applied to patent a 'time machine' they had devised. It was based on the device that Wells had described in his novel *The Time Machine* and its aim was to create the illusion of travelling time. It was to consist of a chamber fitted with movable floors and walls, vents for air currents, and screens on which scenes from different periods of time would be projected by means of slides and motion pictures. Neither of them had the money to develop it and the project was abandoned.

Paul was an engineer rather than an artist and considered his film career to be only a by-product of his primary interest, the design and manufacture of scientific instruments. In 1910 he dropped all his cinema activities, disposed of his studio and burnt much of his large stock of film.

He died in 1943 and his obituary in *The Times* included these words: 'Perhaps it is not an exaggeration to say that next to Edison, Paul did more to develop the kinematograph than any other person.

Both Paul and Smith have lapsed into relative obscurity and it is the name of Georges Méliès that is always mentioned when the subject of trick photography arises. While not wishing to belittle Méliès' own great achievements one hopes that it will be remembered that he was only one of several originators, though without a doubt it was his films that had the greatest influence on other film makers in the field of special effects.

Méliès had wanted to be a painter but parental objections forced him to turn his talents in a different direction. He became interested in conjuring and was soon designing devices for use in his act. In 1888 his family provided him with the capital to buy the Théâtre Robert-Houdin, preferring him to be a theatre manager rather than an artist. The theatre was very successful and Méliès and his magic shows became famous throughout France. In 1895 he attended the Lumière brothers' demonstration of their cinematography machine and decided it would make a marvellous added attraction in his theatre. He offered to buy it from the Lumières for 10,000 francs but the brothers refused. Méliès eventually obtained a projector from none other than Robert Paul, and for a tenth of the price. He made improvements to this and even converted it into a camera with which he started making his own films. His first films, in 1896, were of mundane subjects such as people walking along a street or of a game of cards, the latter copied from a Lumière film. Then one day, while he was filming the Place de l'Opéra in Paris, the famous incident so often mentioned in film literature occurred: his camera jammed. It took a few moments for Méliès to clear the obstruction and then continue filming. Later, after he had developed the film and was screening it at home, he observed the startling transition that the jamming had caused within the scene that he had been filming. Legend has it that it was the experience of seeing an omnibus turn into a hearse that opened up all the possibilities in his mind as to what could be achieved with a movie camera. Whether or not this is true, it is obvious that his magician's mind wasted no time in proceeding from that lucky accident to fast and slow motion, double exposure, multiple exposure, stop motion, the dissolve and the fade.

Méliès utilized all these camera techniques in the series of films he made during the following fifteen years, as well as his full range of stage effects such as trapdoors, secret panels, giant moving cut-outs and the artful combining of painted backdrops with actual sets.

His most successful period was between 1897 and 1902 and most of his best films, such as *Cinderella* (1899) and *A Trip to the Moon* (1902), were made during this time. Méliès' films consisted of four main divi-

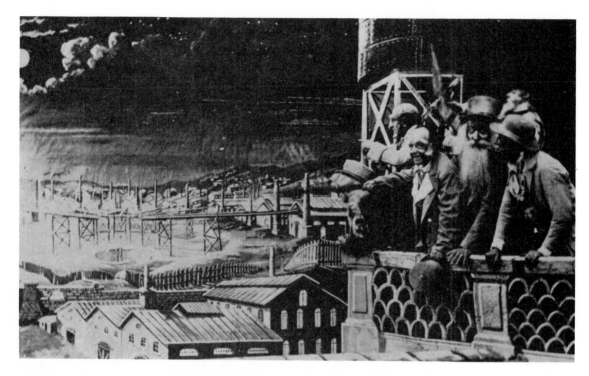

(Above) *Painted backdrop and stage foreground – two effects from Méliès'* A Trip to the Moon

sions: 'enchantments', comedies, trick films, and 'reconstructed actual-ities'. He took great pains with the latter, which took the place of news-reels, it being too difficult to film actual events. The trick films were usually made in the Théâtre Robert-Houdin so as to take advantage of all the built-in stage equipment there.

When shown today his films often provoke condescending laughter but one has to remember that his 'enchantments' and trick films were never meant to be taken seriously. In *A Trip to the Moon*, for instance, Méliès was not attempting to show what space travel might actually be like but was instead filming a zany pantomime and making it as out-rageous as he possibly could. Méliès was primarily a showman and a great sense of fun permeates most of his films, which the following story illustrates:

A comic episode happened in 1901 when I was making my first film of *Joan of Arc*. I made another one later, but the first one was limited to 400 feet, an epic in those days! We had very little film at our disposal and were naturally pressed for time. For the siege of Compiègne we had built in front of the ramparts a formidable looking palisade, which in reality was only made of light planks, so that it would not offer too much resistance. This palisade was supported by three main posts, one on the left, one on the right, and one in the middle of the scene. The posts themselves were firmly fixed and buttressed. I had told one of

the strapping men-at-arms, who was carrying an enormous battle-axe, to break down the centre post, a procedure which should have ensured the collapse of the walls.

Contrary to my expectations, my warriors flung themselves on the palisades with such *furia francese* that in a second the whole thing was borne down under their weight. While the rest were racing for the walls of the town the gentleman with the battle-axe continued to hack away at the post which was in nobody's way and, in spite of all his efforts, refused to budge. What an uproar there would have been if we had shown the film as it was shot! We had to start all over again and put everything back in its place. Naturally I was annoyed but when I pointed out to the fellow what a fool he had been, he was furious. 'What are you talking about?' he demanded. 'Everyone heard you tell me to knock down the post . . . and a stiff one it was too!'[3]

Unfortunately Méliès never really developed as a film maker and despite all his photographic innovations his films were never more than filmed stage shows. This lack of vision led to an early curtailment of his film career. Even by 1904 audiences were looking for something more; it was time for the motion picture to stop being a novelty and to grow up. Other film makers took the hint but even in 1912 Méliès was still making films in his customary fashion. They were more extravagant and spectacular than his earlier ones but as films they were living anachronisms. By 1913 he was bankrupt, having been crushed by the large-scale business operations that had been formed with the rapid growth of the industry. Worse still, during the First World War many of the negatives of his films were destroyed and a priceless film heritage was lost forever.

Méliès enjoyed something of a comeback in the late 1920s (he was found selling toys in a Paris street) when the intellectual community recognized the value of his remaining films. He became the pet of the surrealists and it was planned to remake one of his old films with him as general supervisor, but nothing ever came of it. At least he had the satisfaction of knowing that film makers throughout the world were aware of the debt they owed him. He died in 1938 at the age of seventy-seven and, it is said, with his sense of fun undiminished.

In 1900, G. A. Smith, who, as has been noted above, was one of the first originators of trick photography, joined Charles Urban and the Warwick Trading Company. Urban was an American who came to Britain to manage the office of the London agents for Edison's company. He soon reorganized the firm and named it the Warwick Trading Company before breaking away altogether and setting up his own business. He took several of Warwick's photographers with him, including Smith, who was instrumental in making the several important technical advances that Urban's company is famous for, such as one of the first workable colour systems.

Urban produced all manner of films but his trick films became the most well-known. One of these was *The Airship Destroyer*, as it was called on release in 1909. (Subsequent titles include *Aerial Warfare*, *Aerial Torpedo* and *Battle in the Clouds*.) Inspired, no doubt, by the writings of H. G. Wells, the film is about a mystery attack on London by a fleet of airships. Buildings are blown up, railroads wrecked and some primitive tanks are destroyed. The film ends with the hero launching a number of radio-controlled flying torpedoes at the airships which save the day. Even compared to present-day standards the model work is surprisingly good. Urban was more of a businessman than a film maker but he did have a flair for choosing particularly skilled technicians, which is why his films were often superior to those of his contemporaries.

One of the men he hired was Edgar Charles Rogers, who joined the Urban company in 1911. Rogers's father had been a set designer for the old Drury Lane and Sadler's Wells theatres and his uncle ran a famous puppet show, so it was not surprising that the young Rogers grew up with an interest in the technical side of the theatre. Rogers and his brother first worked at constructing myrioramas, which were large tableaux usually of some historical event in which many of the characters and components moved by mechanical means. Obviously an ideal training ground for a future special effects man. Judging from the titles of some of the myrioramas that Rogers and his brother worked on, such as 'The Battle of Trafalgar' and 'The Russo-Japanese War', they must have been impressive to observe in action.

Rogers joined Urban as an art director and was soon making use of such early innovations as glass shots and experimenting with sound and colour systems. A colour film made in 1912 called *Santa Claus* included a scene showing the world travelling through space with Santa Claus following on his sled. There was no actual trick photography involved – the model was a full-sized one, the world travelled along a track 100 feet long behind clouds on painted glass. The background was a huge black velvet curtain, which during the filming was torn by a storm and was mended with great difficulty. Rogers was also one of the first to fake aerial shots by building a dummy section of an aeroplane on a high platform and filming the scene with the real sky as background. The plane section was rocked by prop men with the aid of long poles and the illusion was created that the airmen were actually airborne. Films that Rogers worked on in later life included *Q-Ships*, for which he constructed the models, and *The Battle of the Somme* (Geoffrey Barkas and Michael Barringer, 1928) which provided him with the opportunity to make use of his myriorama experience. His last work was on *Jack Ahoy* (Walter Forde, 1934) – he did the ships for the Battle of Trafalgar sequences. He was active in the industry until the closing of Gaumont British studios

at Shepherd's Bush in 1938, and he died shortly afterwards.

One of the most important American film pioneers was Edwin S. Porter. After a period, as a young man, of installing film projectors and travelling with a tent show that featured the showing of films, he decided to start making his own films. In 1899 he joined the Edison Company and began turning out a large number of films every week. Porter was greatly influenced by Méliès and for several years he concentrated on making his own special effects films. But it was Porter who was one of the first to make a film that told a story – *The Great Train Robbery* (1903) – thus giving the medium of motion pictures a whole new function other than being just a showcase for cinematic tricks. Thus, ironically, Porter, despite being an admirer of Méliès, was responsible for turning Méliès and his own films into anachronisms. When it was realized that audiences were more interested in films that told a story the pure trick films began to disappear from the market.

It was Porter, also, who first used a special effect for a purely practical purpose rather than as a blatant display of screen magic. In the same film, *The Great Train Robbery*, a train can be seen through the telegraph operator's office window. Actually the scene was a composite achieved with an in-the-camera matte – a form of double exposure which will be explained more fully later in this chapter.

Another American who also did a great deal to develop special effects for practical purposes was Norman O. Dawn. Born in 1886, Dawn had long been interested in photography and was an accomplished artist. At first he worked as a still photographer but during a visit to Paris in 1906 he met both Méliès and the Lumière brothers. The meetings were to kindle within Dawn an ever-growing interest in motion pictures and the technical problems involved. Returning to America he bought his own camera and in 1907 made a short film about the Californian mission buildings called *Missions of California*. It was while making this film that he first made use of glass shots. Glass shots had been used in still photography before (just who invented them is unknown) but it is likely that Dawn was the first person to utilize one in the making of a motion picture.

A glass shot is simply a painting on a sheet of glass positioned in front of the camera in such a way that it blends in with the scene that the camera is filming. The most common use of glass shots was to add extra detail on buildings, which was what Dawn did in his mission film. He combined what was left of the old buildings with paintings of, say, a roof or whatever section was missing, and the finished product gave an almost perfect image of what the building originally looked like. Later, when glass shots were adopted by the film industry, they were valuable aids to set construction. All one had to do was to build the ground floor of

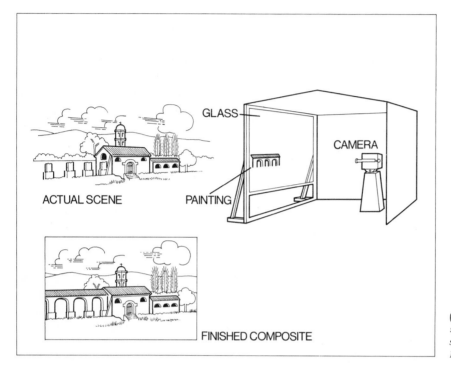

GLASS

CAMERA

ACTUAL SCENE

PAINTING

FINISHED COMPOSITE

(Left) *An example of a glass shot set-up, as used by special effects pioneer Norman Dawn*

the building and a glass painting would add as many floors as were wanted. It was much cheaper than building the real thing. They were also used to create exotic background scenery, such as tall mountains. Glass shots were very popular during the 1920s and 1930s because they were cheap and uncomplicated. Their main disadvantage was that the camera was forced to remain in one position, though it was possible to pan and tilt, and the actors were restricted to a small area – a wrong step and an actor's head might disappear behind a mountain that was supposed to be miles away. But today glass shots are rarely used; production costs are so great that a film crew can no longer afford the time it takes to set one up. What was once one of the cheapest of techniques is now too expensive and it has been superseded by various other methods.

Between 1907 and 1910 Dawn travelled around the world as a newsreel cameraman (or to be more accurate, a prototype documentary maker). He returned to California in 1911 and began working for various film studios. He soon became in great demand as word of his special effects techniques spread, most of which were unknown to the majority of people working in the American film industry at that time. But problems arose. Many directors did not take too kindly to this new breed of technician who was taking away part of their control over the making of films, and others (as today) had little understanding of what special

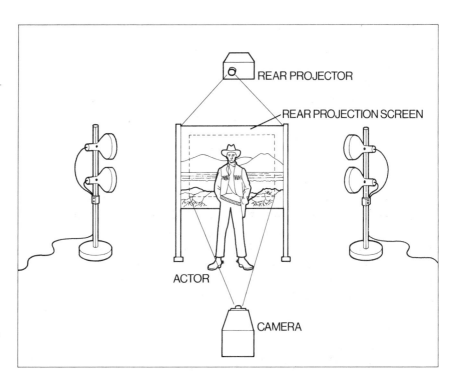

REAR PROJECTOR

REAR PROJECTION SCREEN

ACTOR

CAMERA

(Right) Simplified diagram of the set-up used in a rear projection shot

effects entailed or just how complicated they were. Dawn quickly became impatient with such attitudes and set himself up as an independent producer so that he could make films the way *he* wanted to. His first film was a Western called *The Drifter*, which he produced in 1913 and in which he incorporated many of his innovations, including rear projection. As with glass shots, rear projection had been used by still photographers but Dawn was the first to employ it in motion picture production. Dawn used it for two scenes in his film but was disappointed with the result and abandoned the process. Rear projection, as the name suggests, is a system by which background scenery is projected onto a screen from *behind* the screen. This enables actors to perform in front of the screen without casting a shadow. Either still or moving backgrounds can be projected, but with the latter the system becomes much more complicated. The projector must be synchronized with the camera so that when one frame of the background scene is being flashed onto the screen the camera shutter is opening simultaneously. Rear projection became very popular in the 1930s and 1940s, particularly after the introduction of sound; and it will be covered more fully on pages 47 to 51.

Other films followed *The Drifter* and Dawn's effects became more and more elaborate. In 1916 he made a Keystone comedy called *Oriental Love*

which attracted a great deal of attention within Hollywood. In this film Dawn demonstrated practically his complete range of special effects and so effective was the result that it changed many people's minds about the value of trick photography. One of the most important effects that Dawn popularized was the in-the-camera matte shot. Like the glass shot it had been used previously by still photographers and even the occasional movie maker (as, for instance, by Edwin S. Porter in his *The Great Train Robbery* in 1903), but it was Dawn who developed it into a more practical technique.

An in-the-camera matte shot is one of the simpler ways of combining two images to create the illusion that they are part of the same scene. It achieves *in* the camera the effect one would get by cutting up two separate photographs to form a single composite. Basically it entails exposing only a section of each frame of film while filming a scene, the unwanted part of the scene being obscured by a card, cut to the required shape, which is placed in front of the lens. This is called a 'matte'. The film is wound back and a new scene is then filmed, this time with the previously exposed section of the film obscured by another card, or 'counter-matte'. The result is two different scenes combined on one piece of film. But mattes were used for other purposes too and came in all shapes and sizes. Most silent-film cameramen had a rotating matte device

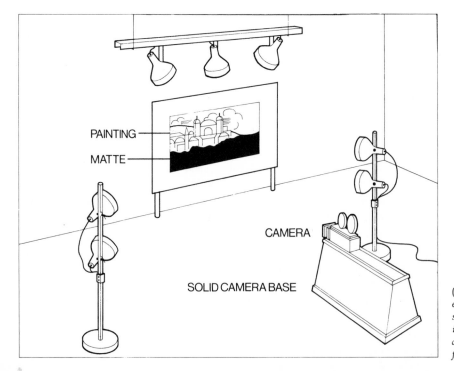

PAINTING

MATTE

CAMERA

SOLID CAMERA BASE

(Left) *An example of an early matte-painting camera set-up. The black matte area is where the foreground action would appear in the finished composite*

attached to their cameras, with which they achieved many of the optical effects that are nowadays created in the laboratory. When a subjective shot of someone peering through binoculars was needed, the cameraman simply rotated the necessary cut-out matte in front of the camera lens. There were other devices too, such as an iris which was used for the circular fades that were so popular in the early silents. (Fades and dissolves also came under the domain of the cameraman. Fades were achieved by the cameraman slowly closing his lens aperture while he cranked, the light was gradually cut off from the film and a smooth fade produced. Dissolves were more difficult, they involved fading out on one scene, winding back and fading in again over the same shot.)

Dawn's original improvement to the in-the-camera matte involved a variation of the glass shot and was much more complicated though it had several advantages, such as allowing greater accuracy and being less time-consuming. It was used to combine live action with painted scenery. First the live action was filmed with the unwanted area of the scene blocked or matted out by black paint on a sheet of glass positioned in front of the camera. The partially exposed film could then be transferred to another camera, back in the studio, which would be heavily weighted and mounted on a secure base so as to avoid vibration as much as possible. In front of the camera would be the easel, or art board, and by utilizing test footage of the live action it would be possible for the artist to determine exactly where the matte line would be. (For example, one method was to project a frame of the test footage through the camera onto the easel and the artist could simply trace out the matte line.) The artist could then prepare his artwork knowing that it would blend in perfectly with the live action. Unlike a glass shot he could take his time, knowing that he was not keeping a whole production team waiting while he worked.

In-the-camera mattes were widely used during the silent era but, like the glass shots and other early techniques, were later replaced by more flexible methods. Some experts, though, consider they give a much better result, when executed properly, than many of the techniques used today in the industry. One Hollywood cameraman who became famous for his skill with in-the-camera mattes was veteran Charles Rosher. In 1921 when *Little Lord Fauntleroy* (Alfred E. Green and Jack Pickford) was released reviewers acclaimed his effects in the film:

The double exposures are the finest that have ever been made in the history of the business. When Mary Pickford [playing a dual role] kisses herself, as 'Dearest', and hugs herself, and when both characters walk off together, one ahead of the other . . . well, it's almost uncanny. Hats off to Rosher.[4]

To get these results Rosher had built a camera stand weighing two thousand pounds so as to muffle vibration.

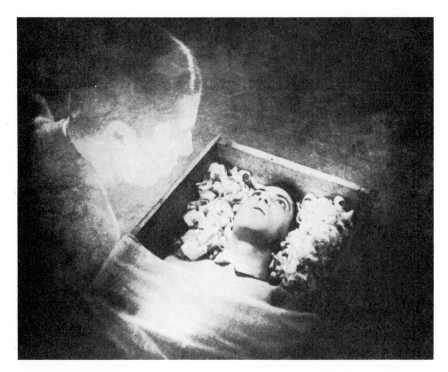

(Left) *A skilful use of double exposure from Dreyer's* Vampyr

Steel girders formed the base and framework [said Rosher], and it was lined with sandbags. The contraption could be moved around on casters but when I'd line a shot up, jacks secured it to the floor. Jacks held the pan head rigid too, once it had been positioned. In front of the camera was the matte box and I moved the matte as Mary walked. The whole set-up was so solid that you could jump around the floor without moving it a thousandth of an inch.

As the *Motion Picture Herald* exclaimed, 'Not even an expert could spot the dividing line.'[5]

Mirrors were another important tool in the primitive days of special effects. Once again it is impossible to say who first introduced them to motion pictures. It is likely that Méliès was among the first, since mirrors had long been used by stage magicians. Mirrors were used in a number of ways, such as superimpositions. A partially transparent mirror placed at an angle in front of the camera will pick up the image of a person standing to one side of the set and superimpose him over the scene that the camera is filming. The result is a transparent image of the person and was naturally used to create 'ghost' effects. Mirrors were also used to combine live action and fake scenery in a similar way to glass shots.

An important innovation in the use of mirrors was made by Eugene Shuftan (originally Eugen Schuffan). Shuftan was born in Breslau in

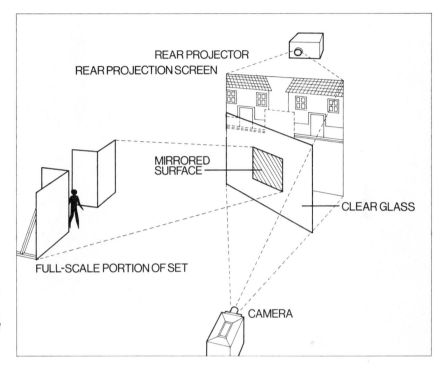

REAR PROJECTOR
REAR PROJECTION SCREEN

MIRRORED
SURFACE

CLEAR GLASS

FULL-SCALE PORTION OF SET

CAMERA

(Right) *One use of the Shuftan Process. Actor and portion of full-scale set are reflected into the camera and thus combined with projected background scenery*

1893 and began his career as a painter, architect and cartoonist before becoming involved with animated films. In 1923 he invented what was to become known as the Shuftan Process. Basically it was a means of combining live action with reflected images of model work or paintings, and vice versa, by means of removing certain areas of the reflective coating on the mirror. For instance, supposing it was planned to combine a model of a building with a shot of a man standing in the doorway, using the Shuftan Process it would be executed in the following way. Between the model and the camera a mirror would be positioned at a forty-five-degree angle. The next step would be to remove all the reflective material from the mirror except in the area of the doorway. Elsewhere on the set would be a man, and a full-sized doorway, positioned in such a way that his image appeared on the area of the glass that was still reflective. The result was that, seen through the camera, the man appeared to be standing in the doorway of the model house. This was just one way in which the Shuftan Process could be used. These mirror shots were popular in Britain and Germany during the 1920s and 1930s. One famous German film in which they were used to great effect was Fritz Lang's *Metropolis* (1927), which centred on a giant city of the future.

Shuftan himself went on to become an important lighting cameraman and apart from Germany worked in France, Britain and the United States.

(Left) *The miniature city built for Fritz Lang's* Metropolis

He was still active in the industry in the 1960s and received an Academy Award for his cinematography on *The Hustler* (Robert Rossen, 1961).

German cinema had a big influence on Hollywood, especially in the use of special effects. It began in the 1920s and reached its peak in the 1930s when Hollywood had brought over many of the best German directors and technicians. Prior to this American films had shied away from fantasy subjects as the American audiences, at that time, preferred their entertainment to keep both feet on the ground. But in Germany the Expressionist movement coupled with the German love of fairy tales provided German set designers and special effects men with plenty of opportunity to devise startling worlds of illusion. Prime examples were *The Golem* (Paul Wegener, Henrik Galeen, 1914; Paul Wegener, Carl Boese, 1920), *The Cabinet of Dr Caligari* (Robert Wiene, 1919), *Student of Prague* (D. Stellar Rye, 1913; Henrik Galeen, 1926) and the *Homunculus* serial (Otto Rippert, 1916). One of the most impressive German films as far as special effects and huge sets are concerned was Lang's *Siegfried* (1922–4). As an art form, Expressionism rejects reality in favour of a more powerful, abstract visual form. Therefore no exteriors were used, everything was filmed within studios where light and all the other facets of production could be completely controlled (it took the coming of sound to force Hollywood film makers into the similarly self-contained

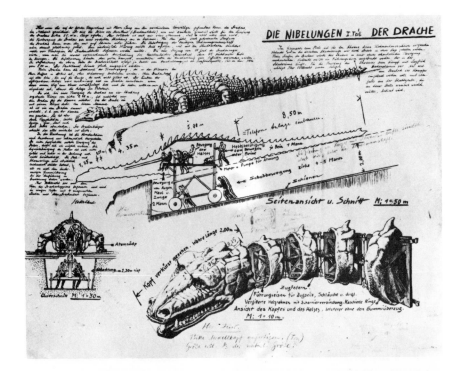

(Right) *Some of the original working drawings of the dragon designed by* UFA *technicians for Lang's* Siegfried (above)*; the hero bathes beneath the gushing blood of the slain dragon* (below)

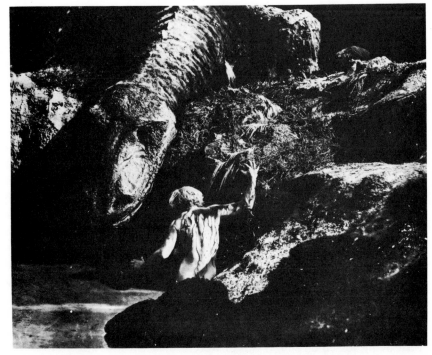

worlds of the big sound stages). In *Siegfried* too everything was filmed in the studio, even the giant forest which was entirely man-made. The optical effects were beautifully executed, such as in the scene where the dwarfs supporting the mound of treasure turn into stone. The film also contained a full-scale mechanical dragon which, though limited in movement, was quite effective.

(Above) A triumphant Douglas Fairbanks on his flying carpet in a climactic scene from Thief of Bagdad

Douglas Fairbanks claimed that his *Thief of Bagdad* (Raoul Walsh, 1923–4) was meant to outdo what the Germans had achieved in spectacle and trick photography. The sets were definitely enormous but the special effects came a poor second. One only has to compare Fairbanks's battle with a dragon to the one in *Siegfried*, which was made at the same time, to be aware of the shortcomings in technique. Some sequences were effective, such as the ones concerning the flying carpet, the scenes with the giant idol, which was most likely a foreground miniature, and the underwater scenes. The latter, incidentally, did not involve any water, they were filmed 'dry' in a fifty-two-foot deep tank filled with three wagon loads of kelp. Everything moved, including the swaying kelp, by the aid of wires. It was filmed in slow motion, achieved by the camera operator over-cranking his camera, and through a filter, to give the effect of being under water. Even the shots of the surface of the sea with the boat being tossed on rough waves were filmed without any water – the

sea effect was created by billowing sheets of silk, an old stage technique. A publicity story, released during the making of the film, told of how the giant spider, which attacks Fairbanks when he is under water, went wrong one day and walked off the set, so frightening a couple of studio visitors that they fainted on the spot. As the spider is so obviously supported by wires in the picture it is rather difficult to give the story any credence, delightful though it may be. Also delightful is the tale of how Fairbanks made use of a forty-mile-an-hour gale, which was wrecking one of the sets at the studio, to film some of the flying carpet scenes with Julanne Johnston, who played the Princess.

Impressive as it must have been in 1924 the film was not very successful for Fairbanks. Though it cost 1 million dollars, an enormous amount for the time, it was out-grossed by his own *Robin Hood* (Alan Dwan, 1922) which cost only $700,000. This was probably due to the American reluctance to accept films of sheer fantasy, a tendency which was mentioned earlier. Fantasy films that were made in America during this period usually had trick endings that gave a rational explanation for all that had gone before. The 1920 version of *Dr Jekyll and Mr Hyde* (John S. Robertson), for instance, used a dream as a means of explaining it all away, and Lon Chaney's vampire creature in *London after Midnight* (Tod Browning, 1927) was revealed as a hoax.

Biblical epics provided the American special effects men with an occasional opportunity to perform magic tricks on screen. Audiences could apparently cope with biblical miracles without having to have them explained away. Cecil B. DeMille's first version of *The Ten Commandments* in 1923 contained several such miracles, including the famous parting of the Red Sea which was achieved by Roy J. Pomeroy and Fred Moran. In the film the divided sea appears to resemble two lumps of quivering jelly covered with running water but is nonetheless quite impressive.

Another epic was *Noah's Ark* (1929) directed by Michael Curtiz from a script by Darryl Zanuck. Like DeMille's *Ten Commandments* the film was only partly set in Biblical times, the bulk of the story taking place during the First World War. A priest tells one of the characters the story of Noah's Ark, comparing it to their situation during the war. Some of the optical effects were handled by Hans Koenekamp, a cameraman who specialized in trick work. He had begun as a projectionist in a 'nickelodeon' where he made his first contribution to the improvement of motion pictures by cranking his projector at varying speeds to compensate for the original mistakes made by the cameraman. In those days of hand-cranked cameras, one man's idea of sixteen frames a second was not another's. Koenekamp could also change a reel in nine seconds flat, an ability much appreciated by the audiences of the day. He entered the

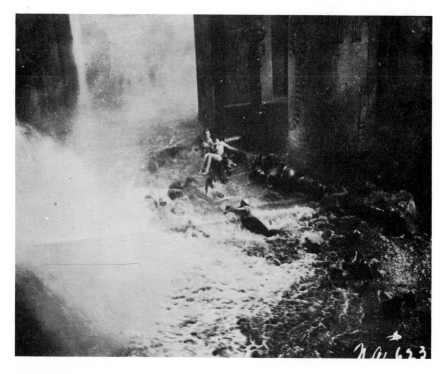

(Left) *Tons of water are unleashed from dump tanks upon the hapless cast of* Noah's Ark

picture business through a meeting with Mack Sennett who, impressed with his skill at a projector, asked him if he thought he might be able to handle a camera. Koenekamp said 'yes', and his first assignment was some underwater photography in the submarine gardens of Catalina Island off the Californian coast. He so pleased Sennett with the result that he received an increase in salary and a company of his own.

In 1918 Koenekamp joined Larry Semon, a comedian who utilized camera tricks to improve his comedy routines. The two stayed together at Vitagraph for eight years, originating several techniques new to trick photography. When Warner Brothers decided, in 1926, to make *Noah's Ark*, Fred Jackman, who was in charge of the photographic effects, sent for Koenekamp, as the picture called for almost every known type of camera trickery. One of Koenekamp's most incredible achievements on the picture was the filming of the animal sequences. He had to make as many as eighteen exposures on one piece of film, carting his camera from zoo to zoo and from one background to another, which resulted in one of the most complicated series of in-the-camera matte shots of the period.

In charge of the photography on *Noah's Ark* was Hal Mohr, who left the picture in the middle of the filming because of a disagreement with Michael Curtiz, the director, and Darryl Zanuck. It was over the method

for filming the picture's big scene where the flood crashes down upon hundreds of people gathered at a temple. Mohr wanted to fake the scene as much as possible with the help of Fred Jackman and Koenekamp. He suggested to Curtiz that Jackman could photograph a flood of water and then matte it into the scenes involving the extras. But Curtiz refused and told Mohr that it was his intention to have the full amount of water actually fall on the crowds below. Mohr told Leonard Maltin in his book *Behind the Camera* that

They had these spillways built on top of the columns that held tons of water, and they would come whooshing down onto the set. I said 'Jesus, what are you going to do about the extra people?' He said, 'Oh, they're going to have to take their chances.' We had 40 or 50 stunt men and women who had been engaged . . . if they know what they are doing they can protect themselves . . . but we had thousands of extra people on the sets, and they would do anything you'd tell them, just to get the day's work, but they had no idea what the hell was going to happen. They insisted they were going to do it, so I told them to shove the picture and walked off the set. They modified their extremities to some degree, but one man lost a leg, a couple of people were injured to the point that they never did recover.[6]

Fred Jackman's talents were utilized for another part of the flooding sequence when a whole city had to be destroyed. These scenes of destruction were to be incorporated with live action in the foreground involving 300 actors. Behind the live action could be seen a model of the temple and behind that was the miniature city. Four months and $40,000 were spent on this set-up in an area on the Warner lot that was 300 feet wide and 250 feet deep. Below the ground and above the set a vast network of water pipes was arranged. As with the scenes inside the temple a huge water tank was used that held 600,000 gallons. The next step was to remove every single one of the miniature buildings, break them apart and then reset them with clear clay in the broken joints in order that the flood would break them up realistically. As an extra precaution to ensure that the buildings would shatter on cue, wires and dynamite caps were also attached to the buildings.

Apart from the 300 actors there were also 105 men on the set to handle the wind machines, rain, flood water, lightning and other effects. Fifteen cameras were positioned – eleven set for high-speed shooting and four at normal speeds. It was important that nothing should go wrong as there could be no retakes without an enormous amount of extra time and expense. The shot had to be photographed between 11.45 and 12.20 in the morning, otherwise the huge sky backing set up behind the miniature city would cast a shadow.

Fortunately, while the actors had a rough time, everything went as planned as far as the effects men were concerned, although Fred Jackman

spent four days in bed afterwards suffering from nervous reaction. But despite all his nerve-racking work the miniatures did not receive much praise when the picture was released. One critic, in fact, described Noah's Ark as looking like something out of a child's toy set.

Ben-Hur (Fred Niblo, 1925) was another famous epic of that period and contained not only impressive optical effects but also outstanding miniature work and mechanical effects. The miniatures were designed by Cedric Gibbons and A. Arnold Gillespie and were built under the direction of Andrew McDonald. Cedric Gibbons began as an art director for the Thomas Edison studio in 1915 where he stayed until 1917 when he joined the Goldwyn Pictures Corporation. He was with MGM from its formation in 1923 until his retirement in 1956. A. Arnold Gillespie has had one of the longest running careers of any special effects man and claims the singular honour of having worked on both versions of Ben-Hur and both versions of Mutiny on the Bounty (Frank Lloyd, 1935 and Lewis Milestone, 1962). In an interview in 1972 he had this to say about his early career and his work on the first Ben-Hur:

'Apparently I'm more or less the doyen of special effects . . . I say that with no ego at all, it's just that there are very few of my contemporaries left now. I wanted to be an art director when I arrived at MGM in 1922, which wasn't even MGM in those days. I started as a draughtsman in the

(Below) *The Circus Maximus from the 1925 version of* Ben-Hur, *much of which was an ingenious miniature complete with tiny human figures*

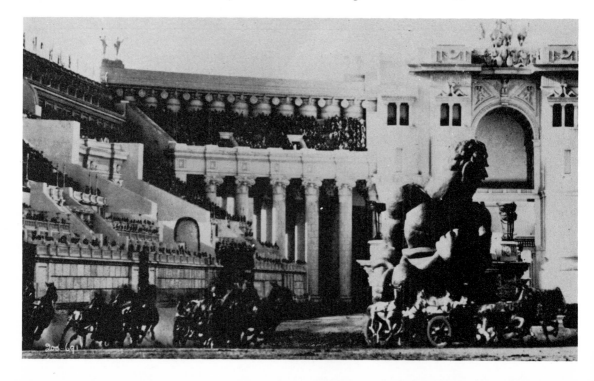

art department, an architectural draughtsman, which is a very important phase of any work in this area. Cedric Gibbons was the head of the department and I was working under him, a wonderful man. Being the kind of man he was he gave us almost complete autonomy, he was a good executive who surrounded himself with capable people and let them go ahead. He didn't *have* to be the boss type. So the association through the years with Gibbons was wonderful. I did a number of pictures as art director, the list of credits goes on and on. I think I did about 286 pictures as an art director, and I've got over 300 special effects credits on pictures. [It was Gibbons who designed the 'Oscar' trophy for the Academy Awards.]

'I went to Italy to work on the first *Ben-Hur* and was there nineteen months. I went over there as the assistant to Horace Jackson and came back as what we called the unit art director. People ask me which was the better of the two films and I kid them that the first one was by far the best, but they were both pretty good. I think the circus in the first *Ben-Hur* was better, the one we built in Rome. I enjoyed myself there, I used to go out and exercise the chariot horses by riding the chariots around the track. But the weather was wrong at that time to film the chariot race so the crew returned to the States while I stayed in Italy. They were supposed to return the following May but back in the States they decided to build *another* Circus Maximus over there. The first one in Italy I thought was beautiful but the second one I didn't think was as effective. The one in the last *Ben-Hur* [William Wyler, 1958–59] was much better, I thought. The design of the reclining figures at each end of the track, for instance . . . the ones they did in California for the first film, I thought, were pretty horrible but the second were much better. The general design was similar but totally different in execution.'

Gibbons's and Gillespie's crowning achievement in the first version was the miniature they built to combine with the full-size set of the Circus Maximus where the chariot race was held. The miniature section combined with the full-scale section in much the same way as a glass shot would. The camera filmed miniature and full-scale together and, as the perspective disappears on the screen, the two merge together. The miniature was designed so that a camera could pan over them and not lose register (on a glass shot the camera is restricted in its movements). A master stroke was a set of galleries with ten thousand tiny people, all of whom could be manipulated by mechanical means to stand up and wave!

Gillespie was also involved with the famous sea battle in which full-sized vessels, Roman triremes and pirate ships, designed by the Italian art director Camillo Mastrocinque, were used. The script called for the Roman flagship to be rammed by one of the pirate ships during the battle.

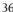

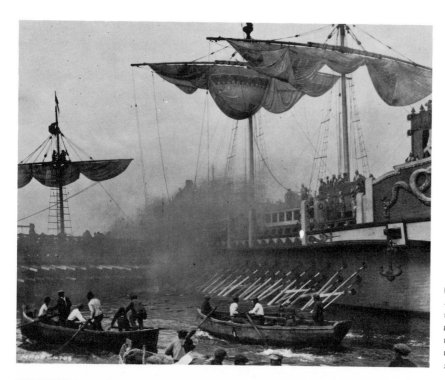

(Left) *The naval battle sequence in the 1925* Ben-Hur *with full-size vessels* (above); *the same sequence in the 1959 version, but this time filmed with miniature ships in a studio tank* (below)

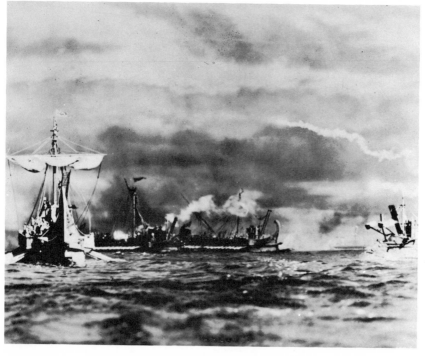

The pirate vessel was attached by cable to a motor boat which pulled it through the water and sent it crashing into the side of the flagship. After a fight between the two crews the trireme was to be set alight. This unappealing task fell to Gillespie.

'I was aboard the ship, the only American, acting as the assistant director and everything else. I had two assistants posted down below who were supposed to start the fires. We were to start the first fire forward by igniting something like a roman candle. It was to be fired up into the bow which had been loaded with barrels of sulphur and other chemicals. Now the assistant who was supposed to fire the thing was so nervous he couldn't so I had to take it from him. I lit it and it went whoosh! . . . and started the blaze. Now we'd anchored the ship so that the wind would keep the fire towards the bow but with seventy-five oar holes on each side a hurricane of a draught below decks was created and by the time I reached the stern the decks were smoking. Now we had four hundred Italian extras on board dressed as Romans and pirates. They were told that they were going to be given an extra hundred lire for staying on the ship when it sank. Even though they'd been told they'd need to be able to swim it turned out that about a third of them couldn't! When the ship caught fire and began to sink – we'd weakened part of the hull with a sledgehammer – they started to jump overboard. Soon they were clustered around the big oars and the rudder like bees round a pot of honey, calling out for the Madonna to save them. We were about a half a mile off-shore. All the cameras were on shore, it was being filmed in long shot. Just before the ship sank I dived overboard, still wearing my Macedonian costume, and swam to the shore.'

Boats were used to pick up those extras who could not swim but there is still some controversy over whether any of them actually lost their lives or not. The makers of the second *Ben-Hur* played it a lot safer. 'We did the entire galley sequence in miniature except for full-size sections of the galley that were filmed on the sound stage and blended in with process backgrounds and a few travelling mattes,' said Gillespie. One new innovation was the use of fireballs to liven up the action.

A travelling matte was also used to good effect in the first *Ben-Hur* in the scene where the senate building collapses on a crowd of people. Gillespie worked on this with Frank Williams who was one of the pioneers of this valuable film process. So far only in-the-camera mattes have been mentioned but they were succeeded by a technique called 'bi-pack contact matte printing'. In-the-camera mattes depended on a single negative being exposed more than once to combine the various image components. Naturally the risk of making an error would increase with every subsequent exposure which would mean having to scrap the whole thing and going back to the beginning again. The bi-pack method

BLUE BACKING SET WHITE LIGHT PLATE COMPOSITE NEGATIVE

LENS

ACTOR

(Left) *A simplified diagram of the Dunning travelling-matte process*

involves first printing the original negative, containing the live action, onto a master positive. This is then threaded into a special process camera capable of holding two rolls of film (from which the term bi-pack arises), the other roll of film being raw negative. A white easel is placed in front of the camera and on it a black matte is painted to match exactly that area on each frame of the live action that will not be required in the finished scene. The two rolls of film, which both come in contact behind the aperture, are run together through the camera. The black matte on the easel does not permit enough light through the master positive for the unwanted images to be printed on the negative behind it. So after the first run-through you are left with the new negative containing the live action but with a blank unexposed area on each frame. It is into this area that the artwork will fit. A counter-matte is then prepared on the easel, this time matching the area of the live action, along with the artwork. The negative roll is then run through the camera again. This time the counter-matte prevents the live action from being over-exposed and only light reflected from the artwork is absorbed by the film. The result is live action combined with artwork on one roll of film.

This method allows a greater degree of flexibility than in-the-camera mattes, one advantage being that there is no delay while an artist paints a matte onto a sheet of glass before the filming of the live action. Also if

an error does occur during the later stages, the original negative remains untouched and another master positive can simply be printed from it. Apart from artwork it is possible, using the bi-pack method, to combine live action with a variety of visual elements, such as miniatures, still photographs, or other live action, or even combine all these elements onto the finished negative. This process only became practical after the development of high-quality negative stock with very fine grains, after which time it soon replaced in-the-camera mattes.

In these examples, however, the matte lines remain stationary, the live action being limited to a certain area in which it must remain. A 'travelling matte', on the other hand, is one that changes shape and position with each succeeding frame. One of the earliest ways of doing this was to draw each matte by hand. This was the method used to produce the scene of the falling building in *Ben-Hur*. Each frame of the background action showing the collapsing building, a miniature, was enlarged to a scale sufficient to allow a matte to be traced around it. A series of matte drawings were prepared which were then combined with the live foreground frame by frame in a similar way to that used to produce animated cartoons. This is obviously a slow and expensive method and demands great skill but it is the most versatile of the various types of travelling matte. For instance, the falling debris from the building in that scene falls on and obscures from view the crowd of people. There is no other way of achieving this interaction between the visual elements of a combined scene except by hand-drawn mattes.

But in situations where it is required merely to combine live action with backgrounds, moving or otherwise, less time-consuming travelling matte techniques have been devised. One of the earliest versions was devised in the 1920s by C. Dodge Dunning and later Roy J. Pomeroy. A complicated affair, it involved a bi-pack camera containing an orange-dyed master positive of the background action in contact with raw negative film. The live action, illuminated by orange light, was filmed in front of a blank screen illuminated by blue light. The blue light caused the background action on the master positive to be printed onto the negative, while the orange light reflected from the actors passed straight through the dyed master positive and exposed the negative in the normal way. The actors, blocking the blue light with their bodies, became living mattes and so were combined onto the negative with the background action around them. This method only worked with black and white photography. Another version which could also be used with colour photography made use of a totally black background but was not very effective in either medium, the actors often being surrounded by a visible matte line resembling a halo. In the 1930s these techniques were superseded by back projection and for some time travelling mattes were

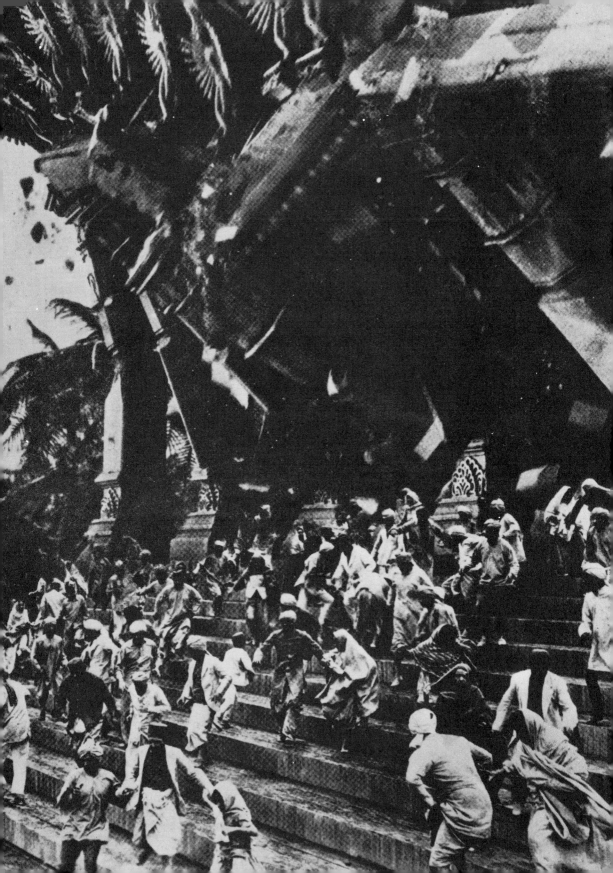

rarely used, except where a hand-drawn one was necessary, but since colour photography has become widespread much more efficient methods of producing travelling mattes have been developed, some of which will be mentioned in later chapters.

Comedies of course also provided special effects men with opportunities to put the impossible onto the screen. Mack Sennett comedies, for instance, depended for a great deal of their impact on the skill of the cameraman when filming the inevitable mad chase sequence. By cranking his camera at various speeds he could determine just how fast the vehicles would appear to move. Physical effects were also important and it was here that piano wire came into its own. Piano wire is very strong and virtually invisible on film, making it indispensable when a car is required to teeter on the edge of a cliff. There is a story that an accountant working for the Sennett studio complained about the huge bill for piano wire when he never saw any evidence of it on the screen. But though capable of supporting heavy weights the wire is also rather brittle and can easily snap if there is a very sudden increase in pressure or if there is a kink in it. At least one person, a cameraman, is known to have died as a result of wire breaking at the wrong moment. William Hornbeck, at one time vice-president in charge of the editorial department at Universal, once had his new car drop thirty feet when piano wire broke during filming. It was never the same after that, he later claimed.

Piano wires also played an important part in the making of Harold Lloyd's 'thrill' pictures which usually included sequences that had Lloyd precariously suspended on the side of some tall building. These scenes were actually filmed as far above the ground as they appear to be on screen, without the aid of travelling mattes or rear projection. Sometimes Lloyd's stunts were performed on a false section erected on top of the buildings but at other times they were filmed on the sides of real buildings. Of these latter scenes Lloyd liked to boast that the only safety precaution he had was a wooden platform, covered with mattresses, situated below him out of camera range. (There was a story of how Lloyd's prop men once tested the platform by dropping a dummy on it – which bounced off and landed in the street below.) Lloyd later admitted, however, that he did use wires in his stunts because the Los Angeles city authorities insisted upon it.

A comedian who did make use of trick photography as well as relying on his acrobatic talents was Buster Keaton. One of his films, *Sherlock Junior*, is a surreal *tour de force* of camera trickery at its most skilful. One of the best scenes involves a masterly double exposure showing a ghostly Keaton rising out of his body as he sleeps. The phantom Keaton then walks down the aisle of a cinema and climbs into the screen where he joins the characters in the film being projected onto it. 'We built a stage

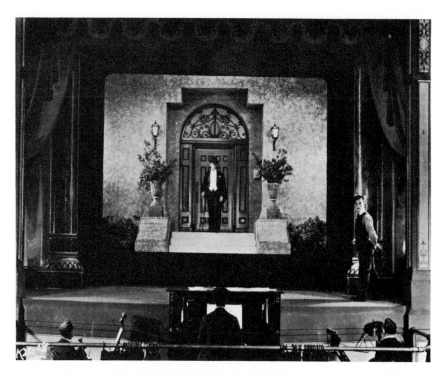

(Left) *Buster Keaton standing on the special stage built to resemble a cinema screen (from* Sherlock Junior*)*

with a big, black cut-out screen. Then we built the front row of seats and orchestra pit and everything else,' Keaton explained later. 'It was our lighting that did it. We lit the stage so that it looked like a motion picture being projected on a screen.'[7]

The mechanical effects in Keaton's films were always of a very high quality. Keaton, whose childhood ambition was to be a civil engineer, had an aptitude for designing gadgets and solving technical problems, a talent that was put to better use in film making than it could have been in any conventional career. Keaton was aided in this area by Fred Gabourie, who was his chief prop expert, technician, set designer, builder and mechanic, all rolled into one. Due to his work on the Keaton films, Gabourie became one of Hollywood's most sought-after technical men and was eventually head of MGM's prop department. Evidence of his particular genius can be seen best in the hurricane sequence in *Steamboat Bill Jnr* where whole buildings rise into the air or collapse perfectly on cue. But both Keaton and Gabourie were stumped for a time, during the making of that classic two-reeler *The Boat* (1923), when they could not get a boat to sink. The boat did not refuse to sink at all but would not sink completely. The scene called for a vessel to go straight down under the water with Keaton standing on it but no matter how they arranged it something went wrong every time. To give it extra weight they loaded

it with sixteen hundred pounds of pig iron. It sank, but so slowly that they could not use the shot. Next they modified the boat so that the stern broke away when it hit the water. The result was that the stern sank very smartly but the bow remained sticking up. Air pockets were the culprits so holes were bored everywhere to prevent air from becoming trapped. But still the natural buoyancy of the wood prevented the boat from sinking immediately. By this time Keaton and his crew were fed up. Instead of wasting any more time they went out and dropped a sea anchor into the water. The anchor was attached by a cable to the stern and then via a pulley to a tug situated out of camera range. This time when the signal was given the boat was *pulled* under the water.

For most of the silent-film era special effects did not come under the supervision of any one particular person or department. Different special effects were handled by different people in the film crew. Optical effects were, of course, handled by the cameraman but mechanical effects by whoever could come up with what was required at the time. Edward Sloman, director of numerous silent films, said years later, 'The director of today yells to his staff, "I need this . . . I want that." The director of yesterday, if he wanted something special, often had to create it himself.'[8]

Joseph Henabery, who worked as a prototype art director on some of Griffith's films, gave an example of thinking on the run during the making of *Intolerance* (D. W. Griffith, 1916).

We had battle scenes on the walls of Babylon in which people were supposed to be thrown off. We had tried dummies for the long shots. I thought they were putrid. They'd flop this way and that, and they looked like what they really were . . . stuffed long johns.[9]

He suggested to Griffith that they ought to build something better and Griffith told him to go ahead and try. After a late night in the prop department, with the assistance of several prop men, Henabery came up with a dummy whose joints would not bend the wrong way. It was fitted inside with strings so that as the dummy fell they would snap, releasing an arm or a leg which resulted in natural body movements.

Cecil B. DeMille, writing in his autobiography about the making of *The Warrens of Virginia* in 1914, said:

The only way we knew how to blow up a wagon train was to actually blow it up. We rigged the insides of the wagons with bombs, put strong sheets of iron behind the drivers to protect them, fixed the wagons so that the drivers could break the forepart away and drive clear on the two front wheels, and made a good battle scene with nobody hurt.[10]

Even though this may have been true of the filming, afterwards two men each lost a hand while fooling around with unexploded bombs.

It was only natural that departments combining all the various facets

of special effects, for reasons of safety as well as convenience, came to be formed within the studios. The first special effects departments, however, were concerned only with effects concerning the camera. Mechanical effects were not incorporated until later, depending on the studio concerned. No two departments were the same, each studio having its own idea as to what constituted special effects and under what system they would operate.

Just who started the first special effects department is unclear. According to the *American Cinematographer* magazine it was Irving G. Ries. Ries became interested in films while working as an usher in a nickelodeon. In 1907 he bought his own camera and joined a Chicago production company. They were in the middle of a film and had just lost their cameraman, who had quit, taking his camera with him, so they were overjoyed to take on young Ries – and his camera. In 1924 he was hired by MGM for a three-week assignment, his task being to do the trick work in a comedy sequence in which the script called for the star, Louise Fazenda, to ride an ostrich. To quote the *American Cinematographer*:

The results were so good with such a saving of time and money to the production that Irving realized the creation of a department where all trick shots could be handled would be most beneficial to the studio. He sold the idea to *Metro* officials and his three weeks stretched to many years.[11]

Veteran special effects man Lee Zavitz has, however, a different story, as previously mentioned.

'The credit title "special effects" was introduced by Louis Witte, to whom I was assistant for ten years with the old Fox Company. Later, when sound and synchronous motors came in, permitting rear projection, the cameraman in charge was credited with photographic effects, not special effects. The pictures I worked on with Lou Witte were not the first, but the first of any consequence was *What Price Glory?* in 1926 and to the best of my knowledge the first picture in which the credit of special effects was used, and the start of a special effects department. My union card, which I believe is the first for special effects, was issued in the middle of 1929.'

The introduction of sound hastened the spread of special effects departments and by the early 1930s all but one of the major studios maintained such a unit. But not everyone in the industry approved, in particular a few directors and cameramen who felt that an important segment of film making was being removed from their control. Cameraman Karl Freund voiced his opposition in 1933 saying:

I feel that the policy of having a separate special effects department is ridiculous. It leads to undesirable confusion, duplication of effort and responsibility and,

in all too many instances, to inferior work. In Germany – and all through Europe for that matter – the production cinematographer is invariably in charge of any special effects work, no matter what sort, for his production.[12]

Probably some of Freund's criticisms were valid but there was no avoiding the fact that as the Hollywood studios grew in size film-making methods had to change. The big studios were becoming film factories and had to be organized along more efficient lines like any other industry. The old haphazard methods could no longer be allowed, or afforded, and that applied to special effects as well as to all other aspects of production. Artistically limiting perhaps, but this breaking up of the studios into specialized units did result in the attainment of high levels of sheer technical virtuosity. It is doubtful if any European studio could have matched the combined mechanical complexity and technical skill described in the following story by F. B. 'Dinty' Moore about a routine assignment in Universal's miniature department in 1928. The film concerned is *The Michigan Kid* (Irvin Willatt) and Moore's fellow camera-man is none other than John P. Fulton who later became one of the most famous of special effects men.

The picture had, for a climax, a race for life through rapids and a forest fire to ultimate safety. To actually fire a forest was, of course, out of the question. 'Uncle Carl' Laemmle [the head of Universal at that time], his nose to the wind, was sure to smell the added expense, and besides the Forest Service wouldn't allow it. The job was up to the miniature department and John and I were ordered to shoot the scene. The following day, as I checked all camera equipment on location for test shots and set-ups, there lay before us a perfect pigmy forest covering an area half as wide as a city block and nearly half a block long; an interesting study of wild mountainous country and the ingenuity of the property department. Down through the center wound a dry river-bed in whose channel a narrow-gauge track followed the flow to guide the wheels of a camera-car. At the upper end an artificial lake awaited the opening of its flood-gates to raise the river in a perfect imitation of white-water rapids whose angry flood would swirl down through the set to pour over the falls at the lower end into a catch basin below.

The banks of the river, lined with lava-rock and tiny boulders among which fallen tree trunks a foot and a half in length lay in natural confusion, were built up of soil and silt, covered in spots by dwarf underbrush by property men who were artists at the game. The forest itself came almost to the water's edge; pines, hemlock, fir, all of them perfect specimens, twigs and small seedlings of the actual trees, the highest not over two feet in length but rising on the sides of the set to match the contours of the country. On either bank of the river the ground, covered by forest, in turn covered a network of hidden perforated pipes through which fine invisible streams of high-test gasoline could be sprayed on the trees and thus ensure a roaring blaze.

Finally everything is in readiness. To create a better fire effect, the scene is

to be shot at night and the call is for eight in the evening. All day trucks have been bringing up giant arc lights. Prop men have been cleaning up details and debris. Down in one corner I've set up a small box lab to develop tests in case the director wants a quick check on some of the takes. And, as sound effects are still in the fabulous future and the minds of the Warner Brothers, such equipment is, as yet, unheard of. By 8 p.m. everybody is in place. Thirty or forty juicers stand behind their arcs; prop men wait at vantage points with flares to touch off the set when the man on the gasoline drum turns the valve that starts the flow. The artificial lake, filled to the brim, is ready. The camera-car, at the top of the set, is in place and the cameras, minus their tripods, are slipped onto metal plates and screwed to the floor so the lens will be as close as possible to water-level. Irvin Willatt [the director], John and I, clad in asbestos suits borrowed from the local fire department as a protection against the flames, take our places.

The signal is given. The flood-gates gap and the water rushes past us in a white foam that rises to the floor of the car which several prop men in hip boots hold with difficulty. Fine sprays of gasoline spurt from the hidden pipes and the forest is aflame. The arcs flare up in a flood of light. Camera! John and I begin to grind; the prop men jump to one side; we're off!

Carried faster and faster by the weight of the rushing water, the car swinging on the uneven track, we whirl down the river bed. We speed round the last bend, breaking through a safety rope and come to a crashing stop against a bumper of boards at the top of the falls. Unable to see because of our asbestos hoods, the fire and the blinding arcs, the unexpected and sudden stop bounces all three of us off the car for comic though somewhat painful sit-falls in a two-foot rush of cold water. The camera-car, now acting as a dam, is mounted by a wall of water, flooding the film box before we can regain our feet and stage a rescue. But, almost at once the flood-gates are closed, the gasoline flow ceases and a fire hose is played on the smouldering trees. The arc lights show up a partially burned fairy forest, still substantial, still amazingly real.

Then, the camera dried, fresh magazines procured, the car returned to the top of the set, the scene is shot again. And again and again, frontward, backward and sideways until the miniature forest, only recently completed is now completely finished. It is after midnight. Wet and shivering and slightly scorched, John and I return to the lab for dry clothes and clean our bedraggled camera equipment.[13]

2/After Sound

The introduction of sound at the end of the 1920s brought about many changes within the picture industry. Methods of production had to be adapted to accommodate the requirements of primitive recording techniques which meant that filming on location became almost impossible. This forced production crews to retreat into the studios where they were able to record dialogue under controlled conditions. Even the cameras, which had achieved a great deal of mobility during the silent era, once again became static objects, sealed within booths to muffle the noise of their action. It was this situation that gave a large boost to the importance of the special effects men, for the task of re-creating the world within the sound stages fell to them. The result was that during the following years the size and power of the effects departments increased, aided especially by the development of an efficient rear projection process.

There were several ways in which action filmed in a studio could be made to appear as if it were taking place somewhere else. One way was to use a painted backdrop but this has obvious drawbacks. It is sufficient if a stationary background only is required but for a moving one it becomes necessary to combine a photographed scene with the live action. Travelling mattes achieved this but the techniques available at that time left much to be desired. Rear projection, however, fulfilled all the requirements and had the advantage of being less complicated; it also enabled the director and cameraman to see immediately how the composite would appear.

Rear projection was not new, it had been used by film makers previously, such as Norman Dawn, but only to project a stationary image. To combine a moving image with live action it was necessary to synchronize the rear projector with the camera filming the live action. In other words, as one frame of the background action was being projected on the screen the shutter of the camera filming the actors had to be opening at that exact moment. As usual there are conflicting stories as to who first achieved this. Hans Koenekamp, mentioned earlier, is said to have been the first to develop and patent the system and George Teague at the old

(Left) *An example of a rear-projection screen in operation: this frightening image from Hitchcock's* The Birds *was composed of rear-projected birds and running children*

Fox studio is credited with first using it in a film, which was *Just Imagine* (David Butler) in 1930. But the name most associated with rear projection is that of Farciot Edouart.

Edouart was born in California, where both his grandfather and father were portrait photographers. In 1915 he began work as an assistant cameraman in the Real Art Studio in Hollywood, part of one of the firms that eventually became Paramount. After spending the war in the Army Photography Section he returned to Hollywood and began his own photographic business in 1921. But the movie industry soon attracted him and he joined the Lasky Studio where his photographic experience led him into the making of glass shots. Eventually he found himself heading the special effects department at Paramount where he pioneered several travelling matte techniques before switching his attention to rear projection. Edouart made rear projection his special province and set the pace for what could be achieved with this process during the early 1930s. Before long it was indispensable to the making of almost every picture, and in some involved seventy-five to eighty per cent of their entire footage. Not surprisingly, there was a certain amount of resentment over this new-found power of the special effects man. Cinematographer Daniel B. Clark, writing in the early 1930s, had this complaint to make:

I have recently had a number of experiences with process departments which seemingly went out of their way to avoid co-operation with the production cinematographers. In the making of the process scenes for several of my recent productions, for instance, not only was I never consulted, but I was not even allowed on the process stage, and I understand [the results will bear this out] that the process men did not even trouble to view the scenes which I had made, and which were to be used with the process shots.[14]

Ernest Haller, another cameraman, had the exact opposite to say:

Since I have been at the Paramount studios I have felt myself particularly fortunate in having the superb co-operation of Farciot Edouart and his special effects department who go out of their way to co-operate with the production cinematographers.[15]

Actually, rear projection became something of a fetish with most Hollywood film makers. Even when sound-recording techniques improved to the point where location work once again became feasible directors still insisted on using the process as much as possible. This situation lasted right up until the late 1940s. The trouble with rear projection is that, unless it is handled with great skill and care, the slightest error becomes very apparent and the illusion is immediately destroyed. Cinematographer Hal Mohr, in conversation with Leonard Maltin, described the problems he had with it during the making of *State Fair* (Henry King, 1933):

Now there are certain things you do and don't do with process plates, and there are damn good reasons. Your foreground perspective is married to the perspective you have on your plate; if you're going to have a set built in front of a plate, the set has to be photographed with the same focal-length lens that you shot the plate with, otherwise your vanishing points vary. Henry King [the director] went to the state fair in Kansas and shot all of his process plates there. But he shot all of these plates and everything . . . livestock halls, livestock, etc, with a 25mm lens in order to get scope. When it came to building the interiors that had to go with these plates I had to resort to building them in false perspective. In other words, a hog pen tapered back incredibly, in order to meet the perspective of the 25mm lens. That was a hell of a problem on a lot of that film for that reason.[16]

Mohr admitted that it would have been a lot easier to have simply shot the whole thing on location.

Used sparingly, and with skill, rear projection can be effective as background scenery but directors in the 1930s and 1940s persisted in using the process in many ways that it was simply not designed for. Most fatal of all was the common device of filming people in the studio together with people on the background screen. The differences between the two were much too apparent and could be discerned by even the least aware member of an audience. An example of this occurs with some early scenes in *Tarzan The Ape Man* (1932) when Jane and her father are

shown looking at a group of dancing natives. The shots of the natives are grainy and out of focus and their perspective does not match that of the studio shot; it is a glaringly obvious process scene. (This was in contrast to other sequences in the film which contained much more skilfully executed examples, as well as some excellent matte work in the cliff scenes where Jane falls over the edge and is supported by a rope – a combination of a good matte painting and a travelling matte.)

Directors of that period even liked to have some form of interaction between the actors in the studio and the people on the rear-projection screen. For example, in DeMille's *The Plainsman* (1936), a climactic battle takes place between a group of cowboys and hordes of Indians, the cowboys having been filmed in the studio and the Indians filmed weeks beforehand on location. An interesting idea but it fails to come off. A better example is in John Ford's *Stagecoach* (1939) where several shots of the Indians riding along behind the coach were done with a background screen, but Ford was much more subtle in his use of the process than DeMille and the result is quite convincing.

Another favourite ploy of the time was to have the actors walk on a treadmill while moving scenery was projected on the screen behind them. This rarely ever came off as planned because the scenery either passed too slowly, or too quickly, which created the impression the actors were wearing roller skates. Sometimes it bobbed up and down which was even more disconcerting.

Occasionally a daring idea for using rear projection actually worked. In Alfred Hitchcock's *Foreign Correspondent* (1940) there is a sequence where an aeroplane crashes into the sea, which is all filmed subjectively from inside the cockpit. Between the two pilots one can see the ocean coming closer and closer until finally the aeroplane hits the water which bursts in and floods the cockpit. The whole sequence was filmed without a single cut. Hitchcock had a rear-projection screen built out of paper and behind it had placed a large dump tank full of water. In front of the screen was a full-scale mock-up of the plane's fuselage, including the cockpit. When the shots of the ocean became near enough on the screen Hitchcock pressed a button which released the water. It rushed down the chute, burst through the screen and flooded into the cockpit. The screen was destroyed so swiftly by the rushing water that it was impossible to detect its presence. (Handling the effects on *Foreign Correspondent* was Lee Zavitz, and the production designer was the great William Cameron Menzies.)

Probably the most original use of rear projection occurs in *Casablanca* (Michael Curtiz, 1941) – (which also contains a terrible example of matte painting in the opening shot of Casablanca itself). During the flashback sequence when Humphrey Bogart and Ingrid Bergman are together in

Paris there is a shot of them in a convertible with typical Parisian scenery in the background which is obviously process work. But, strangely enough, the background scene *dissolves* into another scene of Paris while the car and its two occupants remain in focus. I cannot think of a similar example in any other film where the director has so casually drawn attention to the rear projection screen – or, in fact, made use of one in such a novel way.

As time went by, producers and directors made more and more demands on rear projection, requiring bigger and better results. Speaking in 1942, Edouart said:

When the process was first used, a scene inside a closed car, with a screen six or eight feet wide was something to be happy about. But demand has forced us to find ways of using screens 12, 15, 18, and 20 feet across. When we succeeded in using a 24-foot screen we already had demands for a 36-foot screen. My most recent scenes have made use of twin screens totalling 48 feet in length.[17]

In 1942 when Edouart shared an Oscar (with Gordon Jennings) for his work on *I Wanted Wings* (Mitchell Leisen, 1941), the *American Cinematographer* magazine had this to say:

Since this award is given jointly for special effects in both photography and sound, and its selection is participated in by recording engineers and set designers as well as cinematographers, we have at times past found some of the selections open to question, in that sound or set-design seemed to govern the choice, virtually to the exclusion of photographic special effects. But this time, such is happily not the case. We cannot offhand think of a single production which has owed a greater debt to the special effects specialists. Very literally, *I Wanted Wings* could not have been made without the special effects contributions of Gordon Jennings and Farciot Edouart, A.S.C.

In our earlier review of the film we said, 'The production is among the best air films ever made. And a very great part of Edouart's work is based upon the tremendous possibilities stemming from his development of the ultra-powered, triple-head process projector. Without this, it would have been impossible to get the many long-shots in which the players are seen taking off, flying and stunting in angles which show virtually the entire 'plane, and convincingly make the 'plane not merely fly level, but climb, dive and roll, all in angles which give the effect that the camera was flying right alongside.'[18]

The triple-head projector mentioned was an important development in the use of rear projection. One drawback with the process is that the amount of light that penetrates the screen from behind is always less than that which is reflected off the actors standing in front of it, with the result that in the final composite image the background scenery generally looks flatter or more faded in comparison with the live action. The obvious way to combat this would be to project the image from the front, as is done in an ordinary cinema, but of course the players would cast their shadows on the screen (a technique was eventually evolved to

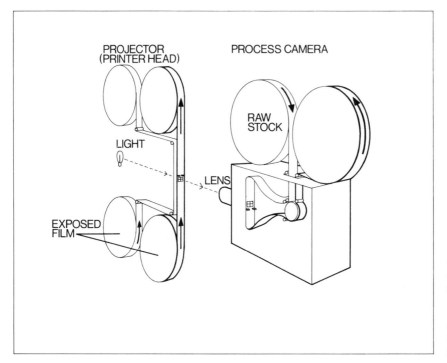

PROJECTOR
(PRINTER HEAD)

PROCESS CAMERA

RAW
STOCK

LIGHT

LENS

EXPOSED
FILM

(Left) *The basic components of an optical printer. The printer head is shown loaded in bi-pack for travelling matte work; the process camera records the combined image directly from the projector*

overcome this problem). Edouart's answer was to increase the intensity of the image cast by the rear projector. He did this by having one projector point directly at the screen and two others positioned one on each side in such a way that two mirrors were able to bounce their images onto the same screen. This meant that three identical scenes were being projected on to the one screen with the result that three times as much light was being picked up by the camera on the other side. It was a complicated technique and naturally great care had to be taken that the three images matched perfectly and did not overlap. It became even more valuable with early Technicolor photography which needed much more light than black and white though it was later superseded when Eastman introduced their very fast colour film in the 1950s.

Another important development in special effects during the late 1920s and early 1930s was the introduction of optical printers. Optical printing has its origin in still photography where it is simply a process of copying a photograph by photographing the original. But transferred to motion picture photography it becomes somewhat more complicated. Basically an optical printer consists of a movie projector and a process camera, both of which face each other. The projector contains the master positive and the process camera contains the dupe negative. In the same way that the projector and camera are synchronized in a rear projection

unit so are the projector and camera synchronized in an optical printer – as one frame of master positive is projected one frame of the negative is exposed.

The obvious use of an optical printer is to make exact copies. If a reel of master positive is run through the projector the images it contains will be duplicated onto the negative, from which another master positive can be printed. Indeed, some optical printers are designed to perform just that one function, but by manipulating the projector in various ways, and by the use of various attachments, all manner of effects can be created by these machines. Optical transitions such as fades, wipes, dissolves, and so on; as well as slow motion, speeded-up action and frame freezing can be achieved with optical printers. For fade-ins the master positive is photographed twice by the process camera, once normally, the second time with the camera shutter being completely closed at the beginning of the shot and slowly opening as each frame is printed. A fade-out is achieved by reversing the procedure. Dissolves are made by double-printing a fade-in of the next shot with a fade-out of the previous shot.

Wipes, when one scene is replaced by another one sliding across in a vertical line, are produced by a device called a wipe blade. The blade acts as a matte as it is moved across the last forty-eight frames of the outgoing shot; the negative is then rewound forty-eight frames and the next shot is filmed, with the wipe blade moving in the opposite direction. Similar devices are used to create split screen effects, such as when two people are shown talking to each other on the telephone in two different loca-tions, or when an actor, playing twin roles, appears with himself in the same scene. By blocking off alternate halves of the two positive films and rewinding the negative, the two images are combined on one film. This principle has been carried further to produce multi-image effects of the type used in films such as *Grand Prix* (John Frankenheimer, 1966) and *The Boston Strangler* (Richard Fleischer, 1968), where up to six or eight different scenes are combined on one screen.

The old silent-film cameraman achieved speeded-up action by under-cranking his camera. By slowing his film he was recording the action on fewer frames than if he had been cranking at the usual sixteen frames per second. When the film was projected onto the screen at the normal speed the action naturally appeared faster. For slow motion he did the reverse; he cranked more quickly. An optical printer, however, produces speeded-up action by skipping frames – that is, the process camera is adjusted so that it will only film every second or third frame of the positive, depending on how much it is required to speed up the action. For instance, if only one frame in every four is printed the action on the negative will appear four times faster than it did on the positive. To slow down the action the optical printer, instead of skipping frames, will

print each one more than once. If each frame of the positive is printed three times in succession on the negative, the action, when it is projected on a screen, will appear in slow motion. This method is also used to 'freeze' frames by printing the same frame over and over again. This produces the type of effect used in the final scene of *Butch Cassidy and The Sundance Kid* (George Roy Hill, 1969).

These are only some of the uses of the optical printer. It is also used to reverse action, enlarge or reduce details in a scene (simulating zooms), convert day photography to night or convert colour photography into black and white (sometimes used for dramatic effect), and superimposing titles as well as numerous other effects. Not surprisingly, the optical printer is considered by film makers today to be of prime importance. Though simple in principle optical printers are very complicated machines and must be carefully designed and constructed, with the result that the average cost of one is at least £40,000. The more a printer is required to do the more expensive it becomes but technicians at the British Film Institute managed to construct one fairly cheaply, using an old camera and projector, for the purpose of salvaging rare old films and transferring them onto new stock.

One of the first special effects men to demonstrate what could be achieved with an optical printer was Linwood Dunn. Writing about *Melody Cruise* (Mark Sandrich, 1933), on which Dunn handled the effects with Vernon Walker, a reviewer commented:

The outstanding feature of this film [a musical, by the way] is the special effects work. The film might be better described as a solo for optical printer accompanied by a film troupe. They have not only used every trick hitherto imaginable, but invented half a dozen new ones of their own. Just a few of the tricks include wipes, blends, whirls, melts, and the like.[19]

The reviewer ended his piece by expressing a hope that the film was not going to start a trend of weird optical transitions.

Linwood Dunn joined RKO in 1929, when the optical department was just being established, and received his first look at an optical printer. During the next few years he handled all kinds of trick work but maintained a preference for working with the printer. His first really spectacular achievement was in *Flying Down to Rio* (Thornton Freeland, 1933) in which RKO not only introduced Fred Astaire but demonstrated the wide range of spectacular effects an optical printer could produce. Another, later, film that employed optical effects to the limit was *Citizen Kane* (Orson Welles, 1940). The picture was about fifty per cent optically reprinted, some reels consisting of eighty to ninety per cent optically printed footage. One such scene was a pan down from a statue of a man to live action at the base of the statue. The statue itself was a miniature, and both it and the full-scale action at its base were photographed as separate

stationary shots. The two separate scene components were joined by a travelling split screen and the vertical panning movement was also put in on the optical printer.

By the mid-1930s the special effects departments were firmly established in all the major studios although their organization varied from studio to studio. When A. Arnold Gillespie, mentioned earlier, took over as head of MGM's department in 1936 he had control of rear projection process, miniatures and physical or mechanical effects, three of the five categories of special effects at that time. Matte painting effects and effects produced by the optical printer came under the control of the optical department.

'Every studio was different,' said Gillespie. 'My counterpart over at Paramount, Gordon Jennings, had nothing to do with process (rear projection), that was handled completely by Farciot Edouart.

'I enjoyed solving the physical problems that came up when making pictures, I had a bent for what I call physically dramatic pictures . . . with earthquakes, etc., so when the opening as head of the special effects department was offered to me I grabbed it. I took over from a very good finding things too quiet there he then moved to Los Angeles and got a He was English and was in World War I, as was I, but he went in as a private and came out a Colonel. He moved to Canada after the war but finding things too quiet there he then moved to Los Angeles and got a job with the studio as a draughtsman shortly after I arrived, and we became very, very close friends. Jim took over the department, which wasn't called special effects in those days, while I remained in the art department. We worked together quite a lot while he was with the studio.'

One film both men worked on was *San Francisco* (W. S. van Dyke, 1936) which contained one of the most spectacular earthquake sequences in movie history. A reviewer commented:

In addition to glimpses of tables falling, walls caving, bricks pouring, houses toppling, streets gaping and a city burning, it includes enough squeaking, howling, booming and crashing to shake the rafters of the sturdiest cinemansion. An earthquake in the real MGM manner, it lasts for twenty minutes on the screen and in all respects except casualties no doubt betters the original of 1906. Incidentally, the reason for the San Francisco earthquake, as all movie makers have long been aware, was not a geological fault but rather due to certain unfortunate conditions in the city's night life.[20]

Filming the earthquake involved 400 extras who were required to stand on balconies that were designed to come crashing down at the press of a button. The entire set actually shook back and forth, shifting as much as three feet laterally in an accurate pattern of destruction modelled on a real earthquake. Due to extreme care and skill on the part of Gillespie and Basevi, none of the extras was injured during the filming.

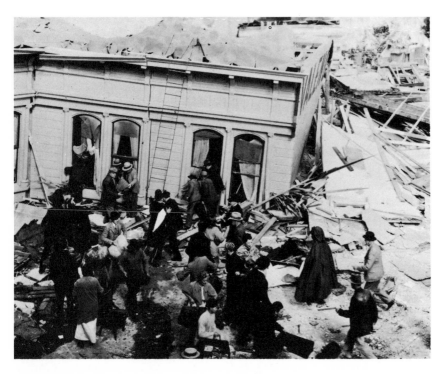

(Left) *A studio-made scene of destruction from* San Francisco

Basevi left MGM to work for Sam Goldwyn and one of the first films he became involved with was John Ford's *The Hurricane* (1937). The hurricane of the title took nearly four months to design, produce and film. The result earned Basevi an Oscar and most film historians agree that it was one of the most frightening storm sequences ever to appear in a picture, all the more remarkable considering that it was filmed entirely within a studio. Basevi, assisted by Stuart Heisler, spent $150,000 building a native village and $250,000 destroying it. The huge set was 600 feet long and consisted of an island sea front with wharves, huts, a church and palm trees. There was also a beach which ran into a limpid lagoon – actually a 600-foot-long tank. Across the 'lagoon' Basevi erected powerful aeroplane props, mounted on towers, into which water was sprayed from several fire hoses. The resulting clouds of spray swept over the artificial island in a remarkable simulation of driving rain. At the same time wave machines (steel rollers that revolved and slid up and down like pistons), churned up the water in the tank to create a boiling sea. To crown the scene, a tidal wave was produced by letting loose 2,000 gallons of water down chutes from dump tanks into the lagoon.

Most of the big studios had similar tank facilities for filming scenes involving water, with either full-scale sets or miniatures. In designing these tanks it was important to be able to drain and refill them quickly,

in order to permit the rigging of various mechanical set-ups. Huge pumps were installed together with an efficient drainage system, the tank being supported by a nearby reservoir, so that water could be stored and re-used as often as required. It was also desirable to keep the water as shallow as possible so that men in waders could get to the miniatures and make repairs without having to swim. The ideal depth was thought to be three feet, but the bottom of the tank often became a problem, especially when cables were used to propel the miniatures. To hide the bottom, and the machinery, it was necessary to add a blue dye to the water.

MGM had a 300-foot-square tank located adjacent to the main studio. Across the rear of the tank was a backing, or cyclorama, 328 feet long and 60 feet high. The backing was often used alone for some scenes.

'I spent most of my life in that tank at Culver City photographing miniatures,' said Gillespie. 'The camera used to float in an old converted garbage wagon which someone christened the ''S.S. Gillespie''.'

Working in these tanks was usually relatively safe but when dump tanks were in use it could become hazardous. Dump tanks, mentioned earlier, were special tanks erected on the side of the main tank. They could release a very large volume of water in a short time and were first utilized by producer Hal Roach in his comedy films. Dump tanks were instrumental in the critical injuries sustained by several extras during the making of *Noah's Ark* in 1929 (see pp. 31–2), but improved safety regulations have prevented any similar tragedies, although there have been a few close calls since then. Several stunt men were slightly injured during the storm sequence in the second version of *Mutiny on the Bounty*.

Incidents involving tanks are also the source of several amusing stories. One that dates back to the 1920s concerns the filming of a miniature French cruiser which had to pass by a fortress at a harbour entrance and narrowly avoid being blown up by a submerged mine. It was decided to build a movable tank out of wood and push it past the fortress miniature. The tank, thirty feet square and one foot deep, was propelled on rollers. Repeated tests were made with small dynamite charges beside the ship but the amount of water thrown into the air was insufficient. This continued until four o'clock in the morning when the frustrated powder man weighted an extra charge and sent it to the bottom. As twelve inches of water offers a great deal of resistance the resulting explosion sent all the water in the tank, 6,500 gallons of it, onto the floor of the studio, leaving the boat high and dry.

Gillespie, the man who worked on both *Ben-Hur*s, also worked on both versions of *Mutiny on the Bounty* as previously mentioned.

'I was in Tahiti for a long time on the first one. The first time we didn't build a complete ship as they did on the second one, we only built a

portion of the ship at Tahiti. We also did some of the shots on Catalina Island (a favourite location for many Hollywood film makers who wanted a nearby tropical setting).'

For the second *Bounty* a sea-going vessel was built, 118 feet long – thirty-three feet longer than the original, but then Hollywood always tries to improve on reality. The extra room was needed to store equipment as well as for dressing rooms and living quarters. Permanent fittings were built into the ship so that camera platforms could be assembled on the sides when required.

For the storm a full-scale *Bounty*, complete with rigging, was constructed on rockers inside an MGM sound stage. The huge dump tanks poured tons of water over the decks, washing sailors overboard. It was while filming this that the stunt men were injured. Four full-scale *Bounty*s were actually built (despite the inflated budget of the second version the original picture was more successful): the sea-going version which was sailed to Tahiti, the rocking one for the storm sequence, another one built on the MGM backlot as part of a large exterior set duplicating the harbour of Portsmouth, and a fourth which was a cutaway model of the below-decks interior of the ship, also built on rockers.

Two unusual problems that Gillespie faced during the course of his special effects career were nothing to do with the tank but were both solved by an ingenious use of water. The first occurred during the filming of *The Good Earth* (Sidney Franklin, 1937) which was set in China and contained a sequence which showed a huge plague of locusts attacking the crops. As it was impossible to persuade a real horde of locusts to perform before the cameras another method had to be found. Finally Gillespie came up with a simple and inexpensive solution. A camera was positioned upside down in front of a glass tank in which a curved piece of masonite was placed under water. Coffee grounds were then dumped into the water and filmed as they glided down over the masonite, forming wave-like patterns. When this action was reversed and superimposed over a scene of the actual fields the coffee grounds appeared to be a dark mass that swirled up from behind the horizon and formed a thick black cloud in the sky. Close-ups of the insects feeding on the plants were managed by using dead locusts that had been pickled in alcohol. By manipulating them with tiny sticks of wood, Gillespie and his crew made them appear alive and kicking.

The second problem arose during the making of *The Beginning or the End* (Norman Taurog, 1946) just after the Second World War. The film was about the use of atomic weapons and the script called for shots of an atomic explosion but at that time no pictures were available of one. Moreover information relating to the subject was still 'classified' by the government which meant that Gillespie and his staff had very little to

work from. Several methods of reproducing an atomic explosion were tried but Gillespie was not satisfied with any of them. Finally he recalled a sequence from an old Tarzan film in which the hero had wrestled under water with a full-size mechanical crocodile. When the apeman had slashed the reptile's neck, small sacs concealed beneath the artificial hide had released a dye that simulated blood. Gillespie remembered that the dye had formed a mushroom-shaped cloud as it floated up towards the surface of the water. Working from this lucky clue, he devised a technique to film the explosion by creating a similar cloud of dye under water and then superimposing it over a background shot. The result was so realistic that it greatly impressed top officers of the Manhattan Project and was later used by the United States air corps in their instructional films.

Gillespie's counterpart at Paramount studios was Gordon Jennings, who remained head of the special effects department from the mid-1930s until his untimely death in 1953. Jennings arrived in Hollywood in 1919 to take on a job as an assistant cameraman with the Lois Weber production company. He became involved with effects when he devised the first example of moving titles. These were done by painting titles on sheets of glass and sliding them over painted scenes in front of the camera. 'They kept the other fellows in the business fooled for a long time,'[21] he later recalled. His work attracted the attention of Cecil B. DeMille in 1925 and an association was begun that lasted until Jennings's death. DeMille said of Jennings:

He was a big athletic man but soft spoken and almost diffident, the best special effects man I have ever been privileged to work with. A director could say to him that he wanted a volcano to obliterate a city teeming with people or Niagara Falls to roll back and expose a cliff, a few weeks later he would come around and say, 'well, you might as well come and look at this. I've spent a lot of money and it's probably not what you want but, well, come and see this anyway'; and the effect would be so realistically perfect that the director could hardly believe it.[22]

A famous DeMille film that Jennings worked on during the 1930s was *Cleopatra* (1934). Unlike DeMille's lavish epics of earlier years this picture, due to the Depression, was made on a much more modest budget and it was up to Jennings to create spectacle as cheaply as possible. An example of how he succeeded can be seen in the sea battle sequence. Although a fleet of thirty-five or more galleys appear on the screen there were, in reality, only two vessels involved, and both of those were miniatures. The two vessels were multiplied into a fleet by the old trick of parallel mirrors and these were again multiplied into the two opposing fleets by split screen double exposure.

Another important miniature shot showed Cleopatra's barge entering

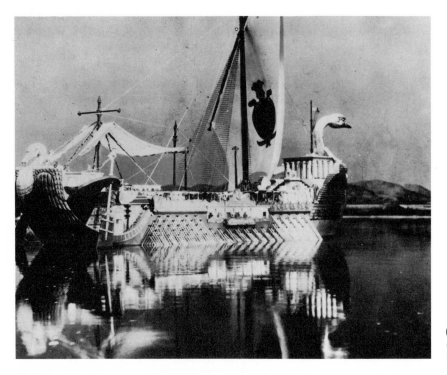

(Left) *The mechanized model of Cleopatra's royal barge built by Gordon Jennings*

and leaving port. Actually this was a miniature only relatively speaking, the barge itself being larger than a rowing boat. It was painstakingly constructed from historical records of the queen's actual barge by Art Smith, who also built the other two vessels mentioned above. The barge was built to a scale of ten feet to the foot, it was over twelve feet long, weighed several tons and had 300 oars that appeared to function. This was achieved by an intricate mechanical linkage powered by an electric motor. The wake of the barge and the spray of the oars were created by carefully directed jets of compressed air fed from tubes under the water.

The land battle was filmed by more conventional methods, using small groups of actors. Some of these scenes were intercut with, or superimposed upon, stock-shots of chariots and horsemen taken from another DeMille picture, the 1920 version of *The Ten Commandments*, made fourteen years earlier when money was more plentiful. The important task of assembling these many scenes fell to veteran optical effects man Paul Lerpae. He began the sequence by shots of Egyptian and Roman trumpeters on high walls summoning the troops. The former were taken from an earlier production, *The Wanderer* (Raoul Walsh, 1926), which, oddly enough, was the work of Victor Milner, who photographed *Cleopatra*; while the Romans were lifted from another DeMille picture *The Sign of the Cross*.

Jennings also worked on DeMille's *Unconquered* (1947). At one point the script called for Gary Cooper and Paulette Goddard, being chased by Indians, to travel down a rapid-filled river in a canoe and then go over some waterfalls. The production crew found a river that had rapids but no falls and another river that had falls but no rapids. So each river was photographed separately, and the two rivers matted together to look like one stream. Using this matted stream to produce a rear projection shot in the studio, Jennings had Cooper and Goddard filmed while being dropped five feet over a studio-made waterfall that blended in with the projected background. At the bottom of this drop the stars were supposed to grasp an overhanging tree limb and swing themselves under the falls to the safety of a hidden ledge. As there was no tree growing near the originally photographed falls artists had to matte paint a tree limb into each frame of film. Then a live 'double' for the limb was installed on the studio tank stage and a stunt man and woman, doubling for the stars in a canoe, slid down an invisible piano wire track through the studio-made waterfall and grabbed, as it were, a tree that was not there.

Jennings and his team won several Oscars over the years for films such as DeMille's *Reap the Wild Wind* (1942), *I Wanted Wings* (Mitchell Leisen, 1941) and later for their magnificent effects in George Pal's early pictures – *When Worlds Collide* (Rudolph Mate, 1951) (ironically, a story bought by Paramount in 1934 for DeMille) and *War of the Worlds* (Byron Haskin, 1953). The latter was Jennings's last film; he died shortly after completing his work on it. Before that he had worked on what was to be his last film for DeMille, *Samson and Delilah* (1950). One of the most spectacular scenes in that film is the destruction of the pagan temple caused by Samson, played by Victor Mature, pushing over two conveniently placed pillars. But Samson has an easier time of demolishing the building than did Jennings, who had to make three attempts before he got a satisfactory take. The temple and the impressive idol, complete with fire burning in its hollow stomach, were built on a one-third scale. The temple was thirty-seven feet high and the idol seventeen feet, miniatures in name only. On the first take the triggering device that was supposed to start the idol toppling over failed to work. On the second take the idol toppled over as planned but this time the device that was to release the back wall and allow it to fall did not work. But a few tests and some additional adjustments caused everything to go off as scheduled on the third take, resulting in the frightening cataclysm that was finally seen on the screen. DeMille's staff expected him to unleash his usual violent anger at Jennings for these costly mishaps (the engineering and construction had taken almost a year, costing $100,000). Even Jennings himself was reported to have said, 'I've got armour plate under my shirt. I'm ready for the Great White Father.'[23] But to everyone's surprise

(Left) *Cecil B. DeMille directs a scene for* Samson and Delilah, *which is being filmed on the full-scale section of the Philistine temple* (above); *Victor Mature as Samson pushes down the temple pillars – or part of them, as the remainder of the collapsing temple (a miniature) was matted in later* (below)

DeMille kept silent despite the extra $40,000 that the refilming cost. This was taken as a sign of just how high DeMille's regard was for the special effects veteran.

The falling of the idol was filmed in slow motion, with the camera speeding up slightly as the idol crashed onto the temple floor. The crowds who were so convincingly trapped in this realistic destruction consisted both of real people, who were matted into the scene, and of miniature dolls, also on a one-third scale.

DeMille hoped to have Jennings work on his big film project *The Ten Commandments* (the second version) but Jennings died of a heart attack as planning was getting under way in 1953. DeMille himself pronounced the eulogy at Jennings's funeral. The man chosen to replace Jennings as head of the effects department at Paramount was John P. Fulton.

While the status of the Hollywood special effects men increased in the 1930s within the industry itself, outside it became almost non-existent. This was because their prime function was to reproduce reality in the films they worked on and naturally enough the more skilful and successful they were doing this, the less obvious their handiwork became. It suited the studios themselves to play down the importance of effects because of a curious guilt feeling that was prevalent among them at the time concerning trick photography. This attitude had its origin in the later stages of the silent era when special effects were introduced on a larger scale. Previous to that audiences had been spoilt by stunt men who performed incredibly daring stunts without the aid of any trick effects, such as stunt pilot Dick Grace who used to produce spectacular air crashes by flying his plane straight into the ground. When the primitive miniature and process work became apparent in films audiences resented it. This feeling is demonstrated by the following review of an air picture, called *The Lone Wolf* (1924), which appeared in *Photoplay* magazine:

It is made slightly ridiculous at the finish by a double airplane transfer in the clouds, a lot of which was too obviously done in the studio. The realism of some of the airplane stunts that have preceded it has not been achieved in this picture and the audience is inclined to chuckle.[24]

But as the techniques of the effects men improved to the point where audiences were no longer aware of their contributions in the films they saw, so too did the effects men themselves cease to exist as far as the public were concerned. The studios, not wanting to spoil their illusions, did their best to restrict information relating to effects work. Even as late as 1947 the principles behind rear projection were being kept under wraps, causing a writer at the time to observe that, '. . . these background "movies" have been the subject of serious studio censorship with magazine writers either refused a view of them or permitted to see them only

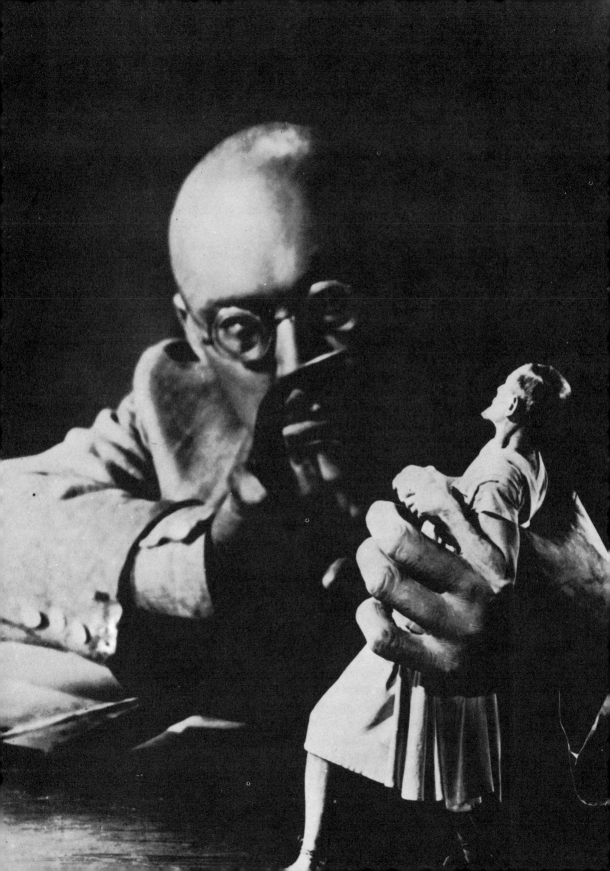

(Left) *A combination of rear projection and realistic giant prop makes for a startling shot in* Dr Cyclops

(Right) *Ingenious giant props, including giant footprints on the floor, create an illusion of smallness in another scene from* Dr Cyclops

after swearing not to tell.'[25] Not that special effects men seemed to mind, on the contrary, many seemed to agree with the prevailing opinion. Farciot Edouart wrote in 1942 that

. . . most of us are sincerely anxious to live down yesterday's publicity that branded special process specialists as camera magicians. The highest praise to any of us is the comment that one of our shots creates such a perfect illusion of reality that nobody takes it for a process shot.[26]

Edouart went on to say that he rarely set out deliberately to 'fool the public' with his process work but that one exception had been made in *Dr Cyclops* (Ernest B. Schoedsack, 1940).

Dr Cyclops was a fantasy and fantasy films, through necessity, bring special effects out into the open. Hollywood produced very few fantasies during the 1920s and there was a saying among the studios that making a fantasy film was the quickest way there was of losing money. Fairbanks's *Thief of Bagdad* certainly did not do well but *The Lost World* (Harry D. Hoyt, 1925) released in the same period was a relative success. *The Lost World*, however, was in a category all of its own at the time and will be discussed in more detail on pages 152 and 153.

It was the German influence in the camera that eventually made fantasy more acceptable, in the guise of horror and science fiction films, to American audiences. One of the more direct examples was *Just Imagine*

(Left) *The huge model of a futuristic New York, built at a cost of $250,000 for* Just Imagine

made in 1930. Basically it was a musical love story set in the year 1980, a rather insipid film as far as story content was concerned but it contained some impressive miniature sets, obviously patterned after Fritz Lang's *Metropolis*. In many people's opinion its futuristic New York setting even outdid the one that featured in the famous German film. The city was built on several levels, one of which contained a canal network for ocean liners to use, and had skyscrapers that were supposed to be 250 storeys high. It included such novelties as traffic cops suspended from balloons to keep an eye on the airborne traffic. The set cost $250,000, quite a figure for a miniature in those days. Effects director on the film was Ralph Hammeras.

In the same year Universal released *Dracula* (Tod Browning), based on Bram Stoker's classic vampire novel, which was photographed by the great German cameraman Karl Freund. The studio felt some anxiety over the public's reaction. They tried to sugar the pill by advertising it as 'the strangest love story of our time', and at the end of the film one of the characters (Edward Van Sloan) makes a direct address to audiences, warning them that vampirism is no superstition but as real as any other communicable disease. But Universal need not to have worried; *Dracula* was a tremendous success for them, and the following year they released *Frankenstein* (James Whale, 1931). This film contains some spectacular

electrical displays which were devised by Ken Strickfaden. He special-
ized in this type of effect and many films during the 1930s made use of
his 'Electrical Properties' as they were called. The other special effects
work on *Frankenstein*, such as the burning of the mill at the film's climax,
was handled by John P. Fulton. Frankenstein's monster, played by Boris
Karloff, owed his now famous appearance to the great make-up artist
Jack P. Pierce. With this film special effects were beginning to come out
from behind the scenery but when the same studio released *The Invisible
Man* (James Whale) in 1933 they became the star of the film, and the man
responsible was again Fulton. (1933 was also the year that saw the release
of *King Kong* (Merian C. Cooper and Ernest B. Schoedsack), perhaps the
ultimate special effects film of its kind. See pages 153 to 159 below.)

John P. Fulton was born in Nebraska, the son of Fitch Fulton who
worked as an artist painting backdrops for vaudeville. The family moved
to California in 1914 where Fulton's father, not wanting his son to make
his career in any section of the entertainment industry, insisted that he
study electrical engineering. (Ironically, Fulton later persuaded his
father to enter the film industry and it was Fulton senior who painted all
the backgrounds for *Gone With the Wind* (Victor Fleming, 1939), some
200 of them.)

When Fulton left high school he wanted to go to West Point military
academy but was unable to get an appointment.

'He was always disappointed about that,' said his wife. 'He worked
as a surveyor for a while after leaving school for the Southern California
Edison Company but he saw that there wasn't going to be any future in
that. At that time Griffith was starting to shoot pictures out here and
John used to go and watch. He was mainly interested in the technical
side.'

One day, when comedian Lloyd Hamilton's outfit was being formed,
Fulton cornered the cameraman and told him he was going to hang
around until he made Fulton his assistant. The man soon gave in and
Fulton became an assistant cameraman. Later Fulton was to regret that
he had not cornered the director or producer instead.

'In those days', said Mrs Fulton, 'being an assistant cameraman was
really hard work. John earned twenty-five dollars a week . . . this was
back in 1923 or 1924. Then an assistant cameraman's main job was to
carry the camera around, they didn't operate the camera at all, plus all
sorts of other hard jobs. But John progressed rapidly and before long he
was an operator. His first big success was *Hell's Harbour* in 1929, he
filmed the whole picture down in Tampa Harbour, Florida, and received
rave notices for his work. Then he shot *Eyes of the World* for the same
director, Henry King, in 1930. These were the only two pictures he ever
photographed as a strict cinematographer. Photography wasn't a big

enough challenge for him. Then he went and worked with Frank Williams who had a studio for trick photography.'

It was while he was at Williams's laboratory that he first became interested in process photography and he was well grounded in its fundamentals by Williams, a man whom Fulton considered to be one of the real geniuses in the field. When Universal offered him the position of head of their special effects department he accepted. During the next couple of years he worked on various films, including *Waterloo Bridge* (James Whale, 1931), for which he supplied bridge, Thames river, London background and even fog which was a mandatory requirement for any film about England in those days.

In 1932 Carl Laemmle Jr approved the construction of a new sound stage at Universal, which cost approximately $50,000, and was to be used exclusively by the special effects department. One of the first films to make use of these new, enlarged facilities was John Ford's classic *Air Mail* (1932). This was to remain one of Fulton's favourite projects because flying was one of his hobbies.

'John just loved danger,' said his wife. 'He'd get into a cage with a lion or get out on a wing and hang over. We had our own plane up until the Second World War and we'd fly cross country. I made myself go but I just didn't like flying. He'd go up into the High Sierras and he'd

(Left) *John Fulton and assistants film a miniature plane during the making of* Air Mail

go down into those canyons. He'd tip the plane and say, "Look Bernice, look down there . . ." '

For the background footage of *Air Mail* Fulton spent four hours every day for a week flying his plane through the High Sierras. He flew at altitudes varying from 12,000 to 14,000 feet, dashing through bumpy air up canyons, skimming along the crests of ridges, plunging through cloud formations. During this period he acquired thousands of feet of filmed scenery. When he had developed the negatives and selected those that would provide the best backgrounds, work in the studio began.

The miniature work that appears in the picture took five months to film. One of the scenes involved the flying of a plane through a blizzard. For this Fulton constructed a regulation cockpit with all the controls, but instead of controlling a real plane, it directed the movements of a miniature. The cockpit was hung from overhead tracks on the roof of the studio. Beneath the cockpit hung the miniature plane. By operating the controls in the regulation manner the tiny plane underneath could be made to dip, veer, twist from side to side – anything that a real plane might do in heavy weather. The whole contraption could be propelled along the rails at a speed of more than twenty miles an hour and required one of the largest miniature sets constructed at Universal up to that time. It was over 200 feet long and almost filled the special effects studio. Fulton filled this set with fake snow and mist, set up his camera and sent the miniature hurtling through it.

In another scene Fulton had the task of making one camera look down from what appeared to be a plane in the sky to another one apparently wrecked on the ground. Beside the wreck the camera was also to show a tiny figure of the pilot, injured but signalling with his arm. Fulton achieved this by hooking a camera onto a giant overhead crane and letting it swing over the miniature set simulating the movements of a plane circling the wreck. The downed plane, surrounded by six-foot-high mountains and tiny trees, was of course another miniature. The injured pilot was a dummy three inches high with built-in machinery to make the arm move.

Fulton constructed miniatures for *Air Mail* that were so realistic that they were claimed to have fooled veteran military pilots. Every detail was constructed to an exact scale. The motors and propellors required much delicate metal work so that the craft would look real in close-ups. There were soft rubber tyres on the landing gear and small electric motors spun the tiny props.

Miniatures that were required to crack up in a scene required special work. They were called 'breakaways'. If two planes had to collide and explode in mid-air each model would be specially prepared. They would

be constructed so that they would fall apart realistically at the crash, parts of the wings would be broken then glued together lightly so that they would shatter easily. Both craft would be made of thin balsa and other materials that would crumble quickly. Tiny flash-powder bombs would be inserted in the miniatures to explode automatically on impact. Although the planes were lightly constructed, lead was inserted in the fuselage to give them an added smashing effect.

To make a miniature plane appear as if it were a real one manoeuvring through the sky as seen from a great distance was a problem. If they used a $\frac{3}{4}$-inch or even a $\frac{1}{4}$-inch model it would still require a large set. Fulton solved it by building a tiny duplicate of the larger miniature on a one-eighth scale and suspending it by a very fine wire in front of a rear projection screen. The picture on the screen was about eight feet by six feet in size. To film this scene the camera ground at eight times the normal speed, 192 frames a second. If the scene was filmed at normal speed the plane would appear to wobble as it was almost impossible to operate so small a model without it swaying a certain amount. But Fulton found that when he shot such scenes at that speed all signs of wobbling disappeared. All of these miniatures were filmed by silent speed cameras. All sound effects were dubbed in later.

The following is a first-hand description of the shooting of a typical scene on the special effects stage during the making of *Air Mail*:

In the foreground were his [Fulton's] camera and an airplane in whose open cockpit the players sat. The camera pointed through the wings past the actors directly at the rear projection screen. This consists of a single piece of sand-blasted plate glass at the opposite end of the room, some 200 feet distant. Arc lamps cast their brilliant rays on the plane and principals, but the camera-side of the screen remains in darkness to avoid washing out the scenery that will appear on it. We were ready for action. A buzzer rang.

'We're in synch,' Fulton said to Ford.

'Okay,' Ford replied, 'start the wind machines. Move that mike in closer. All quiet. Shoot.'

Images of clouds appeared on the rear projection screen. In the studio an actor climbed out of the forward cockpit. The plane swayed on its cable as a carpenter pulled the right wing down. And the camera recorded the double scene, exposing each frame at the precise instant the projector exposed a frame of clouds on the screen. And there we had a conflict over the Sierras made to order on the stage.

After a few minutes the plane's position was shifted. Now it pointed directly at the screen, the camera located a few feet behind its tail. A few preliminary scenes were run off on the screen. They revealed, from the cockpit of a plane, people running and buildings coming up to meet the ship as it dived and rolled in the air. The dummy studio plane was then moved into position to blank out the ship that appeared on the screen. Now all we could see were the changing

sizes of scurrying figures, the shifting pattern of fields and hangars. We were ready to dive again at that airport, safe on the floor of the studio.

The remainder of the scene, which involved a pilot crashing his plane after the entire lower wing had been torn away in the air, was being set up in another studio nearby. Carpenters had constructed a framework forty feet high. At one end they built a short runway, tilted at an angle. With block and tackle they hoisted a dummy full-scale plane into place. The cameras were then pointed at a chalk, outlined circle on the 'tarmac'. A signal was given and the ever-present assistant tripped a lever. The plane slid down the wooden planks and kerplopped at the appointed place.[27]

The following review of *Air Mail* on its release was typical:

Full of air scenes, this picture contains some of the most dangerous-looking stunts ever attempted on the screen. Such faking as is done . . . and there's not a great deal of it . . . achieves a high degree of realism.[28]

As skilful as Fulton's effects were on pictures like *Air Mail* it was for his work on *The Invisible Man* and the various sequels that he became most famous. *The Invisible Man* was based on a novel by H. G. Wells about a renegade scientist who discovers a formula for creating invisibility and who uses it to wage a one-man war on society. Directed by James Whale in a tongue-in-cheek fashion it stars Claude Rains as the main character who remains unseen until the final moments of the film. The job of making him invisible fell to Fulton and his assistants. The scenes where he remains totally invisible were relatively simple to arrange, the various objects that he handles being manipulated by fine wires. But those in which he is partly clothed, with all his unclothed parts invisible, presented more of a problem. The wire technique was unsuitable for the clothes would be empty and would obviously not move naturally. So Fulton used the black-backing travelling matte process. A completely black set was used, walled and floored with black velvet, to be as non-reflective as possible. A stunt man was garbed from head to foot in black velvet tights, with black gloves and a black headpiece which resembled a diver's helmet. Over this he wore whatever clothes might be required for the scene. This gave Fulton a picture of the unsupported clothes moving around on a dead black field. From this negative Fulton made a print, and a duplicate negative, which was intensified to serve as mattes for the printing. Then, with an optical printer, he proceeded to make a composite: first he printed from the positive of the normal background action, filmed previously, using the intensified, negative matte to mask off the area where the invisible man's clothing was to move. Then he printed again, using the positive matte to shield the already-printed area, and printing in the moving clothes from the 'trick' negative. This printing operation made the duplicate, composite negative which was used in printing the final master-prints of the picture.

The chief difficulty Fulton had was in directing the stunt man who was standing in for Rains. It was necessary for him to move in a way that was natural but did not present, for example, an open sleeve end to the camera. This required endless patience, endless rehearsals and many takes. Fulton had to discover ways of getting the man to move normally without passing his gloved hands in front of himself which would, of course, obscure parts of his clothing from the camera.

In several sequences the invisible man had to be shown unwrapping the concealing bandages from about his head; and in another, pulling off a false nose, revealing the absolute emptiness within the head wrappings. The latter scene was made by using a dummy, an exact replica of the actor's make-up and a false chest that was designed to move as if breathing. The unwrapping action was handled in the same way as the other scenes – by multiple printing with travelling mattes. Here again Fulton had considerable trouble in getting the stunt man to move properly. In some of the scenes it was possible to leave small eyeholes in the helmet but in others, especially the close-up of the unwrapping action, this was impossible and he had to work blind. Air was supplied to him through tubes as in a diving suit with the tubes concealed, usually running up a trouser leg. On at least one occasion either the air supply failed or the midsummer heat (aided by the studio lamps) overcame him and he fainted in the middle of a scene. Fulton doubted if the stunt man would have managed to complete the film if he had not been in top physical condition.

The air tubes increased Fulton's directing problems – they made a roaring rumble in the man's ears and drowned out any sounds that might filter through the padding of the helmet. Even when Fulton yelled through a giant megaphone he could only hear a faint murmur.

'We had to rehearse and rehearse,' said Fulton, 'and make many takes; as a rule, by "Take 20" of any such scene, we felt ourselves merely well started toward getting our shot!'

Another principal difficulty was in eliminating the various little imperfections – such as the eyeholes – which were picked up by the camera. This was done by retouching the film – frame by frame – with a brush and opaque dye. Four thousand feet of film received individual hand-work treatment in some degree – approximately 64,000 frames.

One amusing sequence in the film shows the invisible man being tracked down by a group of policemen who can see his footprints appear as he runs barefoot through the snow. One way of achieving this effect would have been to use stop-motion photography; i.e., by stopping the film between making each footprint, but as there were people involved in the scenes an alternative method was devised. A trench was dug and then covered with a board in which footprints had been cut.

(Above) *The footprints from nowhere – one of John Fulton's many effects in the classic film* The Invisible Man

The cut-out footprints were replaced in the board and supported by a series of pegs attached to a rope, and the board was then covered by snow material. By pulling on the rope attached to the pegs the wooden cut-outs dropped away, giving Fulton and his men perfect footprints that mysteriously appear in the snow as if from nowhere.

Perhaps the most impressive sequence occurs at the end of the film when the dying Claude Rains slowly loses his invisibility. On the screen, looking straight down on his death bed, we can see at first only the depression made in the pillow by the invisible head and the shape of the sheets over the unseen form. Slowly a suggestion of bone structure appears, then a full skeleton, then slowly traces of flesh, then skin, and finally we see the man himself.

This was done directly by the camera – there was no process work involved. The pillow, indentation and all, was made of plaster, and the sheets of papiermâché. A long, slow dissolve revealed the skeleton, a real one incidentally; another long dissolve replaced the skeleton with a roughly sculptured dummy that suggested the contours of the real actor, and a further series of similar dissolves, each time revealing a more complete dummy, culminated in showing the live actor himself. After he dies the camera was moved away – straight up – on a special track built for that one camera movement.

Fulton worked on all of Universal's films produced during the 1930s and the early part of the 1940s that involved eerie effects. These included the 'invisible' sequels, such as *The Invisible Man Returns* (Joe May, 1939), *The Invisible Woman* (A. Edward Sutherland, 1941), *The Invisible Agent* (Edwin L. Marin, 1942) (by now the films were far removed from H. G. Wells's original novel and the latter film involved the invisible man, played by Jon Hall, being parachuted into Germany to wreak havoc among the Nazis) and *The Invisible Man's Revenge* (Ford Beebe, 1943). And also supernatural films like *The Mummy* (Karl Freund, 1932), *The Werewolf of London* (Stuart Walker, 1935), in which Fulton transformed Henry Hull into a wolfman, a marvellous transformation which has since become a filmic cliché, and *The House of Dracula* (Erle C. Kenton, 1945), where Fulton achieved an even more impressive transformation by showing a bat turning into John Carradine (who was playing Dracula). It was Universal who also produced one of the first science fiction serials during the 1930s, the classic *Flash Gordon*. The special effects however, which Fulton had nothing to do with, were rather primitive and cheaply done. The miniature work was often laughable, with toy rocketships suspended on clearly visible wires emitting puffs of smoke which drifted upwards. (Not all the special effects in the serials were inferior, however. Republic's serial *The Adventures of Captain Marvel* (1942) contained some very impressive flying scenes achieved by effects men Howard and Theodore Lydecker. By the skilful use of a full-size dummy propelled along hundreds of feet of wire at high speed they could make Captain Marvel appear to zoom up the side of a building or hurtle along highways in pursuit of cars. This was in direct contrast to the shoddy flying scenes in the Superman serials and TV series which respectively made use of bad animation and equally bad travelling mattes.)

The other Hollywood studios seemed prepared to leave these types of fantasy and science fiction films entirely to Universal during this period, though there were a few exceptions. One was Paramount's *Dr Cyclops*, mentioned earlier, in which Farciot Edouart utilized his rear projection process in a new way, using both large and tiny screens to create the illusion that characters in the film had been reduced in size.

Another exception was the Hal Roach production of *Topper* (Norman McLeod, 1937), based on Thorne Smith's books. Roland Young played the confused Topper, a somewhat stuffy middle-aged man who is plagued by two zany ghosts, Cary Grant and Constance Bennet. As with *The Invisible Man*, the special effects involved simulating invisibility but with the added difficulty of having to show the two ghosts either fading slowly into view or fading away in various scenes during the film. Roy Seawright, in charge of the effects, used the same technique that Fulton

had for creating his invisible man: the black-backing travelling matte. The fadings in and out by the ghosts were achieved by a combination of split screens, slow dissolves and a sharp-eyed continuity girl.

A tricky problem the effects men faced was how to show the invisible Miss Bennet having a shower. As she was a ghost of some substance the water could not just go straight through her but had to appear as if it were striking an invisible form in the shower stall. At first the scene was attempted by filming a girl dressed in the usual black velvet costume under a shower but this proved to be unconvincing. The effect was finally achieved by playing several jets of air against the shower of water and filming it against a black velvet background.

The scene where one of the ghosts signs a hotel register was achieved by stop-motion photography. Wires were of course used in a scene where the pen is hovering over the register but in the close shot the pen was animated. It was equipped with a pin in the point which was stuck into the register holding up upright. It was then moved a frame at a time until the signature was complete.

Another Hal Roach film that utilized obvious camera trickery was *One Million BC* (Hal Roach, Hal Roach Jnr, D. W. Griffith, 1940), also known as *Man and His Mate*, which is set in a mythical prehistoric world and concerns the trials and tribulations of two primitive tribes who have to share their neighbourhood with dinosaurs and also cope with frequent geological upheavals. Most of the dinosaurs were 'real'; that is they were ordinary lizards made to appear large by various means, such as travelling mattes and an unusual technique invented by Louis Tolhurst called 'miniature foreground projection'. The latter was a rear projection process that did not use a transparency screen; instead an ingenious use of lens achieved a sharp focus on two or more planes, one of which was the projected image. Charles Oelze was in charge of the lizards and he had a difficult time with his unwilling performers, who sent him to a doctor eleven times to have bites treated. The miniature crew was headed by Roy Seawright and consisted of Frank William Young, who photo-graphed all the miniatures, and Fred Knoth and crew who built them under the direction of Danny Hall. The travelling matte shots were hand-led by Jack Shaw.

When Sam Goldwyn was making the Danny Kaye vehicle *Wonder Man* (Bruce Humberstone) in 1945 he borrowed Fulton from Universal to work on the picture. *Wonder Man* is about twin brothers, both played by Kaye, one of whom is killed by gangsters at the beginning of the film and returns as a ghost to haunt his brother. Fulton produced numerous amusing effects in the film, a memorable one being in a scene where the ghostly Kaye, sitting at a bar, tries repeatedly to pick up a drink but is frustrated by his hand passing through the glass (achieved with a hand-

drawn travelling matte). His work in the film received favourable mention in a number of reviews. Danny Kaye himself said:

(Above) John Fulton, behind camera, prepares to film the miniature set he built for The Bridges at Toko-Ri

... the real hero of *Wonder Man* was John Fulton who made my twin role possible. He arranged things so that I could meet, talk and stroll with myself just as if I were really two people. He did it by blocking off half the film at a time, then cleverly combining both parts. I spent a lot of time talking to a black dot, then shifting over and answering another black dot that represented my twin brother.[29]

Goldwyn was so impressed with Fulton's work that he invited him to join his studio. His offer was not only attractive to Fulton financially but also included a promise to making him a director.

'That's what John always wanted to be . . . a director or a producer,' said his wife. 'He never seemed to feel that his trick work meant anything, no matter what people told him. But Goldwyn's promise didn't come to anything. It never happened and this embittered John quite a bit, especially in his later years.'

The nearest Goldwyn came to fulfilling his promise was in allowing Fulton to handle the second unit work on *The Secret Life of Walter Mitty* (Norman McLeod, 1947) and *The Bishop's Wife* (Henry Koster, 1947). When Goldwyn's company ran into financial difficulties in the late 1940s Fulton left and went into business on his own. Unfortunately

things did not work out as planned – the business failed and Fulton found himself with nothing to do for the next two years. Then, in 1953, Paramount's top effects man, Gordon Jennings, died and an offer was made to Fulton to replace him which he gratefully accepted.

One of the first films that Fulton worked on for Paramount was *The Naked Jungle* (1953) directed, ironically, by a man who had been in charge of the special effects department at Warner Brothers, Byron Haskin. The film stars Charlton Heston and is a melodrama set in a South American jungle. The climax is the most memorable part of the film and concerns a horde of soldier ants going on a rampage, swarming over foliage and people alike. Fulton and his assistants spent a lot of time roaming in the High Sierras looking for suitable ants, and if collecting them was difficult, filming them was even more of a trial. On at least one occasion during filming some of them escaped and infiltrated the adjacent set, at that time being used to film a Bob Hope picture. Filming, it is needless to say, was somewhat interrupted. For one scene the star, Charlton Heston, earned the respect of the crew by allowing himself to be smeared with syrup and then covered with ants.

Another Paramount film of the same period that Fulton worked on is also set in a jungle and also has a climax that involves an invasion of angry jungle beasts – only this time elephants were the culprits. The film is *Elephant Walk* (William Dieterle, 1954). Real elephants were used for most of the scenes (they were kept tethered in the studio tank), but for the scenes where people are picked up in their trunks and squeezed to death it was felt it would be wise to use an alternative. So Fulton had two artificial elephant heads made for the trick work; the heads were mounted on boards and the trunks were manipulated mechanically.

Perhaps Fulton's greatest achievement was his work on DeMille's second version of *The Ten Commandments*, in particular the parting of the Red Sea. Fulton's other effects in the film include the Burning Bush which is used as the symbol of God, the hail from the cloudless sky, the impressive Angel of Death sequence, and the composite of the monumental Exodus scene. But the parting of the sea was rated as the most difficult special effect ever performed. Planning for this and the many other sequences with location background got under way in 1953 when, under DeMille's supervision, the art department began preparing a complete master production design, visualizing each take in step-by-step shooting and providing for matching shots to be filmed at the studio. This was necessary because of the considerable out-of-continuity shooting at location. The sketches, photographed in black and white, when placed in the finder permitted the cameraman to see how the take would appear against the terrain. In following the art design, portions of terrain as wide as thirty miles apart, photographed separately, had

(Left) *Cecil B. DeMille, Yul Brynner and John Fulton on the set of* The Ten Commandments *(1953)*

(Right) *Two views of the elaborate set-up erected at Paramount Studios to create the parting of the Red Sea sequence for* The Ten Commandments *(above), and the final result – after several different image components had been matted together (below)*

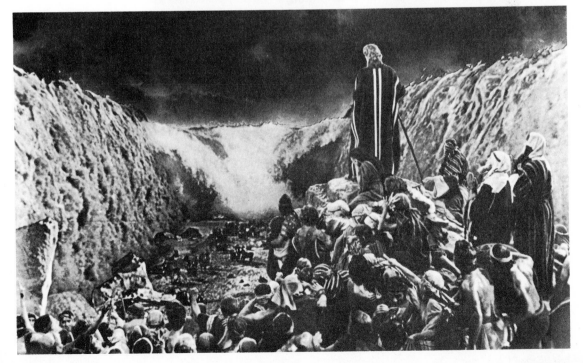

to be included in one take to accommodate the background and action. In the optical work, twelve separate scenes, including as many as thirty rolls of master positives and mattes, were included in the making of a single scene.

The parting of the Red Sea took about six months of VistaVision filming, including the effects. Many scenes were shot on the shores of the Red Sea, ironically not called 'Red' in the film because it was so obviously blue and references to the Red Sea were blanked out of the sound track. Fulton visited Egypt during the making of the film and, according to his wife, really enjoyed himself.

The scenes of the actual location had to be combined with scenes filmed back in Hollywood. The latter phase of the operation involved the building of a huge tank used to create a giant waterfall. The tank was so big it required the use of nearly 30,000 cubic feet of concrete and took up such an area that the fences between the Paramount and RKO lots were torn down to accommodate it. As part of the sequence in which the chariots of the Pharaoh are crushed between descending walls of water, the technicians released 360,000 gallons of water in ten minutes.

Fulton received an Oscar for his effects in *The Ten Commandments*, the only person who worked on the film to get one. (He also received Academy Awards for *Wonder Man* and *The Bridges at Toko-Ri* (Mark Robson, 1955).) In the years that followed Fulton's name appeared on all of Paramount's films that contained trick work, as the head of the department he had no choice, even though he might not have been personally involved with them. Films released by the studio during this period with Fulton's name in the credits include the Dean Martin and Jerry Lewis vehicle *Pardners* (Norman Taurog, 1956), *The Colossus of New York* (Eugene Lourie, 1958), which contains some good effects, and *The Space Children* (Jack Arnold, 1958), which features a giant glowing and pulsing brain. Fulton remained with Paramount until they disbanded their effects department, like many other studios, in the early 1960s. But Fulton was not ready for retirement. Among his planned projects was a film about flying saucers, a pet subject of his, and it was during preliminary work in Spain on Harry Saltzman's epic *The Battle of Britain* (Guy Hamilton, 1968) that he contracted a rare infection that led to his death. He died in a London hospital in 1966. Unfortunately he was never able to achieve the satisfaction from his effects work that he felt he would derive from either directing or producing. But then Fulton was apparently unable to shake off a feeling that picture making as a whole was a nebulous and transient enterprise. He expressed this thought in an interview published in 1945:

As if it would last forever. We are not creating something that will remain for thousands of years. A picture is not a pyramid . . . it's more like a feather in a hurricane.[30]

3/The British Special Effects Men

Despite the large amount of pioneering work in trick photography performed in Britain during the very early days of the film industry, nothing of distinction was achieved in this field until the 1930s. All the major innovations came from Hollywood where there was sufficient money available for technical experiments and improvements. It was not until Alexander Korda, the famous director and producer, revitalized the British film industry in the early 1930s, that films employing lavish effects were made in Britain. Korda's films were on an equal level with Hollywood's products because he not only imported Hollywood techniques in film making but also some of Hollywood's top technicians. Among these was Ned Mann, a special effects expert who has had a very important influence on the British special effects field. Several of the top experts active in the industry today, such as Tom Howard, Wally Veevers and Cliff Richardson, were either trained by Mann or worked with him at some stage of their careers.

Ned Mann's involvement with Hollywood began in 1920 when he was twenty-seven years old. Prior to that he had been a professional car racer, roller skater, stage actor and director. It was as an actor that he first worked in Hollywood but then he became interested in special effects and decided to specialize in that field. One of the first films he worked on as a special effects man was Fairbanks' *Thief of Bagdad*.

Mann's first films for Korda included *The Ghost Goes West* (René Clair) and *The Man Who Could Work Miracles* (Lothar Mendes), which were followed by the epic *Things to Come* (William Cameron Menzies). These were all made in the period between 1934 and 1936. *The Ghost Goes West* stars Robert Donat and is a comedy which contains several effective 'ghost' effects. *The Man Who Could Work Miracles* is much more spectacular. It was based on a short story by H. G. Wells and concerns the adventures of a meek little shop assistant who has been casually granted omnipotent powers by a trio of gods. All the effects, such as in the early scene when the protagonist makes a lamp rise in the air and turn upside down, and at the climax where he causes buildings and people to be swept

(Left) *Two effects from*
Things to Come *: the 'crowd'
actually consists of hundreds
of tiny figures being pulled
along hidden tracks* (above); *a
composite shot that includes a
hanging foreground miniature,
real people and a mirror shot*
(below)

away in a tremendous wind, are skilfully executed and extremely effective. But, of course, the major effects film of the three was *Things to Come*.

Things to Come was an adaptation of Wells's *The Shape of Things to Come*. The picture spans the years between 1936 and 2036 and shows the fall of civilization after a World War and the subsequent rise of a new civilization based on science. Most of the effects are contained in the latter half of the picture with the scenes of the giant flying machines of the 'Airmen', and the montage depicting the scientific progress over a number of years which resulted in 'Everytown', a Metropolis-like city. The final scenes of the picture involve a giant 'space gun' which fires a manned projectile on a journey to the moon. Much use was made of miniatures and mirror shots to create the illusion of huge machines and vast buildings. On the whole the effects and the miniatures are quite impressive though, of course, they do not compare with more recent work in the field. The film was directed by William Cameron Menzies who had previously been the production designer on such films as Fairbanks's *Thief of Bagdad*.

Menzies was also the production designer on Korda's remake of *Thief of Bagdad* (Ludwig Berger, Tim Whelan and Michael Powell) in 1939–40 but Mann himself was not involved. Basil Wright, writing in the *Spectator* in December 1940, said:

. . . the tricks, with a few exceptions, are convincing and exciting. The magical scenes are very satisfactory. The enormous Djinn trying to stamp on the diminutive form of Sabu, who is no bigger than his big toe, the sudden storm summoned by the Vizier to wreck the hero's boat, and the terrifying toy which does a Siva-like dance before stabbing the Sultan to death – all these are the true stuff of fairy tales. Only the scenes of the flying horse fail to come off; the superimposition of a cartoon figure on a realistic background is here too palpably obvious to achieve the magical touch which is needed.[31]

Actually, the critic was incorrect about the flying horse; it was not achieved through cartoon animation but was in fact an early and complicated example of a travelling matte filmed in colour and, when viewed today, appears relatively effective.

Mann had returned to America in the late 1930s but in 1947 Korda, who had just taken over Shepperton studios, once again brought him to England to build up the special effects department, but things did not work out as planned and Mann returned to the States after only a couple of years. He was active in the industry for many years after that; one of the later projects he was involved in was Mike Todd's *Around the World in 80 Days* (1956). He died in 1967 at the age of seventy-four.

One British special effects veteran who trained with Mann as previously mentioned, was Tom Howard. Howard is Britain's foremost optical effects exponent and is based at Elstree studios. He has received

two Oscars for his work, one for *Blithe Spirit* (David Lean) in 1946 and another for *Tom Thumb* (George Pal) in 1959. He was also involved with two other films that won Academy Awards for their special effects – Korda's *Thief of Bagdad* and Kubrick's *2001: A Space Odyssey* (1968).

'I think', said Howard, 'what actually started me thinking about special effects was a picture that Anthony Asquith made many years ago, called *Shooting Stars*, at the Welwyn Garden studios. In this film he was showing behind the scenes in a film studio and he had – and this was the scene that impressed me – two cameras turning, one that was photographing the scene that was supposed to be in the picture, and the other camera, the private eye camera, looking at the whole scene. Then the private eye camera tracked forward on what was supposed to be the interior of a church and it passed, much to my surprise, the East window of the church which was nothing more than a backdrop hanging close to the camera. I couldn't quite believe that I'd seen this so I had a look at it again . . . and I think this was the beginning of my interest in trickery in pictures.

'My father was an electrical mechanical engineer and in those days electricity was comparatively simple. If you hooked something up and it didn't run or it backfired on you with a shower of sparks you disconnected it and tried another way. I worked with him as a boy from about the age of seven, and, photography being my hobby when I got older, I suppose it was natural that I should be attracted to the cinema. I was always very, very keen on the cinema, in fact I used to go to my local cinema and help them show the pictures. Then I got into the theatre, sitting up on the spot-rails pointing spotlights . . . after school hours. My father, being the chairman of the local Tory club, was a bit annoyed at my being associated in this area, but I think this is where my heart was at the early stages.

'When I left school I went to work with a printing firm in the City. It was a "manufactured" job that my father had fixed up. I went along on the first Monday morning and was shown to a little office that they said was mine. It really was little, nothing more than a cupboard. But nothing happened during the day, nothing at all, except that I was brought a cup of tea at 10.30, and at midday told it was lunchtime. At 4.30 I was told that it was time to go home. But I literally did nothing. I told my father when I got home that I wasn't going to have any more of that. He asked me what I was going to do and I told him I was going into the film business. And he said, "Oh, that bloody lark. It's all fake . . . and it won't last!"

'I was just a darkroom assistant when I joined Alexander Korda's company, which was called London Films, around Christmas in 1934. Korda had just left Elstree and moved to Isleworth. I joined him at the

time Ned Mann was with him and working on *The Ghost Goes West* and *The Man Who Could Work Miracles*. Mann, who had been an associate of Walt Disney's for a time, was a very forceful character and with a broad outlook with regard to movie making and in particular to special effects. He didn't specialize in any one category of effects but was involved with the whole vista of the field. He was not really what we would today term a technician but was rather a great experimenter and theorist in all areas.

'Mann's team of Americans included a famous miniature hanger called Ross Jacklin, whose one skill was to build foreground miniatures which you could pan and tilt a camera over yet still keep them married into a full-size set. He also brought with him a man from the RKO studios whose speciality was optical effects. His name was Jack Thomas and I worked with him for about a year before he went back to the States in 1938. After he returned I took over this section for Korda and this was my real beginning in optical effects. To be honest, though photography had always been my hobby, I thought Jack was rather a miracle-man because he was using projection equipment and optical printers that appeared, to me, to be the most complicated types of machinery imaginable. But after a few years I was not only designing and building optical printers for Korda and London Films but also planning equipment for the new

(Right) *Sabu is threatened by the giant (model) foot of the genie in a scene from Korda's version of* Thief of Bagdad

Metro studio at Elstree.

'I wasn't really involved with films like *Things to Come* except in a rather minor capacity but I did a great deal of work on *Thief of Bagdad*. I had a hundred travelling matte shots in that film and I'm credited with, according to *Kine Weekly* [a film trade magazine], being the inventor of the travelling matte process in colour. But an American, Lawrence Butler, took the Academy Award for the effects in *Thief* . . . The picture was started in Britain but due to the war Korda had to complete it in the States. There was another Englishman who worked on the effects apart from myself. His name was Johnny Mills and he did all the hanging miniatures. But neither of us even received a credit on the picture. Butler had actually supervised the mechanical effects, or physical effects as we call them in England, but he was the only one who got a credit . . . so he got the Academy Award as well.

'I spent the war years working on a part-time basis with the RAF. I was processing their night op' films during the early hours of the morning but during the day I was working for David Lean on films like *In Which We Serve* [1942]. This, fortunately for me, kept me in touch with the industry while a lot of the other good people were being killed. So when we opened the Metro studio in 1946 I was all fresh and ready to go into a new area.

'For *In Which We Serve* David Lean wanted "ripple dissolves". He didn't know what to call them but he wanted a fluid effect, as he named it. He wanted the effect of the sea on these men who had been thrown out of their destroyer onto these rafts. He wanted the effect of the water on their minds to gradually push them back into the past or the future. And this was how we evolved the ripple dissolve. Today it can be done in all sorts of ways but at that time we spent weeks trying to come up with something. We tried all kinds of methods, including reflecting pictures off mercury. Finally I had the idea of rippling a piece of glass . . . I did it on my own gas stove at home one night while the wife and kids were in bed. On my first attempt, which was accompanied by a lot of swearing, I broke the glass. It took me about a week to get a reasonable ripple. We created the ripple dissolve by moving the glass back and forth across the lens in an optical printer.*

'For George Pal's *Tom Thumb* [1958] we worked out processes which, as far as I know, had not been used before up to that time. Such as the moving split-matte which we called "automotion". This is split screen work where the split moves within the screen as the scene is progressing. Instead of finding a convenient split-line you split down anything . . . you split down the front of a face . . . or anywhere at all. You can make a man move around himself without a travelling matte. I used this for the

(Right) *The skills of Tom Howard bring together Russ Tamblyn and Peter Sellers in this scene from* Tom Thumb

* Actually rippled glass had long been used by European cameramen to create cheap dissolves.

first time in *Tom Thumb*, at least I think it was the first time, I'd never heard of it before. I think I have a number of "firsts" but it's always very speculative as to who does anything first in this business.

'My father was right . . . the film industry is all fake, and at the moment it's doubtful if it's going to last. But it was in 1926 when I started and it's 1973 now so I've had a fair innings.'

Another special effects veteran who was involved with London Films in the early days is Wally Veevers:

'I spent two years at the Regent Street Polytechnic learning all about cinematography. That's what started me off in the business. Luckily for me, just as I finished the course, the Kordas came along requiring some students to be taught special effects. They were about to make *Things to Come* with Ned Mann. They had brought over twelve Americans to work on the picture and the Board of Trade would only allow them work permits providing they agreed to train some of us while they were in this country. Out of the twelve students who went for the interview only four were chosen by Ned Mann and I happened to be one of them. We were then taken on by London Films and it was a marvellous opportunity, having just finished school which couldn't really teach you more than the basic technical theory. Mann at that time had a machine shop, a plastering shop, an optical printing set-up, a camera set-up, an art department and all his own personnel. He brought over all the key men from the States. Like Lawrence Butler, who was under him, Jack Thomas who was in charge of the optical special effects, and on back projection he had Harry Zech. Eddie Cohen [now known as Eddie Colman] was his cameraman and he eventually brought over Paul Morell for developing his own mattes, and he had Ross Jacklin who was the miniature expert.

'We went through a terribly hard time in this special effects training with Mann. We had to go through all these various departments, the machine shop, etc., to find out what the terms were. We were supposed to spend two weeks in each of the departments and to complete the course we were supposed to go to the States for a month. Korda was very wonderful, he gave me every opportunity one could ever wish for but I never did get to go to the States. They sent one person and he came back and didn't make much use of what he'd learned, so they stopped the rest of us from going over. When our training was completed we could take up any side we wanted to. I took on the camera and hanging miniatures . . . I was very lucky there.

'I learnt a lot from Ross Jacklin, the miniature specialist, he taught me many things that to this very day I haven't used in the industry but which I've always kept at the back of my mind. We did all the hanging miniatures for *Things to Come* . . . it was a wonderful experience. We worked day and night on that picture. On one occasion I worked a whole week

without stopping even to sleep. But those were wonderful times. I used to work days for one group of people and nights for a different lot because I was so interested in special effects. But Ned Mann never used to do anything until after six o'clock in the evening, he wouldn't start work until the bosses had left, and as a result we often didn't finish until about four in the morning. But we had to report at 8.30 every morning no matter what time we'd finished.

'I was in the miniature department for about three years then I left to go free-lancing. After that I joined Mr Percy Day [known as Poppa Day to many people in the industry] who was a matte painter for Korda at Denham studios. I went to work for him for two days but we got on together so well that I stayed with him for years. Eventually he retired when he was about eighty-four and I took over the department which by that time had moved to Shepperton studios. I stayed there until I was offered a job by Kubrick on *2001*. Now I'm a free-lance again and have my own studio which specializes in optical effects.'

Perhaps the doyen of British special effects men is Cliff Richardson, who started in the industry way back in 1923. He first worked for a company called Stirling Films which had a small studio situated near the Clapham High Road. They used to specialize in Grand Guignol quickies, turning out at least one a week. Their films were shot in glass studios; sunlight provided all the illumination for filming. Richardson can still remember a sign on the front of the building warning cast members not to wear their costumes out onto the street.

Richardson then joined Barker's Motion Photography Company which was on the site of the later Ealing studios. At that time he worked as a prop assistant, although even then he was developing an interest in firearms, gunpowder and so on, which would later serve him well. Richardson remembers an amusing incident that occurred during the making of one film at the little studio:

'We were making a picture once about Sexton Blake [a famous fictional detective] and as he was supposed to have a dog called Pedro I was sent to fetch a suitable animal from a dog breeder called Colonel Richardson. I caught a train out to his place and was handed this big bloodhound on a lead. It dragged me back to the station and eventually I got back to Clapham with it. Everyone there admired the dog and said what a lovely animal it was and so on, and it was decided to show it to the director the following morning. The next morning, when the shooting was due to start, the property master, a man called Chapman, proudly brought this dog out. Being the boy around the place I was just an onlooker. The director, Jack Denton, took one look and said, ''Chapman, you bloody idiot . . . Pedro, Pedro, Pedro . . . and you bring me a bitch with two great rows of tits!'''

In 1926 Richardson joined British International Pictures at Elstree, the studio where Alfred Hitchcock made his early films, as a prop man but his knowledge of firearms and explosives led to his being given more and more war-type material to handle. While making *The Poppies of Flanders* (director unknown) in about 1927 he recalls meeting Edgar Charles Rogers (see page 20) who was painting backdrops for the film.

Richardson left BIP in 1932 and moved to the Ealing Studios where he remained for the next fifteen years. At Ealing he acquired a reputation as the man who would attempt anything, taking on jobs that no one else would tackle. He invented devices that are still in general use, including a portable fog machine that used oil vapour, a machine gun operated by coal gas, and a nozzle for spraying foam so that it resembled snow. While there he became associated with Roy Kellino, son of a BIP director, and together they built up the model department. The model department became very important during the war when, for obvious reasons, filming on location became unfeasible.

When Kellino left for the States, where he later directed TV films for 4 Star Productions, Richardson took over the department but left soon after to work for Korda at Shepperton.

'This was in 1947,' said Richardson, 'when Korda had just taken over Shepperton and he'd brought Ned Mann back from the States to build

(Left) *Ted Samuels, head of the special effects department at Shepperton Studios, displays the painting of Big Ben which was used as an emblem for Korda's London Films*

up the special effects department. It was going to be the greatest special effects department there ever was – but unhappily it didn't work out that way. Anyway, I was asked to go and work as Ned's assistant and then take over when he returned to America. I was given a three-year contract with London Films.

'At this time Poppa Day was at Shepperton. I fortunately got on well with him. He ran his department with Wally Veevers and the Samuels brothers, Ted and George [Ted Samuels is now head of the department at Shepperton]. They handled all the matte painting. The whole point was that Pop Day wanted to keep the whole thing under his domain and of course there was opposition between his crowd and Ned's. There was a certain amount of antagonism between Pop and Ned because I think Ned rather looked upon Pop as an old-fashioned man whose ideas were out of date – though I didn't agree with him – and Pop looked on Ned as the interloper who wasn't even necessary. So there was this sort of unfortunate atmosphere.

'I was about the only one in Ned's crowd who was allowed into Pop Day's department. Both Pop and Wally Veevers, I think, realized that I was having rather an unhappy time of it, which I was, and they were very good to me. I've always remembered this about them, particularly Wally Veevers whom I have the highest regard for and who I think is an excellent special effects man. Being a physical effects man, as I am, you come across occasions where there is something you think could be achieved by other means, such as with mattes, etc., and Wally had always been very helpful with his advice on these matters.

'When my contract with Korda expired I went free-lance. At the time I was about the only free-lance in the business. The first film I worked on was *Captain Horatio Hornblower RN* [1951] for Jerry Blackner of Warner Brothers. We spent eight months on that. It was made at three different studios – at Teddington, when Teddington was the Warner Brothers' studio, at EMI which was then Associated British Pictures, and also at Denham studios. All the miniatures were shot at Denham. Actually the place had just folded, Rank had moved out, and we were the only picture shooting in there. We spent a couple of months up at what they called the "city square" on the lot shooting the miniatures in an enormous tank that they had built just for the picture. It was a big tank by any standards – 300 feet long by 200 feet wide and 6 feet deep. The man responsible for building it was Peter Duco who is a quite well-known construction manager. It was made of timber and the floor and interior walls were covered with asphalt. We had rostrums built all around the sides of the tank, for the many wind machines were capable of 12,000 horse power. But we would start a shot of our miniature fleet sailing majestically down the tank with the sails billowing beautifully from

the wind created by these machines and a slight natural breeze would come from the opposite direction and blow the sails inside out, which ruined our shot.

'It was a bad summer that year with a lot of rain and our shooting was often delayed. Scenes with model ships, in my opinion, present some of the greatest problems. The density of the water is not proportionate to the scale of the models so we have to put wetting agents into the tank to reduce surface tension. Our model ships in *Hornblower* were built on quite a large scale, they averaged about thirty feet long and carried forty square feet of sail. We had three men on each one. Their job was to handle the auxiliary engines – we had to have engines to give the models more speed as we were filming with high-speed cameras – and also to fire the guns and tack the sails. I always remember at that time we hadn't got round to using squibs, these little explosive charges that we use now for blowing holes in cloth and for bullet hits. So we found the best way to create the effect of a cannonball going through the sails was by using ordinary No. 6 copper detonators. I had steel plates made to go over the top of the chaps in the hold but on some days it was very hot weather and I always used to make a point of shouting out: "Are you chaps covered up?", before I fired these things and they would say "yes" whether they were or not. I remember that several of them got hit by fragments of copper from the detonators exploding in the sails. Nothing ever serious but they often had the nurse picking pieces of copper out of their backs.

'The tank was dismantled after the picture. Most big tanks are built outdoors but there's one big indoor one at Shepperton. It's called "H" Stage but to people in the business it's always been known as the "silent" stage. It was originally built by Korda for *Things to Come* at Worton Hall Studios at Isleworth. When Korda took over at Shepperton it was decided to shift the silent stage from Worton Hall to Shepperton. I can't verify it but I was told by Ned Mann that it cost £9,000 to build in 1934 and £45,000 to take it down and rebuild it at Shepperton in 1948. Ned's original idea was to flood the whole stage and make it into a tank when required but this never worked properly. His plan was to use bulkheads which would partition parts of it off so that it would be possible to flood either the full stage or only a half or a quarter of it, depending on what size tank was needed at the time. I don't think the idea was a very good one but Ned was of the old school . . . he would spend, say, £2,000 to try out an idea and if it didn't work he would say, "Oh, well . . ." and try something else. But of course you can't afford to do that these days. So the plan for dividing up parts of the silent stage were abandoned and what they do instead is build wooden tanks inside it . . . they at least have a cement floor to start with.

'Worton Hall Studios, also known as the Isleworth Studios, was another of the Korda babies but when they took over Shepperton they thought it was uneconomical to have two studios so they let the Gas Board have Worton Hall. It was a pity because I thought it was a wonderful place to work in. It dated back to the very early days because they still had a glass studio there that had been painted black. Actually that was where I did the miniatures for *The African Queen* [John Huston, 1951] and where the interiors were built for the picture. I was on the picture more or less to do the miniatures but I did get involved with a lot of the studio shooting as well. For instance, I made the leeches for that famous scene where Bogart gets covered with them. At first they had real leeches which were supposed to be stuck on the back of a stunt man, but they wouldn't stick. They even arranged for a nurse to puncture his back in the hope that the blood would interest the leeches but that failed too. So I made a plasticine model of one of the leeches and from that a plaster mould was made. We cast the ''leeches'' in rubber and inserted a small blood sac into each one. To stick them onto Bogart I used a waterproof adhesive. They had a hell of a job pulling them off but they worked like a charm.

'I also handled the scene where Bogart and Katy Hepburn are enveloped in mosquitoes. Two thousand real mosquitoes were specially bred for us by the Institute of Tropical Diseases, the idea being to photograph the mosquitoes flying around in a glass-sided box and then superimpose this over the actual scene in the film. Unfortunately the mosquitoes refused to co-operate and settled on the floor of the box and nothing we tried would shift them. We eventually solved this problem by shooting through an aquarium filled with clear water which was vigorously stirred after throwing in a handful of tea leaves. The gyrating leaves together with the high-pitched buzz of mosquitoes on the sound-track proved quite successful.

'I enjoyed working with Bogart and Hepburn. Bogart was quite good fun, always larking. Katy Hepburn, of course, was out of this world . . . she was the friendliest of people. She would put up with anything. I always remember when we were shooting the scene near the end of the picture when she and Bogart were supposed to be swimming in this lake. They had warmed the water in the tank . . . Katy had already been in and she was out and sitting in the boat, obviously cold. Suddenly she said, ''I'm going back in. It's warmer in the water . . .'' and she just jumped back into the tank again. I remember she also used to ride a bicycle around the lot and leave it in all kinds of extraordinary places . . . she'd go somewhere and forget where she left it. But a very, very nice and friendly person.'

After *Hornblower* and *The African Queen* Richardson worked on a num-

ber of films for Warwick Films, a company run by producers Irwin Allen and Albert Broccoli. He had a year-to-year contract with Warwick, though he was still officially a free-lance, and stayed with them until the company folded in 1959, working on such films as *The Red Beret* (Terence Young, 1955) with Alan Ladd, and *Zarak* (Terence Young, 1956) with Victor Mature.

'I liked working with Alan Ladd,' said Richardson. 'He was a charming, reserved . . . almost shy man. He nicknamed me the "nonchalant bomber". I worked with Yakima Canutt [the famous American stunt man and second unit director] on *Zarak*. He was the one who showed me how to turn a coach over . . . I'd never been asked to do that before. Victor Mature was nothing like his he-man image, he wouldn't even get on a horse if he could avoid it.'

During the 1960s Richardson worked on many of the top films made in Britain, including *Lawrence of Arabia* (David Lean, 1962), *The Battle of Britain*, *Help* (Richard Lester, 1965) and *The Dirty Dozen* (Robert Aldrich, 1966). He is still very active in the industry and now has his own son, John, as a partner.

Les Bowie and Bill Warrington are two familiar names that have appeared in the credit lists of many a British picture. Les Bowie is probably best known for his effects on the Hammer horror pictures while Bill Warrington has worked on such films as *The Heroes of Telemark* (Anthony Mann, 1965) and *The Guns of Navarone* (J. Lee Thompson, 1959–61) and won an Oscar for his effects in the latter.

'I became involved with special effects', said Warrington, 'as a model maker and an exponent of the Shufftan Process. In those days the Shufftan Process was the only known trick way [in Britain] of putting fake top sets on sets, which, of course, today you can do in so many other ways. We used to do it then with photographs of the interiors of, say, the Houses of Parliament or some other well-known lavish interior, using the old Tanning still plates which would take half an hour to expose . . . it was a very delicate process. From those we would make transparencies, usually twenty-four inches in width, and these were attached to the side of the camera and reflected into a mirror, part of which had been scraped clear so that you could see through it into the set that had been built behind it. Then you lined up the full-scale set with the reflected image and you had a perfect illusion of actors being inside, say, the Houses of Parliament. That was one way of doing it. For things that didn't exist you had to make models and these were miniatures, and when I say miniatures I mean *miniatures*, because you had a limited focus range in which to build these things. Today you can go on and on but the lenses we were using then only gave you one square metre or one square yard of area to play around in. So the models had to be finely constructed,

and they *were* bloody fine. We used to make them with a special type of paper because the grain and finish of timber wasn't fine enough in texture and so on. So that's how I started in the industry, making these extra-fine models, but after a few years I was doing all sorts of other special effects jobs as well . . . and before I knew it I was a fully-fledged special effects man. This was at the Elstree studios before the Second World War.

'After the war I joined Arthur Rank when he was having his big dream about starting the largest and best special effects department in the world . . . it was to be on the grand American scale. This was when Rank had the studio at Denham but there was also a studio at Highbury which is where I first met Les Bowie. The Highbury studio was an empty shell of a place which you could hire for a reasonable rate and we started using it for the odd model shot. We used it mostly when we had to bring outsiders in so the unions wouldn't know. It was a backwater where you could work away from everyone's view; you could work quietly and get on with it. And good fun it was too because you were your own boss and all you had to do was produce the results. So the next morning with a fast motor-cycle or car you went down to Denham with the rushes.

'At first the place was used exclusively for special effects but then it became a charm school. Rank wanted a place to breed, well . . . not breed exactly, but to bring up young actors and actresses and groom them for stardom, etc. As they were a bloody nuisance in the studio itself they had to find an out-of-the-way place for them and they picked the Highbury studio. And we, as a result, were slowly eased out of the place and had to go to Denham. Denham was and is the biggest film studio in Britain. It was built by Korda and was bigger than anything else in Europe, and just as big as any of the major studios in the States. Its one disadvantage was that it was too sprawling in its lay-out. You could walk out of the office of one production and have to walk half a mile along a passage to reach the office of another production. Pinewood is much more compact and when Rank had both studios it came down to a choice between them and they chose Pinewood. It was at Pinewood that Rank built up his new effects department and where Les Bowie developed his new technique for producing matte paintings'.

'At Pinewood, during the late 1940s', said Bowie, talking of the same period, 'they'd just started a new system of making films which they called the "independent frame" method. Actually it was like a sausage factory with different sections of the same film being made simultaneously. They had all this fabulous new equipment made by Vickers for the special effects department. It included everything, such as back projection which was handled by Charles Staffel. They brought in a man to organize it all but Bill Warrington was actually running the set-up.

(Left) *The 'before' and 'after'
stages of a typical matte shot.
A set on the back lot at
Shepperton* (above) *is
transformed on the finished
film by the addition of matte
painting* (below)

George Blackwell, another model specialist, was also there . . . in fact you could say it was the only real special effects unit operating in the English film industry. Of course there was also the small unit at Shepperton with Poppa Day and Wally Veevers, but it was on nothing like the scale of Pinewood's.

'I had worked with Poppa Day at Shepperton just after the war. This was when he would have been the only one in the country doing matte painting. He tended to make a great magic out of it and while I was there I realized that there must be a quicker way of doing it. His method was to use a number of girls who would paint and do only what he told them. First they would trace off a drawing of the original set onto a sheet of clear glass with wax pencil then they would add onto it with slow, dry paints. It was a painstaking process that would take anything up to a month to complete . . . and there were endless tests to make sure that the colours matched, etc.

'One day at Pinewood, this was several years later, I said to Bill Warrington: "Look, if I told you that I could do a matte painting in virtually a day instead of the usual fortnight or month would you let me have a go?" He said okay, so I picked up a job. It was a black and white picture, as most of them were in those days, and there was a scene that required the cutting off of the tops of some cliffs and replacing the coast-guard

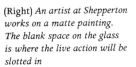

(Right) *An artist at Shepperton works on a matte painting. The blank space on the glass is where the live action will be slotted in*

station, which was on the actual clifftops, with a school. So I used the camera itself and I projected the scene through the camera onto the glass. This was the first time, in this country, that the scene had been projected through the camera in that way . . . before they used projectors with comparable lens but as no lens was ever the same when they tried to marry the finished painting with the scene it often wouldn't line up. But as I projected through the actual camera that would be used to film the scene with the same lens, no tests were needed. And I prepared the glass with a water paint, like distemper, so that you could paint on the distemper immediately with oil paints. The oil paint binds the distemper to the glass but where you don't paint you can simply wash the drawing away. By using these techniques I did this first matte painting in *one day*, when previously it had taken two to three weeks. So the studio said, right, this is how we do matte paintings from now on. This resulted in some animosity but I did become the chief matte painter at Pinewood.

'After that, on behalf of Rank, I went to all the art schools looking for people who might be suitable as matte painters. But most of the art students had individual painting styles unsuitable for matte work, which has to be as representational as possible. We found that the best people for matte painting were those that had originally been scenic painters for the theatre. Later I organized a training scheme which has produced many of the best matte painters currently working, such as Ray Caple who came to me when he was fifteen and is now, in my opinion, one of the top boys at it.

'At the moment the bottom has rather fallen out of matte painting. It could be used more but the younger art directors and technicians don't know much about it. When you explain it to them they say "Isn't that clever!" as if it had just been invented and never used before. And of course everything you do in this business has been invented by someone else before . . . by Cecil B. DeMille or someone like that. All these things have been done but now with modern techniques you can do them so much better.'

Les Bowie left Pinewood during the early 1950s when the film industry was experiencing a depression and became a free-lance, a move he has never regretted.

'I had been playing around for a year before that, with Bill Warrington, drumming up work from outside the studio to give ourselves something to do. We were under contract and they had to pay us a certain amount of money every week whether we did any work or not. We thought this was silly and we'd go out and get work, but by the time the paperwork had gone through the front office the studio had added such a huge price for our services that we'd lose the jobs. So we just kept on doing nothing and getting paid for it. It was silly but typical of the way things were done

in that period. That's when I decided to go on my own. They said I wouldn't be able to do it without all the necessary equipment and it was an awful struggle at first but I existed by doing matte paintings. Later I formed a company with Vic Margutti and we specialized in travelling mattes. When Eastmancolor came along I had a brainwave . . . I said right, Rank and the others have been doing these travelling mattes using split beam cameras and so on but with the Eastmancolor Process you had everything in one . . . all this split beam stuff wasn't necessary. My then partner did experiments on the idea and the result was very successful. Margutti has been the chief exponent of this type of travelling matte ever since.'

It was also during the early 1950s that Bowie began his fruitful association with Hammer Films. The first film of theirs that he worked on was *The Quatermass Experiment* (Val Guest, 1954), which was also the one that marked Hammer's entrance into horror films.

'When Hammer made that film', said Bowie, 'they were virtually only making second feature films on very, very low budgets. We did *Quatermass* on a budget so low it wasn't a real budget. It's a film that if you see it today you say . . . ugh, what terrible effects, but if you know how little was spent when we were making it, it becomes quite a different thing. I did it for wages really, not as a proper special effects man who is usually

(Right) *Richard Wordsworth as the tragic monster in* The Quatermass Experiment

allotted a certain budget when he works on a film. But there was no budget as such on *Quatermass,* I think I received only £30 a week for working on it. We did a lot of matte shots in it as well as designing and making the actual monster.

'I think what came over in that picture is the sadness of the situation. The creature was basically sympathetic, you felt sorry for it as well as the victims. Hammer has used this situation often since then. The Frankenstein films usually have a sympathetic creature in them. In this new one that I've been working on, *Frankenstein and the Monster from Hell* [Terence Fisher, 1972], there is a rather pathetic monster with a great hairy body but a sad old professor's brain. When they kill it in the end you think, ''Thank God the poor thing is out of its misery.'' You really feel sorry for it. And I tell you, it's a really difficult job of special effects to make a hairy monster that people don't laugh at.

'I suppose you could describe me as the real Dr Frankenstein . . . I build the monsters, cut out brains, sew hands onto dead bodies and supply all the other gory paraphernalia for the operations. But Hammer horrors are not really horrors, I think, there are much more horrible things around. But I draw the line at certain things. For instance, I saw a script recently for a horror film that was not really horror, in my opinion, but one of the sickest things I've ever read. In fact both Bill and I said we would have

(Below) *Such scenes keep the wolf from the door for many British special effects men*

nothing to do with it. I doubt if it will be made in this country. But Hammer films are more like thrillers than horrors.

'One type of effect that I do a lot of for Hammer are matte paintings showing castles on hilltops, etc. I used to be ashamed of them when I actually did them but I've seen them recently on TV in colour and I think, why was I worried? They look pretty good to me, nowadays. Another job I often do for Hammer is dispose of Dracula at the end of his films. I've lost count of the times I've killed Christopher Lee. Sid Pearson finished him off in the first Hammer *Dracula* [Terence Fisher, 1958] but I handled the falling through the ice sequence in the second one, *Dracula, Prince of Darkness* [Terence Fisher, 1965]. We utilized a number of methods to get those scenes . . . sometimes we used real blocks of ice in a swimming pool for a few of the close shots . . . for other shots we used wax . . . if you pour wax on water it forms a coating on the surface.

'For the final shots of Dracula sliding under the ''ice'' we used a circular section of plaster mounted on pivots. In the latest Dracula film he gets caught up on a hawthorn bush, which is a bad thing for any vampire, then he shrivels away. I use a series of dummies and slow dissolves for these sequences. The methods vary, depending on whether he goes wet and bloody or if he is supposed to wither away into dust. I have to resurrect him as well which is just as difficult. They're quite lengthy

(Right) *Jenny Hanley is attacked by hand-held bat in* The Scars of Dracula

operations, almost animations really, and they usually take a few days to complete. I have to find a quiet room somewhere in the studio to work on them in peace.

'In *Kiss of the Vampire* [Don Sharp, 1962] I had to show a swarm of bats breaking through a skylight and attacking a group of people. We had a number of rubber bats made which we hung from a framework of chicken wire. They were rather difficult to control and kept getting tangled up with each other. We used them to create shadows mainly. When they were shown crawling on the people we used different models that were made to stick on the actors' skin and we manipulated them with thin nylon cords. The result was quite life-like.

'In *Pirates of Blood River* [John Gilling, 1961], which was one of Hammer's non-horror films, I had to create the effect of a school of piranha fish moving across a lake and attacking a girl. For some shots we used little model fish made out of silver paper. For the effect of them coming across the water I sprayed a stream of lead shot into the air, gradually decreasing the arc of the stream to make the resulting tiny splashes move towards the girl. Then I sprayed the lead in a circle around her and she gave a scream and went under.

'I like working for the Hammer people and I trust they feel the same way about me. They give me a fair amount of freedom and usually leave it up to me to decide how the effects will be done and what they'll look like. And being more artistic than many effects men, I can draw my effects beforehand and show them exactly what they're going to get.'

Over the years, due to his work on Hammer films and similar productions, Bowie has acquired a reputation for creating good effects on relatively small budgets. In *One Million Years BC* (Don Chaffey, 1966) he had to create the world in six days on a budget of only £1,100. He managed to do it, despite going over the budget by £100, using such economic short-cuts as porridge to represent lava and water running out of taps to represent a vast prehistoric deluge. Bowie can also claim to have parted the Red Sea for only £80, and in Technicolor! It was not that impressive apparently but as Bowie says: 'What do you expect for £80?' He likes to work on these small films because of the freedom but feels that the lack of money often prevents him from giving his best.

'I always wish I could spend more on my effects . . . I never have enough money. But I just have to accept this because that's the sort of special effects man I am, I specialize in doing effects for people who don't have much money to spend. But I've never done anything yet that I haven't always wished that I could have afforded to do miles better.'

Some of Bowie's more hastily executed jobs still trouble him years later, especially when they turn up to haunt him on the TV screen.

'I did a film once called *The Trollenberg Terror* [Quentin Lawrence,

(Right) *A scene from* The
Trollenberg Terror, *a film
that still embarrasses special
effects man Les Bowie*

1957] that had an awful lot of effects on it and there was one shot of a
cloud on a mountain that was really terrible. I squirm when I see it on TV
now and I squirmed when I filmed it but I did it in a mad hurry at the
time. We did the cloud effect with a piece of cotton wool . . . we stuck it
on a photograph of a mountain with a nail and then filmed it. And they
used that photograph time and time again during the film . . . everytime
a character looked out of a window they'd cut to this mountain and we'd
have stuck the cotton wool in a new position. Awful!

'A similar thing happened with *The Day the Earth Caught Fire* [Val
Guest, 1961]. I became involved with that picture at the very beginning,
when Val Guest still had it as a story. I suggested various ways of chang-
ing the script so that the special effects would be easier and cheaper to do.
But there were still a lot of effects in it . . . we had to dry up the Thames,
for instance. And there was a scene where a great bank of fog has to drift
down the Thames. We did it with travelling mattes but the result had
fringing around it and looked awful so I wanted to do it again but they
said no, they couldn't afford the money. People commented on that when
it was first released though overall it was a very successful film and Val
Guest did quite well out of it, but I still wish we could have redone that
one awful scene.'

Not that a cheap and simple technique necessarily looks obvious on the

screen. A very effective innovation of Bowie's was a method by which buildings could be apparently blown up without having to use actual buildings or even miniatures. His idea was to use a large photograph of a building with an explosive squib attached to the back of it. The squib is detonated and the camera gets a passable shot of the building being consumed by an explosion. Of course, there has to be a cut rather soon after the explosion otherwise it will be quickly apparent that the scene is only two-dimensional.

'Many of the explosions in the Bulldog Drummond pictures, *Deadlier than the Male* [Ralph Thomas, 1966] and *Some Girls Do* [Ralph Thomas, 1968], were done by blowing up photographs,' said Bowie, 'and I mean that literally. In the first one, the scene where the office ten storeys high is blown up, we just used a photograph about four feet tall. And in *The Face of Fu Manchu* [Don Sharp, 1965] every explosion in the film was done using these photographs, even the monastery at the end.'

'I've never been the boss on a big prestige picture. Bill Warrington has though, and he got an Oscar for it. But I'm sure he'll be first to agree that he had a good team of boys working under him on *The Guns of Navarone*, including Pat Moore and Johnny Stears, who helped to earn that Oscar.

'One of the more expensive films I worked on was *A High Wind in Jamaica* [Alexander Mackendrick, 1966]. I say *worked* but for me it was more like a glorious holiday in Jamaica. My biggest job in that was to handle the storm sequence where the house was destroyed. It was a major operation with a full-scale set, wind machines, tractors with wires attached to pull down sections of the set . . . and lots of water. Our big difficulty was in having to change the course of a stream so that we could form a reservoir to provide us with a ready supply of water. We weren't allowed to fly any equipment in so we had to make it all on the spot, including six wind machines. We waited for a real hurricane which was expected at the time but we were only on the edge of it. They filmed a bit of it but not enough. They were so busy hiding and protecting the unit when the hurricane came that there was no one down by the water's edge to film it as they should have been. I was really mad about it. I was sitting down by the sea watching this storm smash buildings to bits while all the cameramen were sheltering up the mountain. I thought, well they're a fine lot! A God-sent hurricane and they weren't there. I was very annoyed . . . but it was good fun, that picture.'

Unlike Les Bowie, Bill Warrington did not become a free-lance until relatively late in his career, a move which he now thinks was too late.

'I stayed at Pinewood until 1959 and I used to work like a maniac, during the weekends as well as nights. I had units all over the world, I had to sign all their time sheets and I slowly began to realize that these young free-lance fellows that I was hiring, telling how to do the jobs and

equipping them up, were getting three times as much money as I was . . . and I was the head of the department! So I decided I wasn't going to be a slave to the studio any longer and left to start free-lancing. I should have done it years before.'

Both Bowie and Warrington have been responsible for introducing and training many of the younger top men active in special effects today in Britain. One of Warrington's protégés was John Stears, the man who worked on all the James Bond films up until *Diamonds Are Forever* (Guy Hamilton, 1971) and who is probably the highest-paid special effects man in Britain. Stears, who had trained as a silversmith at Harrow Art College, was working as a model maker when Warrington more or less dragged him into the film industry.

'It was in the early 1950s and we were making a flying film. At that time we didn't have enough of our own skilled personnel with a delicate feeling for light models. In those days you had two alternatives for getting extra help: you could go to the studio carpentry shop and end up with a chap that had hands the size of an octopus – and you couldn't really expect these people to make model aeroplanes properly, they were used to making doors and tables and their models always turned out too heavy and solid looking – or you could go outside the business and risk trouble with the unions. But on this occasion I went to the front office and laid my cards on the table. I told them that unless we got outside help on this picture we were going to be held up for several weeks. So they allowed us to employ some local model makers and Johnny Stears was one of them.'

British special effects men, say Bowie and Warrington, are different in many ways from their American counterparts.

'I would say that the average British special effects man', said Warrington, 'is a far more skilled man *overall* than the average American one. The Americans tend to specialize a lot more in their various sections. The Britisher was much more versatile because he *had* to be, for obvious economic reasons. We never had anything like the budgets the Americans had. I've worked in the States and it was a revelation . . . like going into Aladdin's Cave. A childhood dream for a special effects man. Bloody great organizations, huge departments and whatever you managed to dream up you could have. You could try out all your ideas there but here in Britain you had to rethink everything four or five times until you were sure you had the cheapest possible way of doing a thing. But, of course, it's different in America now. They've had their financial troubles too and most of the departments have closed down.'

Bowie agreed with Warrington on this subject:

'Special effects men in England have to do everything . . . we have to be powder men, water men, etc., yet we are also specialists in our own

right as well. Wally Veevers, for instance, is a special effects *cameraman*, Bill Warrington is basically a *model* specialist, Cliff Richardson is an *explosives* expert and I'm a matte painter . . . but we've had to know all about every other aspect of effects too. Naturally there are times when you *have* to bring in an expert in a particular field to handle a job that you can't do by yourself, which is the American way, but on the whole I think we do a wider range of tasks ourselves over here.'

Bowie and Warrington had first-hand experience of American methods when they went on location in Jamaica to work on the Walt Disney production of *Swiss Family Robinson* (Ken Annakin, 1959).

'We were working with these two American effects men on that picture and they had all this fabulous equipment. And they'd do things like fly off to Trinidad to spend about £16,000 on outboard motors . . . they had no respect for money at all. They had all sorts of fancy gadgets, including these special mortars that were used to fire clumps of arrows through the air. These, along with their other equipment, had been flown out from Hollywood at great expense. One day one of these men told me to go and practise firing arrows out of this mortar. So I did, I carried one of these gadgets away from where we were based, set it up, put some arrows in it, fired it . . . and the arrows went about ten feet before dropping to the ground. I was rather upset about this because it meant I was

(Left) *Stunt men dressed as pirates are buried beneath an avalanche of dummy logs in* Swiss Family Robinson

going to have to tell the fellow his gadget wasn't working any more. In desperation I just grabbed a handful of arrows and flung them into the air . . . and they just flew and flew. After a few more tries I even worked out a way of throwing them so that they separated in mid-air and landed like a swarm of arrows would if they'd been fired by several bows. Anyway I went back and confessed to this bloke that his mortar wasn't working, so he came back and checked it over and said it was working perfectly. "But it only propels them about ten feet", I said, "do you know that you can throw them much further by hand?" And I demonstrated to him how far I could throw them. He was shocked. "For God's sake", he said, "don't do that on the day of filming!" But when the day came an assistant and I were hidden in the woods, throwing the arrows out by hand. All that equipment shipped out at such a high cost and yet no one had tried just throwing the things!'

Usually, on the frequent occasions that American and British effects men work together, personal relations between them are quite friendly. However, during the making of *Swiss Family Robinson* a certain amount of animosity developed between Bowie and one of the Americans.

'We were filming the sequence where the outrigger is overturned in the rough sea and the two boys are thrown into the water. To film the scene we had to wait for fairly rough seas, which we got after a storm that lasted three days. A promontory was built out into the sea for the camera and we were all out there trying to get the outrigger into position. The idea was to have it moored out in the water then turn it at the right moment, and release it so that it would be flipped over by one of these eight-foot-high waves that came rolling in all the time. As you can imagine it was a complicated procedure and we'd been trying for hours without success. Every time we almost had it right this American standing on the promontory would do something wrong with his rope and foul the whole thing up. And he was blaming *us* calling us goddam bloody limeys . . . he was really angry yet it was all his fault. Now I'd been in the water for hours struggling with these ropes . . . I'm a good swimmer and one of the reasons I went out there on that film was to do aqualung work if required. I wasn't enjoying it because the water was murky, which meant it was ideal for sharks. Also all these Portuguese Man-O-Wars had been battered to pieces by the storm and the water was full of little bits of them . . . and if they touched you on your bare skin it was like being burned with a cigarette end.

'So I was in the water getting more and more exhausted and angrier and angrier with this American. Finally I said to myself – I'll fix you – and I swam under the water, took hold of his rope and gave it a terrific tug . . . he took off like a rocket. While he was in the water we managed to get the shot okay.'

4/ More Blood! More Blood!: Developments in the 1950s and 1960s

In earlier chapters it has been observed how the role of special effects was altered when sound was introduced to Hollywood film making. The special effects departments, together with the art departments, served primarily to recreate the outside world within the studios. Location work, local as well as foreign, was rare during the 1930s, even when the sound-recording equipment became more efficient. Most of the exterior footage shot during this period was for use in conjunction with the rear projection process.

The coming of the Second World War continued this trend. For obvious reasons filming in foreign locations was much restricted and the general lack of finance available for the film industry meant that as many production short-cuts as possible had to be used. Greater use was made of miniatures and models, especially in the making of the large number of war-oriented films that were produced during and after the war. As a result of all this the special effects departments flourished.

Location work became more common during the second half of the 1940s, especially after *The Naked City* (Jules Dassin, 1947), which was shot entirely on location in New York, but the majority of Hollywood productions remained studio-bound. For example, if one looks at *Key Largo* (John Huston), made in 1947 and a typical film of the period as far as production techniques are concerned, it is obvious that, apart from an opening aerial shot, the whole film is shot indoors. This is despite a good deal of the action being centred around a sea-front setting which includes a jetty extending out into the water, several launches moored nearby, and a large yacht moored in the distance. Actually the 'sea' is a studio tank and the launches vary in size from full-scale to miniature (the 'large' yacht is only a few feet in length) in an attempt to force the perspective and to create the illusion that the horizon is miles away instead of the mere twenty or so yards it in fact is. The later scenes in the same film which supposedly take place on a launch at sea were also filmed in a tank, but in this case the horizon had been camouflaged with a studio-made fog which makes the whole thing much more effective.

(Right) *The bloody trend of the late 1960s and early 1970s is typified in this scene from* The Blood Feast *(filmed, according to the promoters, in 'blood colour')*

It was not until the early 1950s that Hollywood's traditional methods of film making began to undergo various changes. Hollywood itself was shuddering under the impact of television and this had its effect on the different types of film then being produced. The 'epics', for instance, came into vogue in an attempt to outdo television in terms of sheer spectacle but though they were, in essence, *Hollywood* films they were often made in their entirety in foreign locations. Location work in general also became much more common, but despite all these changes the studio special effects departments remained relatively secure. There was still plenty of demand for their services, particularly in the making of the science fiction and monster films that had also become extremely popular at that time.

A prime example of how much the studio was still being utilized in the 1950s can be seen in *The Night of the Hunter* (1955), that unique film directed by Charles Laughton. The impressive scenes of two children asleep and floating down the river at night with various animals silhouetted on the bank were all actually filmed in a studio tank. The same section of the tank was redecorated for each shot and though the final result on the screen is of one continuous action the boat was really only travelling the same few feet again and again. Even more remarkable is the scene where the young boy looks out of the barn and sees the

sinister preacher, played by Robert Mitchum, riding along in the distance and outlined against a huge moon. Hard as it is to accept, this too was filmed in the studio. 'We built the whole set in perspective,' said Stanley Cortez, cameraman on the film, 'between the hayloft and the fence, which was about 500 feet away. The figure moving against the horizon wasn't Mitchum at all. It was a midget on a little pony.' [31]

Probably the major change that special effects departments experienced at that time was a technical one. Rear projection, that invaluable tool of movie makers for over twenty years, was being superseded by improved techniques in travelling matte. Travelling mattes are cheaper to produce than rear projection and they have the added advantage that if an actor makes a mistake with his lines a retake can be done immediately, whereas with rear projection the background scenes must be halted and rewound which naturally causes expensive delays. Today the various types of travelling mattes have replaced rear projection almost completely but it is still used on certain occasions, usually to provide a moving background for scenes shot inside cars.

One of the first major productions to use travelling mattes on a large scale was *The Gift Horse* (Compton Bennett, 1952) which was made in Britain at the Shepperton studios. The picture is a sea drama about the transfer during the Second World War of an American destroyer to the Royal Navy. A full-scale section of the destroyer was built in Shepperton's huge 'silent stage' and behind it was mounted a large blue screen. This blue-backing screen plays an important part in several of the most popular processes used to create travelling mattes. A blue-backing was also used in the early Dunning-Pomeroy Process but these later techniques are much more complicated.

The basic 'blue screen' system, the one used in the making of *The Gift Horse*, is still popular with many film makers. It involves a blue backing, which is either a screen painted blue or illuminated with blue light, in front of which the actors, lit with ordinary white light, are posed. A standard camera, loaded with a colour negative, is then used to film the action. The colour negative then undergoes a series of printings. First it is printed onto a black and white master, which records only the blue area of the scene. The result is a black and white colour separation positive in which the background area is clear. The original colour negative is again printed to another black and white positive but this time only the red components are recorded, so that the background area appears black in the resulting colour separation positive. This second strip of black and white film is printed onto a duplicate negative which produces a negative image of the actors against a clear background. Finally this red-filtered negative and the blue-filtered positive are printed together to produce a strip of black and white film which is clear in the area of the

actors but opaque in the background area. This is the travelling matte.

From this a counter-matte is printed which is the reverse – opaque in the area of the actors and clear elsewhere. Now, if the original colour negative of the live action is run through an optical printer with the first travelling matte (containing the opaque background) the new duplicate negative records only the images of the actors. And when the negative containing the background scenery is run through the optical printer with the counter-matte (opaque in the area of the actor) the new negative has an unexposed area on each frame which matches exactly the shape of the actors. When the two negatives are combined actors and background scenery fit together in each frame like a jig-saw puzzle. When the process has been performed correctly, that is; any errors result in a 'fringe', or matte-line, around the actors which most cinema-goers can remember seeing at one time or another. A red background screen can also be used with this process but if fringing does occur a blue fringe is less noticeable in most circumstances than a red one.

There are several other travelling matte processes in use today, most of them even more complicated than the one described above, and that, it must be emphasized, was a very simplified description. Many of the more recently developed processes make use of 'beam-splitting' cameras. These cameras have a prism behind the lens that divides the light entering the camera so that two identical images are passed to two different strips of film. One of the strips is a standard colour or black and white negative, which is used for the ordinary photography of the action, and the other strip is a specially selected film stock which is used to produce a travelling matte of the same action.

A beam-splitting camera is an integral part of the 'sodium light process', perhaps one of the best travelling matte processes in use today. This was originally developed by the J. Arthur Rank organization and first used in a film called *Plain Sailing* which was made at Pinewood in 1956. It has since been adopted by the Walt Disney Studio which has achieved some particularly fine results with it. The process employs a yellow screen which is lit from the front by sodium vapour lamps which emit a yellow light. The actors are lit with ordinary lamps filtered to prevent any yellow light getting through. The beam-splitting prism in the camera is filtered in such a way that the negative strip of film used to record the action is only exposed by the light reflected from the actors while the other strip of film is exposed only by the yellow light reflected from the backing. This latter strip of film – the travelling matte – is therefore clear in the area of the actors' bodies and opaque in the area of the background. The final composite is made on an optical printer in the same way as in the previously described blue-backing process. The sodium light process is superior in many ways to most of the other

(Left) *Twin cameras mounted on the helmet of driver Bob Bondurant added to the realism of the racing scenes in* Grand Prix

travelling matte techniques, particularly in that it is free of any fringe or matte-line effect.*

The 1960s brought more than just technical changes to the special effects departments. By this time Hollywood was really coming apart at the seams and the big studios were foundering. The type of films that were commonly made during the sixties had no need for the elaborate studio set-ups, and that included the special effects departments. Of course special effects still played an important part in the making of many of these films but they tended to be effects of a physical kind – explosions, car crashes and so on. The effects men who specialized in this type of work were in much demand while the miniature and optical specialists discovered that the reverse applied to them. The studios began to close down their effects departments and the special effects men themselves turned free-lance or, depending on their particular skills, went into another line of business.

In the making of *Grand Prix* (1966), for instance, director John Frankenheimer specifically said that he wanted complete realism and that there were to be no process or matte shots in the picture. In one of the several car accidents in the film the character played by Yves Montand

* For further information on these and other techniques, see Raymond Fielding's *The Technique of Special Effects Cinematography* (Focal Press, London; Hastings House, New York).

(Right) *Two spectacular shots from* Grand Prix: *a dummy car, complete with dummy man, is fired from Milt Rice's air cannon* (above), *and a car is sent skimming across the water by the same means* (below)

is supposed to get killed when his car spins out of control on a section of the famous banked track at Monza. To eliminate the need for rear projection shots, effects man Milt Rice built a special 'double-decker' car, the top half of which was able to swivel. A camera was mounted on the side of the top section for the close-ups of Montand and the impression that he was in a car that was spinning out of control was created in a most effective way.

No miniatures were used for the scenes of the cars actually crashing. Instead Rice devised an air cannon that could catapult a car (minus the engine) at speeds between 80 and 100 miles an hour. The air cannon had a steel tank 7 feet long and 5 feet in diameter that held 500 pounds of compressed air. A cylinder 4 feet long and closed at one end was welded to the rear of the car and this was fitted over a tube projecting from the air tank. In the scene where one racer's car hurtles into the sea there is a stunning subjective shot from behind the driving wheel just before the car hits the water. To obtain this a special sky-diving camera was mounted in the car at the driver's eye-level, and the hands of a dummy on the steering wheel completed the illusion. The car was then propelled by the air cannon through bales of hay and out over the sea, thus giving the cinema audiences a unique experience. This sort of realism is very impressive but, of course, it is also very expensive.

Another example of what lengths directors were going to in the 1960s to avoid optical effects took place during the making of *The Great Escape* (John Sturges) in 1963. An aeroplane, supposedly carrying two of the main characters in the picture, played by James Garner and Donald Pleasance, was to hit a tree and crash. The shot was filmed without any special effects; the pilot, an expert, brought the plane in low among the trees, caused the right wing to catch a branch and it crashed to the ground, right in front of the cameras. The pilot was uninjured and it was a perfect take.

For that sort of thing you need people willing to risk their necks for the sake of realism. This job usually falls to the professional stunt men, a hardy breed who are experts in their own right. One of Britain's top stunt men is Bob Simmons, responsible for many of the thrills in the James Bond pictures – the pictures that really began the current vogue for violent action on the screen. Stunt men and the special effects man usually work closely together on this type of picture, as the stunt man obviously likes to know that his life is in capable hands. This was the case on the Bond films which Simmons worked on with effects man John Stears.

When Johnny blows you up for a scene, you are actually catapulted several feet into the air, but he will never allow anyone to do a stunt unless he has checked it first to make sure it's safe. He will load the explosives pan and detonate it while

we both watch. Then we work out how close I can get to it, and what the safety margin is if I am right on top of it. He prepares his explosions beautifully, the most you would get is a flash burn – provided, of course, you wear the correct protective clothing.[33]

Simmons thinks his most dangerous stunt was one he did during the making of *Thunderball* (Terence Young, 1965).

I had to drive a car that was hit by rockets fired from a motorcycle travelling behind it. I had to control the car from the floor, out of view of the cameras. The rockets hit the car fair and square, but they sliced through the thick armour-plating Johnny and I had fixed up. That really was a near thing. I drove faster than I had intended and managed to throw myself clear seconds before the car somersaulted four feet into the air. That time I really thought I'd bought it![34]

Stears salvaged the car, straightened it out and the scene was shot again, this time without anything going wrong. Stears, incidentally, won an Academy Award for his effects on this film.

Like all stunt men Simmons plans all his stunts carefully beforehand to minimize the danger as much as possible but on at least one occasion he was unable to do this. In *Dr No* (Terence Young, 1962) the script called for a spider to walk over Bond's body. A specimen was hired from the London Zoo and in some of the shots that featured the star, Sean Connery, the spider was filmed walking on a pane of glass with the actor safely on

(Right) Sean Connery as James Bond gives stunt man Bob Simmons an unforgettable send-off in a scene from Dr No

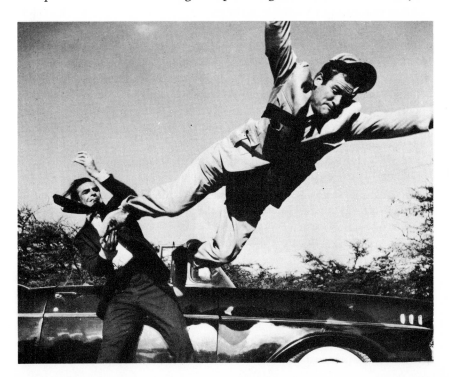

the other side of it. But for several close-ups it was necessary to show the spider in actual contact with someone's skin, and this was where Simmons came in. It was hoped to remove the spider's poison before shooting began but it was discovered too late that this was not possible. So Simmons agreed to let it walk on him, poison and all. As a sting from the creature could have resulted in permanent paralysis a medical crew were kept standing by in case anything should go wrong, but the scene was shot without any mishap.

Stears called me a bloody fool for doing it [said Simmons]. Some time later I was working with Bob Hope on a film and he wanted me to stage the same gag. But I managed to get a harmless bird-eating spider and used that.[35]

One of America's well-known stunt men is Yakima Canutt. Canutt was a rodeo champion before he went to Hollywood in 1920 to work as an actor. He turned to stunting when he discovered that his voice was not right for talkies. During the 1930s and 1940s he doubled for a lot of the top western stars whenever the script called for them to perform some riding stunt that would alarm their insurance companies. One of Canutt's most famous stunts takes place in John Ford's classic *Stagecoach* (1939) when the John Wayne character leaps between the two rows of horses pulling the out-of-control stagecoach. In his later years Canutt also made a name for himself as a second unit director, handling the action sequences in epics like *El Cid* (Anthony Mann, 1961), *Spartacus* (Stanley Kubrick, 1960) and *Ben-Hur* (William Wyler, 1958–9). The chariot race in the latter film contains some particularly impressive examples of his work. (Another second unit director, Andrew Marton, was also involved with the race.) The script required five of the chariots to collide and throw their drivers during the race, all of which demanded excellent driving and split-second timing. The chariots that were to crash and turn over had hydraulic brakes installed. The stunt men were able to flip the chariots suddenly by applying the brakes a split second before they released the horses from the chariots. Dynamite was used to disintegrate the wheels as the chariots collided into each other.

The wrecks and turnovers were real [said Canutt] but were so well prepared that not one horse was crippled [unlike the similar scene in the silent version of *Ben-Hur* which resulted in several horses being destroyed] and not one man was hurt, with the exception of my oldest son who cut his chin when he was tossed over the front of his chariot. He was patched up and back at work the next day.[36]

The incident Canutt refers to about his son's being tossed out of his chariot provides one of the most thrilling moments in the race. Canutt's son was doubling for Charlton Heston, who was playing Ben-Hur, and the script called for his team of four white horses to jump over the wreckage of another chariot. On the day of shooting this scene everything went as planned, the well-trained horses cleared the wreckage but

(Right) *Director William Wyler, not satisfied with Stephen Boyd's battered appearance in* Ben-Hur, *ordered make-up man Charles Parker to pour on 'more blood'*

Canutt's son was unexpectedly jolted into somersaulting over the front of the chariot. This scene was so impressive it was decided to leave it in the film and the script was altered to accommodate it.

Ben-Hur's chief rival in the race is the evil Messala, played by Stephen Boyd. Messala comes to a sticky end near the finish of the race, his chariot falls apart and he is dragged around the arena by his horses as well as being trampled on by all and sundry. Make-up expert Charles Parker said:

Stephen had to look mangled and beaten up. I made bits of flesh to hang from him, and with all his scars and cuts and chewed-up elbows and blood he looked quite horrible. But Willie Wyler, the director, was still not satisfied. 'More blood, more blood,' he demanded. 'Give *me* the bottle!' Then he threw more of it all over poor Boyd.[37]

Make-up men naturally play an important part in creating much of the graphic realism that is seen in films today. Canadian-born Charles Parker, former head of the make-up departments at Shepperton and MGM, has been responsible for a good deal of screen gore. One of the films he worked on in more recent years was Ken Russell's *The Devils* (1971). One of his tasks in that film was to turn the beautiful Vanessa Redgrave into a hunchback. He made her an entirely false back which she had to wear at all times.

Uncomfortable effects for
The Devils: *(left)* John
Richardson 'nailed' to the
cross that he and his father
constructed for Oliver Reed's
crucifixion scene; *(right)*
Vanessa Redgrave and hump,
amidst hysterical nuns

I was exhausted at the end of *The Devils*. Some of the make-up jobs were rather tricky. In the scene where the priest, Oliver Reed, is burnt at the stake I had to treat his hairless face and head in various stages, gradually, as the fire built up and licked around him . . . blisters appearing, one eye going and so on. And there was a torture sequence in the film, quite horrible. No, I wasn't particularly revolted by it. I view it objectively. I'm interested in the technique, the challenge.[38]

It was the effects veteran Danny Lee who handled the famous death scene in *Bonnie and Clyde* (Arthur Penn, 1968) which started a fashion for actors dying in slow motion while being riddled with bullets. These 'bullet hits' as they are called, are achieved with 'squibs', which are tiny, smokeless explosive charges mounted on thin, steel plates backed with foam rubber. The squibs can be detonated by small batteries strapped to the actors, or by being wired to a control board or even by radio control. For her death scene in *Bonnie and Clyde*, Faye Dunaway had scores of these squib devices wired to her clothes and to her skin. Lee arranged them in connecting sequences, then detonated them by running a line from a battery across a 'nailboard' of pins connected to the explosives. The sequence as it appears on the screen was composed of a number of takes, in each one a series of squibs were detonated, on Miss Dunaway and also on the car which had holes pre-punched into its body that were

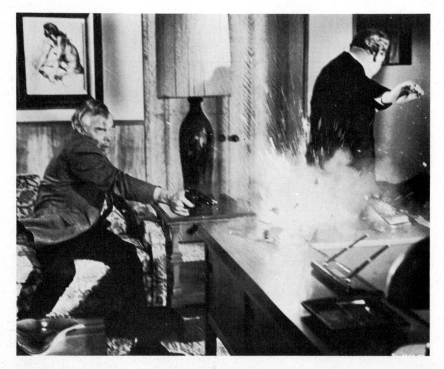

(Left) *Explosive squibs embedded in the desk top explode on cue for Lee Marvin in* Point Blank

plugged up and painted over, then there was a pause while Lee prepared the next series of explosions. The scenes were filmed at high speed which produced the slow, dream-like movements.

Sam Peckinpah's *The Wild Bunch* (1969) also made use of slow-motion deaths but added a large amount of blood to the proceedings. To the squibs, effects man on the picture, Bud Hulburd, attached small latex 'blood bags' which were filled with a bright red, gelatin-based fluid. When the squib is detonated the bag is punctured and the blood spurts out.

Violence was carried a step further in Ralph Nelson's *Soldier Blue* (1970) which showed people being shot in the face, a woman decapitated and several children displaying bloody stumps after their limbs had been hacked off. Bullet hits in the face, most special effects men will admit, are rather difficult. They can be achieved by several methods. One consists of firing gelatin capsules containing red liquid out of an air gun – the capsule, moving too fast to be visible on screen, hits the actor and bursts open. Another way is to fire, also from a compressed air rifle, wads of cotton wool soaked in simulated blood. The most complicated, and dangerous, method is to build a section of false flesh onto the actor's face under which is placed the squib together with the fake 'gore'. The scene in *Soldier Blue* where the Indian woman is beheaded by the soldier on horseback was done by using a dummy and also by some skilful editing. The film was cut just at the point when the cavalryman, wielding a sabre, approaches the running woman. The scene was set up again but this time, instead of the woman, a dummy was used which had a detachable head, complete with its own supply of blood. Spliced together the two scenes produce, as anyone who has seen the film will remember, a startling effect. As for the Indian children with missing limbs, they were real cripples who had had their stumps 'dressed up' by the make-up man. This is a common device, and sometimes false limbs, cast in rubber, are attached to people with an arm or leg missing so that they can be realistically removed on screen.

Mike Nicholl's *Catch 22* (1970) also served to push the frontier of graphic screen gore still further. During the course of the film one man is cut in half by a low flying aircraft and another's intestines fall out of his body. The former scene was arranged in a similar fashion to the beheading in *Soldier Blue*, a combination of clever cutting and the use of a dummy, but an added touch was to have a pair of very realistic legs, attached to the bottom half of a torso, slowly topple over after the impact of the aeroplane. The legs were real, of course, belonging to a man whose upper body had been matted out of the film. The scene with the 'open stomach' involved the unfortunate actor concerned sharing his costume with a great deal of animal offal.

A unique piece of cinematic butchery took place in *A Man Called Horse* (Elliot Silverstein, 1970) when star Richard Harris apparently had hooks thrust through his pectorals and was then suspended in the air by cords attached to these hooks. Actually he was wearing a false chest, designed and built by make-up expert John Chambers. It resembled real flesh because during the Second World War Chambers had learned techniques for creating, in plastic and rubber, artificial flesh to be used in the construction of noses, ears and so on for returning war veterans.

How do the effects men themselves react to all this gore? Les Bowie thinks there are limits to what should be shown on the screen but is not particularly worried by current trends.

'I always ask the directors, "What sort of horror do you want to see? Do you want to see a Ralph Nelson-Soldier Blue on this or do you want to see a Peckinpah?" And they'll say, "No, not so much a Peckinpah, more of a Soldier Blue." I'm always having to cut people's heads off, and having throat arteries belching blood all over the place.'

Cliff Richardson thinks that one should see what happens when a bullet hits somebody – 'That it should be shown realistically. But when, as in *The Wild Bunch*, a pint of blood appears to spurt out of a mere shoulder wound, I think it's getting rather ridiculous.' Recently, A. D. Flowers of 20th Century Fox had to fix a hose to pump three gallons of thick blood out of a man shot down in a street. 'I felt this was getting out of hand,' he said.[39] 'Geysers of blood is a thing that is cooling very fast,' said Fred Penedel of Warner Brothers. 'The women object to this sort of thing.'[40]

Although graphic violence really came in fashion during the 1960s, the depiction of violence in general has featured in pictures from the very beginning. Over the years a number of methods have been evolved for the purpose of showing people hit by arrows, knives or bullets. Before squibs came into use it was not uncommon for bullet hits on inanimate objects such as walls, trees, fences and so on, to be created by a marksman using a real gun. When an actor was shown being hit by a bullet he usually carried, if it was required to show any blood, a blood capsule in his hand which he pressed against his clothing. As a forerunner to squibs, ordinary detonator caps containing gunpowder were often used in the early days but these were rather dangerous and could result in burns. (Even squibs, which are really modified detonators, are not without their hazards. During the making of *Where Eagles Dare* (Brian Hutton, 1968), for example, one of the actors, portraying a high-ranking German army officer, received a serious eye injury when a squib was detonated on his chest.) Knives and arrows hitting people are achieved by a variety of ways, often being fired, by compressed air, along a thin wire which is attached to a stunt man wearing a cork-covered metal plate, under which

(Right) *A hollow spear travels along a wire to 'impale' Phillip Locke in this scene from* Thunderball

he is also well-padded. A less elaborate method involves having the knife or arrow held flat inside the actor's clothing and then being released by a spring mechanism, with the result that it appears as if the weapon has just landed in the victim. An even simpler method is to pan the camera very quickly as though it is following some object in flight, then to focus on the actor who has been previously rigged up with either an arrow or knife hilt protruding from his body.

There are also knives that telescope into themselves when pushed against anything, such as an actor's back, and other knives that have thin tubes running into the blade, which is usually made of resin coated with a metal finish, from which blood can be squirted. For minor cuts the blood is produced by squeezing the rubber handle which contains a small supply but if, for example, a throat-cutting is required it is necessary to pump the simulated blood through a tube that is hidden within the actor's clothing and which is connected to the knife. The results of this technique can be seen in *The Wild Bunch* when one of the characters has his throat cut by the vicious Mexican army general.

Close-ups of knives or spears actually entering someone's body, with the inevitable gory results, are sometimes achieved by quickly cutting to a dummy torso (or whatever). These are usually prepared in such a way as to bleed realistically when penetrated. The close-up is then

(Left) *Prelude to a throat-cutting in* The Wild Bunch

quickly followed by a medium shot of the actor, with the section of the spear, sword or stake firmly fitted into place, looking suitably impaled.

Fast cutting (*sic*) also plays an important part in scenes of beheading. The blade of the axe or sword is shown swishing towards the victim's neck and the following shot shows a dummy head flying through the air. (Gone are the days when the camera would tastefully avoid the execution block and point up at the sky instead.) The beheading of Macbeth in Roman Polanski's *Macbeth* (1971) is carried out in a more realistic fashion. For the final scenes actor John Finch was replaced by a young boy wearing a full-size suit of armour with an artificial neck and head (complete with blood supply) attached to the top of it. Macbeth was then decapitated in front of the camera in one continuous shot. When the dummy head had fallen to the bottom of the steps Polanski then cut to a shot of Finch's real head apparently lying in a pool of blood on the ground, but actually protruding through a hole. The whole sequence is extremely effective.

Oriental film fans have always liked to see plenty of blood and gore in their films (Hammer used to make special versions of their films for the Japanese markets) and a Hong Kong film producer called Run Run Shaw has devised the perfect formula to satisfy them. So successful has he been, in fact, that his product is now very popular in Western countries

(Right) *Director Michael Winner inspects Marlon Brando, who has been rigged up for his bizarre death scene in* The Nightcomers, *a film inspired by Henry James's story* The Turn of the Screw

such as the United States and Britain. His films consist basically of almost continual series of fights and battles, unhindered by either characterization or plot development. Filmed in 'Shawscope' with titles like *Fist of Fury* and *King Boxer*, the films offer non-stop action, the ultimate development of the trend begun by the James Bond films and the spaghetti Westerns, and are filled with hurtling bodies, flashing blades, decapitated heads, gouged eyeballs and much blood (though in Britain the censor has been limiting the excesses of the latter ingredient). But despite the gore the fighting is too stylised to be taken seriously (the fairytale settings add to this atmosphere of unreality). The various opponents make impossible leaps into the air and when they actually clash the sound effects make it sound as if two heavy wooden planks had been slammed together. Various camera tricks are utilized, such as high-speed shooting, and reverse printing as well as a great deal of fast, clever editing, but one cannot deny the sheer physical skill that is also involved in these intricately choreographed fight scenes.

Comedies were one of the few types of film made during the 1960s that still made use of the more traditional special effect skills, in particular the 'epic' comedies such as *Those Magnificent Men in Their Flying Machines, The Great Race* (Blake Edwards, 1965), *Monte Carlo or Bust* (Ken Annakin, 1969) and *It's a Mad, Mad, Mad, Mad World* (Stanley Kramer, 1963).

The latter film contained a quite lengthy sequence which made use of several miniatures, matte paintings, and stop-motion photography. Willis H. O'Brien himself was hired as a consultant and a director of animation but he died just as production was starting. Jim Danforth did most of the animation in the sequence which involved miniature figures, representing the main characters in the picture, clinging to a fire-escape ladder which has come loose from the side of an old building. The ladder begins to sway about and the figures are flung off it one by one. Three complete sets were made of the miniature figures, each set being built on a different scale – $\frac{1}{4}$ inch, 1 inch and 2 inches to the foot. Each set was filmed using a different camera technique. The $\frac{1}{4}$-inch scale was used for the extreme long shots, while the one-inch miniatures were filmed in stop motion and the two-inch scale figures were filmed at high speed for the shots of the characters falling off the ladder.

More than twenty-five matte paintings were executed for use in this sequence. The main ones covered the various angles of the building top, showing the surrounding city below. The most complicated matte painting composite was the extreme long shot of the building which required twenty-one separate exposures.

It's a Mad, Mad, Mad, Mad World also contained a great deal of ingenious mechanical effects, organized by Danny Lee. One of these was the specially constructed service station that comedian Jonathan Winters completely destroyed during one continuous take. And for the scene where the aeroplane crashed through the signboard, Lee and his men built an extra-fragile one made of balsa wood and styrofoam paper-backed board only three-sixteenths of an inch thick. The signboard was so flimsy that the slightest wind would topple it but this made it possible for the plane to fly straight through it without any damage. Another scene involved an aeroplane crashing through a restaurant window. Once it would have been the job of the miniature department but on this occasion a full-scale plane was used. The restaurant window was made of a special 'break-away' material and the plane was attached to a cable to prevent it from entering too far into the restaurant.

Lee and his team were proudest of a special car they built for use in the opening sequence where Jimmy Durante's car plunges out of control down a mountain road and off a cliff. The car contained a radio-controlled automatic pilot that was built out of electronic equipment acquired from the laboratories of the California Institute of Technology and also from nearby aerospace companies. For the shooting of the scene Lee stood on a hill a mile away from the car, controlling it with a radio-transmitting device.

The rear projection shots in the film were handled by Irmin Roberts and Farciot Edouart, the man who had played such an important part in

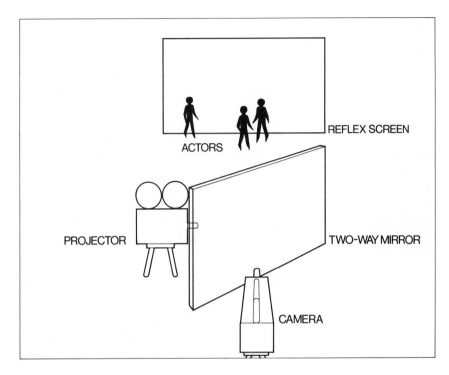

(Right) *The basics of front projection – the background image is bounced off a two-way mirror onto the reflex screen behind the actors. The camera films the scene through the two-way mirror*

developing the process over thirty years before.

Probably the most important new techniques incorporated into special effects during the 1960s was front projection. Front projection, as the name implies, is a system of projecting background scenery from the front, the exact reverse of the traditional rear projection process. The advantage of front projection is that the image is much stronger and sharper in comparison to a rear projected image.

Front projection is achieved with a projector facing a two-way mirror which is positioned at a forty-five-degree angle in front of a special reflective screen. The camera faces the screen directly behind the mirror which, being two-way, allows it to record the image on the screen. Actors standing in front of the screen do, of course, cast shadows onto it, but these are not picked up by the camera because the screen reflects the light back in a straight line to its source, the actor's bodies therefore mask exactly the area of their shadows. Obviously these unique reflecting qualities of the screen are what makes front projection possible. The secret is a special reflective material on the screens which consists of millions of tiny glass beads. Each bead acts as an optically perfect reflex reflector which reflects incoming light back in a straight line.

As with most cinematic techniques, front projection was developed by a number of people independently of one another. British effects man Tom

Howard recalls that a Frenchman first tried to patent the idea in 1942: 'The patent papers were published in 1942 but due to the war he couldn't patent the process in England and it became public domain.' It was not until the American 3M company developed their highly reflective material for use in road signs that the system became a much more feasible proposition. In 1949 the Motion Picture Research Council of Hollywood instigated research into the idea and published a description of the system in 1950. Working independently, science fiction writer Murray Leinster (real name Will F. Jenkins) designed a similar process and succeeded in having it patented in 1955. At the same time, in France, two inventors by the name of Alekan and Gerard, developed their own version of front projection which was patented in England in 1957. The patents of the latter system were later taken up by the Rank organization. But despite all this interest and activity in front projection it was not used in feature-film production until the late 1960s.

It was director Stanley Kubrick who first used the process in a major film – his science fiction epic *2001 : A Space Odyssey* (discussed at length in Chapter 9).

'This was the first time anyone had seriously taken it up for the movies,' said Tom Howard, who worked on *2001*. 'There had been the odd shot in a movie by pushing the projector literally up at right angles to a camera and interposing a mirror on a pedestal between them but nothing scientific. This we did with *2001*. We designed and patented a lot of new equipment, they were literally my patents but they had to be assigned to Metro. But it doesn't completely displace back projection. There is still a use for it. It depends on the requirements of a particular scene as to what process you use, unless you're trying to push a process that you developed yourself. Back projection is still best for doing backgrounds seen through car windows or trains, etc., while front projection is best for projecting massive backgrounds. In this *Young Winston* picture [Richard Attenborough, 1972] we photographed the central lobby of the Houses of Parliament and had 300 MP's milling around in front of what amounted to a ninety-foot screen.'

Since *2001* front projection has been used in a number of major films, such as *Tora! Tora! Tora!* (Richard Fleischer, 1970), *The Battle of Britain*, *On Her Majesty's Secret Service* (Peter Hunt, 1969), *Barbarella* (Roger Vadim, 1967) and *Silent Running* (Douglas Trumbull, 1972).

5/Disney's Live Cartoons

Though the Walt Disney studios are synonymous, in most people's minds, with animated cartoons they have also produced a large number of live-action films since the beginning of the 1950s. Most of these films have relied, to a large extent, on special effects for their appeal and these effects have been executed with just as much care and skill as Disney's animated product.

The man who has been most responsible for the high level of technical accomplishment in both Disney's special effects films and cartoons is the late Ub Iwerks. Iwerks had been associated with Disney from the very beginning. They had both worked together in the 1920s for a company based in Kansas City which produced primitive animated commercials. When Disney later moved to Hollywood and started making his own films which combined real people with cartoons (*Alice in Cartoonland* was the name of the series) he invited Iwerks to come and join him. Iwerks worked on the first Mickey Mouse cartoons and is credited with being the original designer of the famous character.

In the early 1930s Iwerks made the tactical error of leaving Disney and attempting to set himself up as a competitor. In this he was urged on by Disney's distributor at that time who provided Iwerks with capital. He made a series of cartoons based on a character called 'Flip the Frog' which were technically competent but failed to catch on in the same way that Disney's characters had. After a few years he was back working with Disney again though apparently he was never entirely forgiven for his act of desertion. Iwerks stayed with the Disney organization right up until his death in 1971.

Over the years Iwerks developed several animation techniques for Disney as well as the device known as the multi-plane camera. The multi-plane camera is used to create depth in cartoons by photographing through a series of animation cels (a cel is a square of transparent plastic/film on which the various elements of the animation are drawn and painted) that are spaced at different intervals in front of the camera. Objects that are supposed to be in the foreground are naturally on the

(Left) *Mary Poppins (Julie Andrews) and mechanical feathered friend*

cels nearest the camera while such elements of a scene as distant mountains are placed furthest away from the lens. The principle is straightforward enough but the actual building of a working model took years of development. Iwerks made the first version while working independently but it was not until he could make use of the better facilities at Disney's studios that he perfected the device.

The first multi-plane camera he built there consisted of an iron framework fourteen feet high with the camera on the top and pointing down through layers of cels set in grooved shelves. After that Iwerks was involved in the building of a horizontal one which allowed the camera to pan across the various layers of artwork as well as to appear to move through them (Willis H. O'Brien, the model animator – see page 151 – also developed a version of this device). The camera was put through its paces in a special short cartoon, released in 1937, called *The Old Mill*. The multi-plane effects were so successful that Disney won an Oscar for the cartoon and his studio won a special award for developing the device. Disney's first full-length cartoon, *Snow White* (1937), contained several multi-plane shots and they have featured in every full-length cartoon since then. One of the most spectacular occurs in an early scene in *Peter Pan* (1952) when there is a shot down through a layer of clouds to the city of London far below – the effect is almost like watching a 3-D film.

(Right) *An example of special effects being used for humorous purposes in* Son of Flubber

Iwerks later became very much involved with travelling matte processes and it was he who was instrumental in having the Disney studio adopt the British-developed sodium vapour travelling matte system. Since then the Disney technicians have achieved some incredibly good results with this particular process in films such as *Darby O'Gill and the Little People* (Robert Stevenson, 1958), *The Absent-Minded Professor* (Robert Stevenson, 1961), *Mary Poppins* (Robert Stevenson, 1964), which combined live actors with cartoon animation, and *Bedknobs and Broomsticks* (Robert Stevenson, 1971).

The head of Disney's special photographics effects department now is Eustace Lycett.

'I came to Disney's after graduation from college and have been here ever since,' said Lycett.

'I didn't really choose special effects as a profession; I was originally hired by the studio as a mechanical engineer and drifted into effects as the studio grew and developed. Now I am principally involved in photographic effects. My first credit was on *The Absent-Minded Professor* but I'd worked on many pictures before that. I didn't get a credit on any of them because I wasn't, at that time, head of a department and therefore didn't have full responsibility for the effects.'

In charge of the mechanical effects at the Disney studios now is Danny

Lee (of *Bonnie and Clyde* fame) who recently took over from Bob Mattey, the head of the department since the early 1950s.

Apart from their common high level of technical achievement the special effects films are similar to the Disney cartoons in other ways. Both types of production are originally laid using the storyboard method – a series of sketches or paintings that cover all the key scenes. In a sense, the Disney special effects films are actually cartoons that use live people. The storyboard system is ideal as far as organizing the effects are concerned but it is obviously artistically limiting in other areas. Angela Lansbury had the following to say about the making of a Disney film, *Bedknobs and Broomsticks*, that she starred in:

It's purely a matter of fitting in visually, in a jolly manner, into a sort of Disney groove. The shooting is literally done by numbers. That's the Disney system and it's terribly disconcerting. In fact, for an actress it's absolutely maddening. You never rehearsed. You simply got out there and said the lines and got off. And if it worked technically, it was printed. It's no way to get a performance but then they don't want a performance really. They want visually the right things, going through the motions that they've already plotted on the drawing board.[41]

Occasionally a Disney film manages to rise above this built-in handicap, such as *20,000 Leagues under the Sea* (Richard Fleischer, 1954) which was an excellent adventure film complemented by very good special effects. *Twenty Thousand Leagues*, it must be pointed out, was made before the Disney studio became so restricted in the type of story material it was willing to handle. It included a number of visual treats, such as the beautifully designed *Nautilus* submarine, surely one of the most fascinating miniatures ever to appear on the screen. Sinister when it makes its first appearance – eye-like portholes glowing eerily as it churns through the water towards its victim – it also manages to combine the impression of being ahead of its time as well as definitely belonging to the Victorian era.

The baroque interior of the *Nautilus* is also very impressive, in particular Captain Nemo's quarters which include a glittering organ that he plays whenever his submarine is about to ram another surface vessel. Art director John Meeham won an Oscar for his design of this submarine, as well as for the interior sets.

Also memorable is the giant squid that attacks the submarine at one point in the film and almost crushes Nemo (marvellously played by James Mason). The squid, with its huge, sucker-studded tentacles, great circular eyes and parrot-like beak, rates as the most effective of all movie monsters. A full-scale model, it weighed several tons and worked hydraulically, operated by a team of sixteen men. The man responsible for its construction was Bob Mattey and, not surprisingly, the picture also won an Oscar for its special effects.

(Right) 20,000 Leagues Under the Sea: *the* Nautilus *prepares to ram an unsuspecting vessel – both of which are models in a studio tank (above); a member of the Disney studio art department at work in front of a storyboard for the same film (below). (Overleaf) The attack of the giant squid – originally the filming of this sequence had been planned in daylight and on a calm sea, but it was decided that the action would be more effective if it took place at night during a storm, when any defect in the mechanical squid would be obscured*

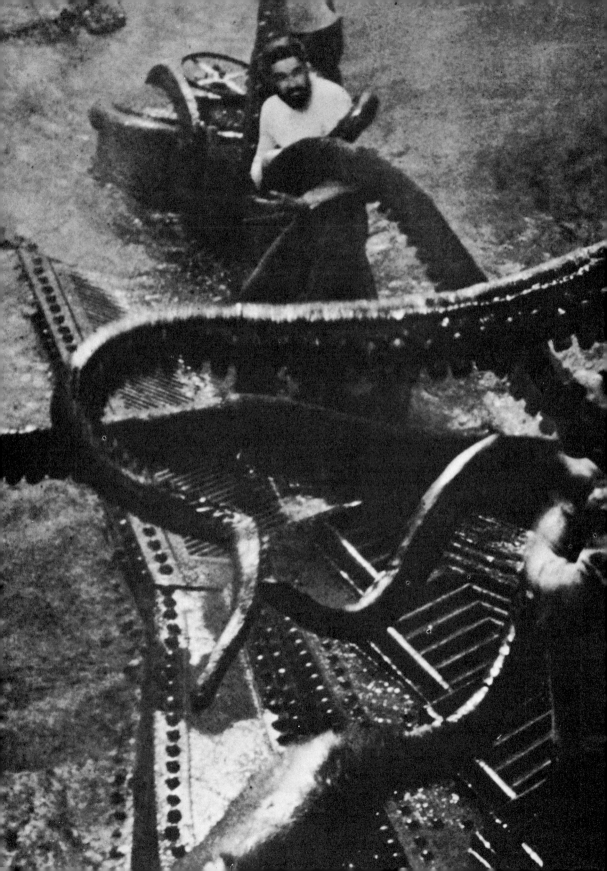

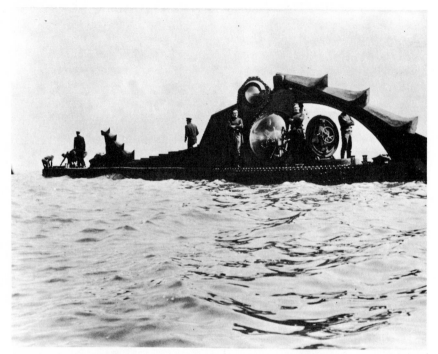

Further scenes from 20,000 Leagues Under the Sea*: (above left) a full-scale mock-up of the upper part of the* Nautilus*; (below) one of the several models of the* Nautilus *used in the film*

Other people on the effects team were John Hench, Joshua Meador, Peter Ellenshaw (chief matte artist at the studio for many years who later built up a reputation as a landscape artist and only works on the Disney films part-time now, usually in art direction), Ralph Hammeras, and Ub Iwerks who was credited for the special processes (travelling mattes in this case).

Unfortunately, *Twenty Thousand Leagues* was a rare exception among the Disney films. Although productions such as *Mary Poppins* and *Darby O'Gill* have a certain undeniable charm and are often technically breathtaking, their one-dimensional quality is a sign that they have fallen victim to the danger that is common to films that are special-effects orientated. When the effects are emphasized to the extent that other aspects of the production are neglected, the film suffers as a whole. This has occurred with many science fiction/fantasy films, as has been noted in other chapters. As fascinating as special effects are, they should never be incorporated into the making of a film for the sheer sake of using them. Cinematographer Lucien Ballard gave an example of this while describing the making of Disney's *The Parent Trap* (David Swift, 1961) to Leonard Maltin (*The Parent Trap* starred Hayley Mills playing a dual role as twin sisters):

It involved double exposure with the backgrounds and it was very complicated. Plus, when you were shooting, you could never tell the girl which light to look into or anything. I told them it was too complex and asked instead for a double. I found a girl who was the same height, had the same features, and at several figures away, you couldn't tell the difference between her and Hayley. So I did a lot of over-the-shoulder shots, and threw out most of the vapor shots; I think we only had two double-exposures in the film. But Walt made me put some of the trick stuff back in, because he liked technical things.[42]

6/War Films and Special Effects

Special effects of all types play an important part in most war films, especially in the large-scale productions such as *The Battle of Britain* and *Tora! Tora! Tora!* In fact, they are one of the few categories of film that still make use of a great deal of miniature work, which is really the essence of special effects.

During the Second World War there was naturally a big demand for films that dealt with the war, to which Hollywood responded with gusto. But as the armed forces could not afford to have either men or equipment tied up with mere film making, as they often do during peace-time, it was up to the special effects men to supply the spectacle. As a result, the special effects departments in the various studios flourished and expanded in a way similar to the time when sound had been intro-duced at the start of the previous decade.

Of course, an alternative to miniatures was to use newsreel footage, but this was only done on rare occasions as the film makers did not think that scenes of actual military conflict had sufficient dramatic quality – neither was it always possible to make them fit the script requirements. As Byron Haskin, supervisor of special effects at Warner Brothers during the 1940s (and later director of such films as *War of the Worlds* and *Robinson Crusoe on Mars* (1964)) said:

I am quite sure that the marines who actually defended Wake Island never saw as much of the Jap fleet which shelled them as Gordon Jennings' miniatures brought to the screen in the picture of that name. The miniature sequences in the film put over the dramatic import of the action in terms that the movie-goers could understand.

Such Warner Brothers productions as *Air Force* [Howard Hawks, 1943] and *Action in the North Atlantic* [Lloyd Bacon, 1943] depended upon special effects camerawork to the extent that they absolutely could not have been produced without it. In these pictures, as was the case in every studio with productions of a comparable nature, a very considerable proportion of the films' ultimate release footage was handled by the special effects personnel. In our case, this was immeasurably aided by the organizational set-up of the Warner Brothers' special effects department which, as laid out originally by Fred Jackman, and

since then continued and expanded, was virtually a studio within a studio. Almost every department of the studio had its counterpart in the special effects organization. We had our own designers, art directors, and set-building facilities; our own camera and electrical equipment, personnel and stage crews generally. The department also had its own film laboratory, cutting facilities, business office and even its own writers.

Most important, I believe, was the unit plan of organization under which the department operated. Instead of rigidly centralizing the entire department's output under a single head, the department under my general supervision was organized into units, each of which was under a capable special effects director like Jack Cosgrove who handled *Action in the North Atlantic*, Roy Davidson who had charge of *Air Force* and Lawrence Butler who was capable of handling all the varied special-effects work on a group of several productions.[43]

During the war money which would have normally been spent in other areas of production was instead channelled into special effects. One result was that the 'miniatures' became larger and larger, reaching a scale that would have been considered impossibly expensive before the war. According to Haskin it was necessary to build them as large as possible in order to fit in all the intricate mechanism needed for manoeuvring the ships, swivelling the turrets and firing the guns. They became so large that they outgrew the studio tank. For many of the scenes in *Air Force* and *Action in the North Atlantic* the miniatures were filmed in the

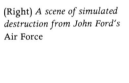

(Right) *A scene of simulated destruction from John Ford's* Air Force

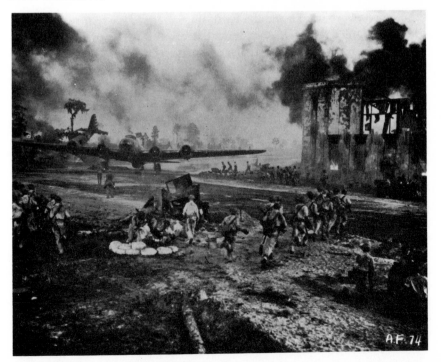

(Left) *Spectacular fire effects in a sequence from* Action in the North Atlantic

sea off Santa Barbara. The model battleships were so big that two of them completely filled a fifty-foot railroad flatcar en route to location.

The bigger the miniature the more realistic the effect, though it is possible to achieve spectacular results using much simpler methods. For instance, the miniature specialist at MGM, Maximilian Fabian, created the impressive fleet of motor boats for the Dunkirk sequence in *Mrs Miniver* (William Wyler, 1942) with mere cut-outs.

Years later, in an interview with Andrew Sarris, director Otto Preminger gave the impression that the idea of large miniatures was something that he had apparently thought up himself. Talking about his picture *In Harm's Way* (1964) he said:

I had originally hired a famous expert for these models. You know, they usually make them with ships about two to three feet long. When I saw the beginning of his work, which was also quite expensive, I threw the whole thing away because it didn't seem to be right. And then I proceeded to build ships. I did it myself after the picture was finished. I decided to direct myself without any specialists, and we built ships that were 35 to 55 feet long so that when we photographed them the detail was very much like on the big ships. And as a matter of fact, the Navy asked us, when the picture was finished, to give them the ships for their various exhibitions [that seems to be an occupational hazard with these type of films]. And we didn't shoot any of these miniatures in a tank. We shot the night

miniatures on a lake in Mexico, because we needed the straits with mountains in the background. We shot the day battles in the Gulf of Mexico. I needed a real horizon, you know, and I think that makes a lot of difference.[44]

It is very interesting to note that the person who is officially credited for the effects in *In Harm's Way* is none other than Lawrence W. Butler whom Haskin mentioned earlier as being part of his set-up at Warners during the Second World War, when all those giant miniatures were being used for the first time.

In Harm's Way is about the Japanese raid on Pearl Harbour, one of several films that have featured that historic attack, such as *From Here to Eternity* (Fred Zinneman, 1953). Probably the most spectacular of these is *Tora! Tora! Tora!* which cost $25 million to produce, $1¼ million of which was spent on the miniatures alone. In charge of them was L. B. Abbott, who began his career with the William Fox Company in 1926 as an assistant cameraman. In 1943 he was promoted to first cameraman and was assigned to the photographic effects department. He became the head of the department in 1957 and supervised the effects in all of 20th Century Fox's films up until his recent retirement. He also handled the effects in several of that studio's TV series, such as *Voyage to the Bottom of the Sea*. One of the last films he worked on was Irwin Allen's very successful *The Poseidon Adventure* (Ronald Neame, 1972) which features a number of spectacular effects.

For *Tora! Tora! Tora!* which won Abbott an Oscar, Fox's miniature department, under the guidance of Ivan Martin and Gael Brown, built models of nineteen Japanese ships and ten American ships, as well as the Battleship Row docks at Pearl Harbour and the surrounding land areas. Unfortunately, when it came to cutting the picture down to a reasonable length, many of the miniature scenes were omitted from the final version.

The Japanese models were built on a scale of ½ inch to the foot, and the American ships ¾ inch to the foot. The average length of the miniatures was forty feet. The American ships were built on a larger scale because they were to be shown blowing up and explosions can be made to look more believable if they are relatively large. The models were photographed at 20th Century Fox ranch in the Serson tank (originally built for the filming of *Cleopatra* (Joseph Mankiewicz, 1963)) which measures 360 feet square and has a backing 75 feet high.

To create the sequences in *Tora, Tora, Tora* [said Abbott], where the Japanese fleet is seen battling a violent storm on its way to Pearl Harbour, we used just about every fan we could get our hands on. These included six huge aircraft fans [five from MGM and one from 20th], four more truck-mounted fans that were almost as large, and about fifteen conventional fans from the studio strategically placed about the tank. We would get the fans positioned very carefully and then discover that, for some reason or other, there was a 'flat' spot

(Left) *Model ships under attack:* Action in the North Atlantic (above); In Harm's Way (below)

on the water. This would necessitate moving a fan to cover that particular area –
but the annoying part was that the area kept changing, depending upon what the
wind was doing normally.[45]

To create foam, which was needed in the storm sequences, it was
necessary to add detergent to the water in the tank. But this is always a
risky operation and great care must be taken. Too much detergent can
result in bubbles which, of course, destroy any illusion of reality.

The conventional way of propelling models through a tank is to attach
them to underwater cables. In the case of *Tora*, the individual models
were fitted with golf-cart engines which worked satisfactorily in some
scenes but were not suitable in the more violent storm sequences. The
engines lacked sufficient power to drive the models through the rough
water and the effects men had to resort once again to cables.

All the ship models were built by constructing plaster casts of the
hulls. As the hulls of both the Japanese and American ships turned out
to be similar only a few casts had to be made. These casts were used to
pour fireproof fibreglass moulds of the hulls. The superstructures were
built separately in order to give each ship its distinctive appearance. The
fire-proofing proved to be useful during the filming of the attack on
Battleship Row. Abbott and his team were able to blow up the ships, then
reset the movable superstructure parts and replace the destroyed ones,
repaint and re-shoot with little time loss.

An ingenious rig was used to lend the greatest possible realism to the
sequence in which the ship *Arizona* is shown being destroyed. When the
Arizona blew up the mast canted over to an angle of about forty degrees.
This fact is so well known to the American public that it was important
to show it happening just that way in the picture. The mast was built and
mounted on an axis within the hull. There was a trip system that could
release a hook electronically and a spring that would give momentum to
the mast and cause it to cant in the right direction. Abbott and his men
would blow up the model and if they needed another angle or decided
that they did not like the explosion, all they had to do was reset the mast
and then they were ready to begin again.

The model of the *Oklahoma* was mounted on a rig that could turn it
over a full 180 degrees. Since the depth of the tank was only four feet it
was not possible actually to capsize the model in a single shot. Instead
it was turned halfway over, at which point there was a cut to something
else, the superstructure was then removed and the shot was continued,
showing the ship turning bottom-side-up.

When filming miniatures at high speed there is a basic rule that links
the frame-per-second rate to the scale of the models. A model built to
the scale of $\frac{3}{4}$ inch to the foot is actually one-sixteenth of the normal size
and so the effects cameraman films it at four times the normal speed.

(Above) Tora! Tora! Tora!:
*a full-scale mock-up of a
battleship, built in Japan; the
mock-up as viewed from the
deck* (left)

However, the filming of miniature explosions demands higher speeds as otherwise they are over with so quickly they can hardly be seen. As the explosions were so important in *Tora* it was decided to use a special high-speed camera which could film as fast as fifteen times the normal speed. The camera was used to shoot all the miniature work in the picture, as well as the explosions, which accounts for the fact that these scenes appear to be more realistic than usual. Using the camera at top speed to film the blowing up of the *Arizona* Abbott discovered that instead of just getting one flash, he got the original flash followed by at least one or two more internal explosions within the primary flash. 'The super-fast frame rate amplifies the size and power of a small, fast explosion to the point where you feel, almost, that it is getting into the atomic bomb category,'[46] said Abbott.

Filming water explosions at high speeds is always a headache because it is impossible to homogenize water. As there were a number of scenes in *Tora* where torpedoes are shown hitting ships in Pearl Harbour, ingenious tricks had to be devised. The torpedoes were operated in the usual way. Each torpedo had an air hose and outlet to create the row of bubbles that mark its passage through the water, a cable to ride on, and a winch to pull it along. To create the spray from the explosions, buckets of gypsum were placed just below the surface of the water so that when the charges were fired the gypsum was sent into the air instead of the water. The danger with this device is that the high-speed camera cannot linger too long on the action as otherwise it will show the gypsum apparently suspended in mid-air.

As well as handling the miniature sequences, Abbott also supervised the travelling matte and front projection shots in *Tora*.

We used front projection quite extensively on this picture. For example, all of the Japanese air sequences in which you see the other planes involved with the foreground characters were done with front projection. The sequence in which Cornelia and her student get mixed up with the Japanese planes flying into Pearl Harbour was also front projection. That sequence particularly interested me, because the director said that he would like to see her plane advancing a little bit across the screen instead of remaining in the same area of frame.

Fortunately, when we built our front projection equipment at 20th Century, I had mounted the camera and projector on a 'table', so to speak, and this could be tilted or revolved, with the camera and projector moving together. You could, for example, create the illusion of an object rising into the bottom of the frame (as long as you had enough excess screen), simply by tipping the camera-projector combination downward. Obviously you could get a similar effect by panning – which is just what we did to make Cornelia's plane seem to be moving across the screen. We didn't have to move the plane itself at all, and the effect worked very well.[47]

In charge of the mechanical effects of *Tora* was A. D. Flowers. Flowers

started as a greenman* at MGM in the early 1940s and was later promoted to the property department. He decided to specialize in special effects, particularly explosives, and over the years has worked in such films as *Red Badge of Courage* (John Huston, 1951), *Battleground* (William Wellman, 1949), *Forbidden Planet* (Fred Mcleod Wilcox, 1956), *Bloody Mama* (Roger Corman, 1969), and *The Godfather* (Francis Ford Coppola, 1972). Flowers has also worked on a number of American TV series, such as *Gunsmoke* and *Combat*. Like L. B. Abbott, he also won an Oscar for his work on *Tora*.

One of Flowers's most complicated sequences in *Tora* was the occasion when Admiral Kinnel walks out of his house and looks towards Pearl Harbour soon after the attack is in full sway. Flowers's effects crew had to rig more than a hundred enormous smoke pots all over Pearl Harbour which sent clouds of smoke hundreds of feet into the air as well as obscuring modern landmarks. The amount of planning that went into this scene was monumental, especially as each pot had to be set off manually.

Explosives are always present in war films, whether the production is a big or a small one. Usually, when a structure of any kind has to be

*A 'greenman' arranges the vegetation used in simulated exterior scenes that are filmed on a sound stage.

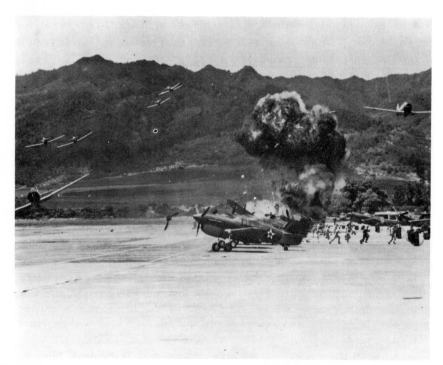

(Left) *Planes in the air and pre-set explosives on the ground create the illusion of an air attack in* Tora! Tora! Tora!

destroyed in these pictures it is customary to build a special 'break-away' set of some kind. Rarely is the effects man faced with the necessity of having to blow up a real building, although this is exactly what Cliff Richardson had to do during the making of *The Battle of Britain*. Moreover it was no ordinary building but a huge, solidly-built aircraft hangar.

'When we got the final "go-ahead" I felt confident that we had studied every angle of this operation,' said Richardson. 'Nothing was left to chance as a blunder could have endangered the lives of the artists and production crew as well as causing damage to nearby property.

'Inside the hangar we had the partition walls knocked down to weaken the structure and this virtually left the roof of the hangar supported on thirty brick piers which measured 4 feet by 2 feet at the base, 30 feet high tapering to 2 feet by 2 feet at the top. We figured that if the piers on one side were cut with explosive the weight of the falling roof would bring down the opposite side. This proved to be correct.

'One hundred and fifty shot holes were drilled into the piers ready to receive the cartridges of explosives which were all linked together with Cordtex detonating fuse. Cordtex has a velocity of 6,500 metres per second and acts as a detonator to each charged shot hole. This was to ensure that all the demolition charges would fire simultaneously. Two thousand sandbags were used to muffle the effect of the blast and to

(Right) *Fibreglass mock-ups of Spitfires are prepared for use in* The Battle of Britain

contain the flying debris into as small an area as possible.

'That took care of the actual collapsing of the structure, but the demolition of a building with high explosives is really not very exciting, visually speaking. Usually all one sees is a cloud of dust, so it was necessary to add a number of extra effects to make the shot visually spectacular.

'Two fougasse charges were utilized for this purpose. These are a type of improvised mortar, made in this case with fifty-gallon drums of petrol which can be used either horizontally or vertically to suit the particular situation. I used one vertically to give the fireball effect through the hangar roof from which an area of heavy asbestos sheeting had been removed and replaced with lightweight plastic, most of which was consumed by the fireball. The heavy asbestos could have created a danger by falling on any of the personnel involved.

'The hangar doors were taped with Cordtex and a mock-up Spitfire was suspended just inside. A horizontal fougasse was then positioned to produce the wall of fire which carried the Spitfire and the shattered doors across the roadway outside. This device had already been tested on the open airfield and it produced a solid wall of flame some 150 feet long and 50 feet high!'

So, altogether, sixty pounds of high explosive and a hundred gallons of petrol, together with flash charges to light up the interior of the hangar, and many days of planning were used to achieve a spectacular screen effect that only lasted a few seconds.

But blowing up that hangar was relatively easy compared to another assignment Richardson had on the same picture.

'Shortly after joining Spitfire Productions to work on *The Battle of Britain* I was shown a number of still photographs of a large warehouse at St Katherine's Dock. On these stills, the art director had painted in some fire effects which would have put Dante's Inferno to shame. "This is what we want," I was told. Considering that even cigarette smoking is forbidden on the docks, I thought this was some kind of joke and I replied that I could make a very realistic shot with a model of about one-sixth full-size which could be built on the studio lot. However I soon learned that this was no joke and the director, Guy Hamilton, looked upon this scene as the highlight of the Blitz sequence and wanted it "for real". So I had to start thinking about the many problems and how to overcome them, but time was on our side as the sequence wasn't scheduled to be filmed for several months.

'Numerous meetings were arranged between the executives of Spitfire Productions, the Port of London Authority and the London Fire Brigade. One big problem was the fact that the surrounding warehouses contained several million pounds of tea and there was a danger of the tea being

(Right) *In the background of this scene of destruction from* The Battle of Britain *are the remains of the giant hangar blown up by Cliff Richardson. Susannah York is in the foreground*

contaminated by smoke. The next step was to arrange a demonstration on the studio lot so that the representatives of the various authorities could see the type of equipment and material which I hoped to use for the actual job. A case of tea was tested in a smoke-filled building and afterwards tested by experts who appeared to be satisfied with their findings.

'My first visit to the warehouse at St Katherine's Dock was not encouraging. The building was an empty shell about 70 feet high and 150 feet along each wall. All the floors had collapsed from a previous fire leaving an enormous pile of combustible timber on the ground level, which, of course, greatly increased the fire hazard. Also, the dilapidated state of the building would make the rigging of our equipment a very dangerous operation for the technicians. On further examination I found that by keeping close to the walls, one had a narrow pathway of sorts on most of the floors sufficient to support the weight of one person at a time. The only really solid part of the building was a stone staircase with small landings on each floor. On these landings I decided to install our fuel pumps and containers and, to make doubly sure, I had the stairs and landings reinforced with tubular scaffolding together with a system of lighting. Lighting was in fact installed in all the dangerous spots where a technician could fall during the hours of darkness.

'An hydraulic "cherry picker" which would extend to sixty-five feet

was used to lift our equipment which then had to be manoeuvred with considerable difficulty through the window openings where one man inside made the pipe joints and fitted the gas burners. Fifty of these gas burners were used to give our flame effect from the window openings.

'Next, the oil-burning jets were positioned and metal trays were placed beneath to prevent any residue of volatile fuel from dripping onto the timbers below. Banks of sodium flares were placed wherever a convenient spot could be found and the surrounding timbers were protected with sheets of corrugated iron. The flares were to give the effect of incandescence inside the building which was a feature of all the big fires during the London Blitz.

'A tank containing one ton of liquid propane gas was positioned across the water on the other side of the dock to be well clear of any naked light and as an extra precaution the supply pipe from tank to warehouse was submerged in the dock.

'For the effect of bombs falling in the dock, I used five-pound charges of blasting explosive, half-pound cartridges being arranged on spreaders to give a greater area of water disturbance. The spreaders were anchored to concrete blocks and it was essential that they should not drift as the tugs and firefloats had to navigate a passage between them as they exploded. These charges each blow a ton of water into the air, and as it has to come down again, some of the spectators got terribly wet!

'Although I have wrecked four trains, blown up scores of aeroplanes, ships, tanks, motor cars and ammunition dumps, I still consider that the warehouse at St Katherine's Dock was one of the most difficult jobs I've ever been called upon to do, partly due to the problems of rigging and partly because of the fire hazard in the dock area. However it was nice to know that we had lots of water, in the Thames, only fifty yards away.'

7/The Model Animators

Model animation is one of the most specialized types of special effects and demands great skill and patience. The basic principle behind the animation of models is the same as that used to animate drawings for the making of cartoons. The model is put into the required position by the animator, a single frame of film is exposed then the model is adjusted slightly and another frame of film is exposed, and so on. When projected onto the screen the model appears to be moving of its own accord. This process is called 'stop-motion photography' and has been in use since the very early days of motion pictures. In 1897 Vitagraph produced a film entitled *Humpty Dumpty Circus* that featured animated wooded toy animals and in 1907 screen pioneer E. S. Porter spent twelve hours a day for a week animating seven small teddy bears. The finished film, called *The Teddy Bears*, was only ninety feet long but was a big success, especially with children. The most important model animator of all, however, was Willis H. O'Brien who changed the process from being a novelty for children into something approaching an art form.

O'Brien was born in 1886 in the town of Oakland, California. He began his career as a marble cutter but was also interested in sculpture and cartooning. One day, for his own amusement, he began experimenting with stop-motion photography and filmed two small clay boxers. Intrigued with the result he became more ambitious and produced a one-minute film of a caveman and a dinosaur. The choice of subject was significant as most of O'Brien's later projects were concerned with pre-historic creatures. The caveman and dinosaur were crude, having been constructed out of clay moulded around wooden frames, but one producer was sufficiently impressed to advance O'Brien $5,000 to make a more elaborate version of the same subject. It took two months to make and only ran five minutes on the screen but the Edison Company of New York bought it and released it in 1914. When the picture, called *The Dinosaur and the Missing Link*, proved a success O'Brien moved East and made a series of similar films for the Edison Company which were released under the name of Manikin Films. He made ten of these, each one costing about

$500 and having an average running time of five minutes. They were all Stone Age subjects of a humorous nature but only the title of one of them is known – *Rural Delivery, Million BC* – the films themselves having long since disappeared, unfortunately. His reputation boosted by these, O'Brien had sufficient backing to make, in 1919, a much more ambitious film called *The Ghost of Slumber Mountain* which cost $3,000 to film. The film is an important one especially since it was one of the first to feature both animated models and real people. O'Brien himself appeared in the film playing Mad Dick, the ghost of an old hermit. The clay models used in the film were better sculptured than in previous ones and O'Brien's animation techniques were improving and becoming more adventurous. *The Ghost of Slumber Mountain* was a big success and grossed $100,000.

In 1925 *The Lost World* was released by First National. Based on Sir Arthur Conan Doyle's novel, it concerned the adventures of a group of explorers on a remote plateau in South America where prehistoric animals still survived. At the climax of the picture an escaped brontosaurus, which the explorers had brought back to London with them, ravages the city and destroys London Bridge. A review of the film in the British *Kine Weekly* said that

The reproductions of animals are good, but, as is only expected, somewhat mechanical. There is hardly enough scope allowed for size comparisons except

(Left) *From Willis O'Brien's 1925 version of* The Lost World

in the London scenes. London Bridge appears very unfamiliar.[48]

It was O'Brien's most ambitious project and marked a great step forward in model-animation techniques. Instead of clay models, O'Brien used models made of rubber, a big advantage as these could be lit without fear of melting them, and also a more realistic appearance could be achieved. More than forty models, quite complicated in construction with articulated wooden frames and wire veins, were used for the making of the film. They were made to breathe by means of bladders inserted within them into which air was pumped in and out, carefully applied varnish made them appear to salivate and dark chocolate gave the effect of blood. An aerial brace was also used, consisting of fine wires, which enabled the animation of flying creatures such as pterodactyls, and also permitted other reptiles to be shown running or leaping.

O'Brien was assisted on the making of *The Lost World* by Marcel Delgado. Delgado did not exactly volunteer for the job – he was drafted.

After the family moved to Los Angeles [said Delgado] I worked as a grocery clerk in the daytime and got a job as a monitor at the Otis Art Institute, in order to pay my tuition. It was while I was doing this that Mr O'Brien came to Otis, presumably to study, but probably to find a helper; and when he asked me why I did not criticize his work, I told him that he should be criticizing my work instead. He was then starting work on *The Lost World* and he offered me the job with him several times, but I turned him down. Then he invited me to visit the studio, and when I did, he asked me how I liked *my* studio. It was all set up perfectly, so I couldn't very well refuse, and that was the start of my career in special effects.[49]

The Lost World was another success for O'Brien and he began making plans for his next big project, a film called *Creation* which was to show the beginning and development of life on Earth. O'Brien did a large amount of work on *Creation* and built several of the models that were to be used in it but for various reasons the picture was never completed. The models, and a few of the situations planned for *Creation* appeared in a later film released in 1933. The name of the picture was *King Kong*.

Merian C. Cooper, who produced and directed *King Kong* together with Ernest B. Schoedsack, originally planned to make a film using a live gorilla, about a giant ape rampaging through New York. Cooper, at the time, was one of America's top documentary makers and had become interested in gorillas while filming in Africa. In 1931 he was brought in to reorganize RKO studios, the company that had planned to produce *Creation*. Cooper was very impressed with the models and landscapes that O'Brien had constructed for the abandoned project and it occurred to him that he could film his giant ape, utilizing O'Brien's methods. He decided it would be cheaper than actually going on location and the risk of working with wild animals would be avoided.

Cooper then asked O'Brien to prepare a one-reel test showing the battle between King Kong and a dinosaur, as well as scenes of Kong shaking a tree trunk on the edge of a chasm which sends several sailors falling to their doom. The test met with the approval of the shareholders and Cooper was permitted to begin the production of the picture. *King Kong* took a year to film and cost $650,000, the majority of which was spent on the special effects – a record figure for those days.

King Kong tells the story of how a brash film director, Carl Denham (played by Robert Armstrong), attempts to make a film in an exotic location, in this case a remote place called Skull Island – a situation similar to Cooper's own original plan for filming *King Kong*. But things go wrong when the star of his film, Ann Darrow (played by Fay Wray – the girl with the golden lungs), is first kidnapped by a tribe of savages then sacrificed to their god, who is none other than King Kong himself. Kong obviously appreciates his gift and immediately heads for home with the girl firmly grasped in one huge hand.

He is hotly pursued by Denham, the ship's first mate (played by Bruce Cabot) and several sailors. The latter come to various sticky ends at the claws and teeth of the many prehistoric creatures that live on the island. Kong himself finishes off several of the men by tipping them off a log into a chasm (the sequence which was originally designed as part of the sample reel). Eventually the girl is rescued by the first mate and they escape from Kong's mountain lair by climbing down a length of vine – a marvellous scene that is made even more exciting when Kong starts reeling the vine in like a fishing line.

Kong pursues the two of them all the way back to the water's edge where he is gassed by Denham. The drugged ape is taken back to America (how it is not explained) but he escapes and goes on a rampage through New York. He even manages to recapture Fay Wray in an unforgettable scene when he reaches in through her window, then he climbs to the top of the Empire State Building where he snarls his defiance to the world. But his moment of glory is brief and he is soon riddled with bullets by a squadron of bi-planes. He manages to put the girl safely down before toppling off the building to his death.

King Kong is a true classic, a fairy tale personified, thrilling to watch even today. It has tremendous vitality, it moves at a great pace, and never before or since have special effects been blended with an exciting story so perfectly. Later pictures may have improved on the various techniques but the overall results have never surpassed *King Kong*. It is a picture that succeeds as a whole, not just in any one department.

The models in *King Kong* were the most sophisticated that had ever been built. During the planning stages O'Brien drew several sketches of Kong from which Marcel Delgado sculpted a dozen trial models of the

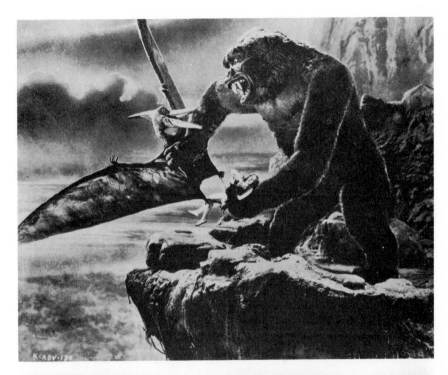

(Right) *Two publicity composites of scenes from* **King Kong**

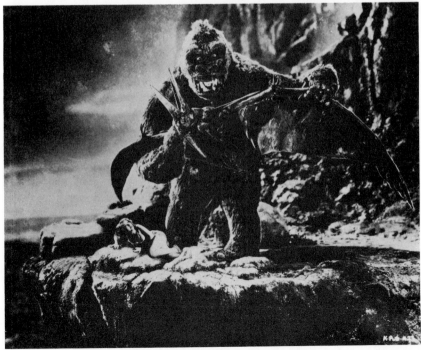

ape. According to Cooper, six eighteen-inch models of Kong were con-
structed so that two or three different sets of table-top work could be
filmed at the same time. The models in *Kong* were the first to utilize metal
armatures, with ball and socket joints, which allowed them to be moved
into various positions that were anatomically correct. Kong's flesh was
made of rubber and covered with rabbit's fur.

*(Right) The giant mechanical
bust of King Kong*

There were also several other full-scale sections of Kong that were
built, including a twenty-foot-high bust that included his head and
shoulders, which was covered in bear hides, and a mechanical hand that
was used for close-ups of Fay Wray in Kong's grasp and for the scene
where he reached for her through her apartment window. Fay Wray
described it as follows:

The hand and arm in which my close-up scenes were made were about eight feet
long. Inside the furry arm there was a steel bar and the whole contraption, with
me in the hand, could be raised and lowered like a crane. The fingers would be
pressed around my waist while I was in a standing position. I would then be
raised about ten feet into the air in the ape's hand but then his fingers would
gradually loosen and begin to open. My fear was real as I grabbed onto his wrist,
his thumb, wherever I could, to keep from slipping out of that paw! When I
could sense that the moment of minimum safety had arrived I would call implor-
ingly to the director and ask to be lowered to the floor. I would have a few
minutes rest, be re-secured in the paw and then the ordeal would begin all over
again – a kind of pleasurable ordeal.[50]

In another interview, on television, Miss Wray described how she had
become involved:

I knew two very fine producers – Merian C. Cooper and his partner Ernest B.
Schoedsack – and I admired the work that they had done. Mr Cooper said to me
that he'd had an idea for a film in mind. The only thing he'd tell me was that it
was going to have the 'tallest leading man in Hollywood'.. Well, naturally, I
thought of Clark Gable hopefully, and when the script came I was *absolutely
appalled*! I thought it was a practical joke. I really didn't have much appetite for
doing it, except that I did admire these two people . . . and I realized that it did
at least have scope . . . a good imagination. It has dimension above anything
else that has been tried in the film.

When asked about her famous screaming Miss Wray said:

Well, I just imagined I was miles from help and . . . well, you'd scream too if
you just imagined that situation with that monster up there. And when the
picture was finished, they took me into the sound room and then I screamed
some more for about five minutes – just steady screaming, and then they'd cut
that and add it in.[51]

Apart from the animation of models, *King Kong* also utilized practically
every other special effects technique known to the film industry at that
time, such as glass shots, travelling mattes, rear projection and optical
printing. Many of O'Brien's methods were kept secret during the making

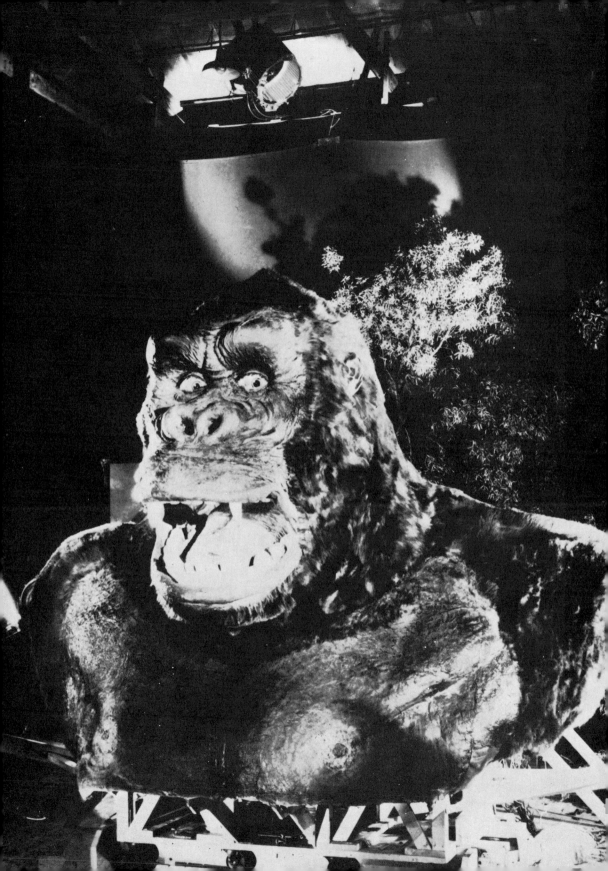

of *King Kong* for fear of imitation but they were basically the same ones he had used in earlier films, such as *The Lost World*, though improved upon and refined by the latest techniques in process photography. Merian C. Cooper later made the following comments about these techniques:

The first shot RKO ever made in rear process is in *Kong*. It's where Fay is on top of the tree and the allosaurus comes for her. That shot took us three days because none of us knew how to do it. We used the first miniature projection, which is the reverse of rear projection . . . we invented it for *King Kong*. I didn't patent it . . . I was a damn fool. Nobody patented it.[52]

With miniature projection the live action is projected onto the screen, which is just the opposite to most rear process work which usually involves live actors standing in front of projected scenery. In miniature screen work a scaled set containing the models is set up in front of the screen. Then a single frame of the live action is projected onto the screen while the models are photographed. The models are then adjusted, another frame of live action appears on the screen and the two are again photographed together. This procedure is repeated over and over again until the necessary combined footage has been achieved. One of the many examples of this in *King Kong* is the famous scene where the ape picks at the clothing of Fay Wray. Cooper describes how it was done:

(Below) *Another publicity composite from* King Kong, *the two components of which were matted with different scenes in the actual film*

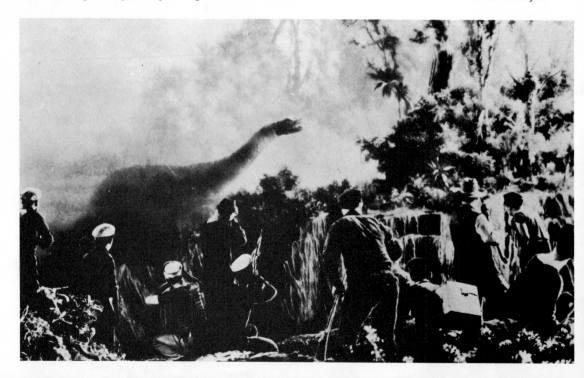

A movie was first taken of her alone while invisible wires pulled off her clothes. Then the miniature Kong was placed on a set built on a waist-high platform, about twice the size of a dining-room table, on which miniature trees, ferns, and plaster of paris rocks had been arranged. Back of this the movie of Fay Wray was projected and Kong's movements made to correspond with it.[53]

King Kong was such an obvious success that Schoedsack and O'Brien hurridly made *Son of Kong* the same year. Unfortunately the film had none of the grandeur of its predecessor, and the script, by Ruth Rose, was abysmal. Robert Armstrong, who played the hero in *King Kong*, returns to the island looking for a comparable attraction, apparently not having learned anything from his previous experience, and discovers 'Little Kong'. This baby Kong would have made his illustrious father roll over in his presumably giant grave – a mere twenty feet tall, he has the instincts of an amiable puppy. The effects were impressive but the overall result was disappointing.

During the 1930s O'Brien worked on other films for Merian C. Cooper, including *Deluge* (Felix Feist, 1933) and *The Last Days of Pompeii* (Ernest B. Schoedsack, 1935), but the effects in these films were rather conventional scenes of destruction though they were of O'Brien's usual high standard. It was not until the late thirties that work began on his next major animation project, a picture to be called *The War Eagle*.

The War Eagle was to have been a true epic on a scale even greater than *King Kong*. The story was to be about natives in a lost-world-type locale who rode on the backs of giant tame eagles. With these living warships the natives were able to subdue the other prehistoric creatures who shared their world with them. Becoming more ambitious, the natives, with their giant eagles, attack the outside world and the picture was to end with a climactic battle above New York, with civilization being saved when the giant birds are beaten off by a fleet of armed airships.

Whatever reservations one might have about the plot there is no denying that it would have made a fascinating spectacle. Unfortunately, Merian C. Cooper, who was to have produced it, entered the armed services in 1939 and the picture was postponed. Years later, when Cooper returned to the studio after the war, he decided that the dirigibles, which were to have played an important part in the picture, were too out of date and the whole project was abandoned. A good deal of work had already been done on the picture, including the sculpting of several models by Marcel Delgado, who had sculpted the models in *King Kong* and *Son of Kong*.

The war also caused the cancellation of another of O'Brien's projects – *Gwangi*, which he began in 1942, and which was to be about a group of cowboys who discover prehistoric monsters on a Texas mesa. The studio decided to make other films in its place that would not take as long to

produce. It was not until 1949 that O'Brien managed to make another
animation feature. This was *Mighty Joe Young* (Ernest B. Schoedsack),
also known as *Mr Joseph Young of Africa*, which, incidentally, was
designed by James Basevi and co-produced by John Ford.

(Above) *A publicity composite from* The Last Days of Pompeii, *on which Willis O'Brien again supervised the effects*

Some of O'Brien's *Gwangi* ideas appeared in this film although it was
necessary to contrive an unlikely plot which once again had Robert
Armstrong on the prowl for animal oddities, this time for his new night-
club 'The Golden Safari'. He is accompanied to Africa by several cowboys
who discover 'Joe Young', the twelve-foot-high gorilla pet of a girl, Terry
Moore. They try to lasso it but fail and Armstrong persuades the girl
to return to America with her pet and to exhibit it at his nightclub.

Dressed as an organ-grinder's monkey, the ape is forced to perform
tricks on the stage of 'The Golden Safari', held in check by the girl whose
singing of 'Beautiful Dreamer' is the only thing that keeps him happy.
Naturally things go wrong, Joe Young revolts and the club is wrecked,
but he later redeems himself by saving a number of children from a burn-
ing orphanage.

Mighty Joe Young was a major improvement on *Son of Kong* but did not
really compare with the original *King Kong*. The effects were as skilful as
always; it took O'Brien and a team of twenty-five assistants, including
Marcel Delgado who once again sculpted the models, three years to com-

plete the picture. Also working on the picture was Ray Harryhausen who later said,

'I did about eighty per cent of the animation. Most of Obie's [O'Brien's] time was, by necessity, consumed in planning and devising ways of doing the many complicated shots. He only had time to actually animate four or five scenes. He animated several shots of the nightclub and two or three of the roping scenes. The late Pete Peterson did the remaining scenes. The first scene I was assigned to do was the basement sequence where three drunks feed Joe many bottles of liquor.'

The years that followed were to prove disappointing for O'Brien and he was never again to know the satisfaction of making a film the way he wanted to. As well as *Gwangi* and *The War Eagle* his other most cherished projects, such as *El Toro Estrella*, which was to combine an animated dinosaur with a live bull and a young boy, were also abandoned. Not that O'Brien was idle during the 1950s; 1956 saw the part-realization of his original *Creation* idea in a semi-documentary produced by Irwin Allen called *The Animal World*. With Harryhausen, O'Brien handled the prehistoric scenes which naturally featured several of his beloved dinosaurs. O'Brien also wrote the original story for a picture called *The Beast of Hollow Mountain* (Edward Nassour and Ismael Rodriguez, 1956), although he was not too happy with the result. He handled the effects in the similar but much better picture called *The Black Scorpion* (Edward Ludwig, 1957) and in 1958 he supervised the animation in the British production of *Behemoth the Sea Monster* (Douglas Hickox and Eugene Lourie) which was an interesting example of its type although it obviously suffered from a tight budget. O'Brien was to start work on the animation of Stanley Kramer's epic comedy *It's a Mad, Mad, Mad, Mad World* when he died at the age of seventy-two on 10 November 1962.

The successor to O'Brien as the king of the model animators is Ray Harryhausen who not only worked with O'Brien on two of his films but has been making his own special brand of animation films since 1953. The first film in which he had control of the special effects was *The Beast from 20,000 Fathoms* (1953) which was directed and designed by Eugene Lourie (who later co-directed *Behemoth*). It is about a dinosaur who is brought back to life by an atomic explosion in the Arctic and returns to his ancient breeding grounds, now occupied by the City of New York. The picture is at its most impressive when Harryhausen's work dominates the screen, particularly at the climax when the creature is trapped in a burning amusement park.

It Came from beneath the Sea (Richard Gordon, 1955) was Harryhausen's next film which featured a giant octopus that attacks San Francisco. It was produced by Charles H. Schneer, the beginning of an association between him and Harryhausen that still continues today.

(Left) The Beast from 20,000 Fathoms

Schneer produced Harryhausen's third picture which was called *Earth versus the Flying Saucers* (Fred F. Sears, 1956), a science fiction thriller that included some of the most genuinely convincing alien invaders ever engineered for the screen. Harryhausen's effects are first-class, especially in the sequence when the flying saucers, menacing despite their bland appearance, launch an attack on Washington DC.

After this came *Twenty Million Miles to Earth* (Nathan Juran, 1957) in which a returning Venus spaceship crash-lands in the sea, casting up a jelly 'egg' that hatches out a strange reptilian creature. Only a few inches tall at first, the thing rapidly grows into a monster. Set in Italy, much use is made of Italian scenery and landmarks, especially when the creature invades Rome and makes its final stand on top of the Colosseum. The creature, which looks like a cross between a cat and a dinosaur, is one of Harryhausen's most fascinating creations.

Then came Harryhausen's most important picture, *The Seventh Voyage of Sinbad* (Nathan Juran, 1959), which was the first of this type of animation film to be made in Technicolor. It was a straight fairy tale filled with all manner of strange creatures including a pair of cyclops (one-eyed giants with the lower halves of their bodies resembling those of satyrs), an eerie snake woman and a living skeleton. The sequence involving the latter was so effectively staged that it was censored out of the film when

it went on British release. *Sinbad* was a tremendous success for Harryhausen and Schneer and is said to have grossed over $6 million.

After *Sinbad* came *The Three Worlds of Gulliver* (Jack Sher) in 1960 which is a spectacular and amusing picture but one that depends on contrasting sizes for its effect rather than animation. *Mysterious Island* (Cy Endfield), which followed in 1961, was much more interesting. Based on a Jules Verne story, it is a lively adventure featuring many unique animated creatures. Instead of dinosaurs one is faced with a giant young rooster, a giant crab, giant bees and a squid. For good measure, Captain Nemo and his *Nautilus* are also thrown in.

Jason and the Argonauts (Don Chaffey, 1963) is probably Harryhausen's best picture to date, a fine blend of colourful adventure and fantasy. This type of picture provides the perfect subjects for Harryhausen's unique talents and in *Jason* he succeeded in creating an atmosphere that successfully captured the magic of Greek mythology. One of the best examples of this is the sequence on the island when Jason and his men are attacked by a giant metal statue of Talos. The shots of Hercules, played by the late Nigel Green, and his young friend wandering among the towering statues are certainly impressive, but the scene where the statue of Talos suddenly turns its head, with a nerve-jangling creak of metal, and looks down at the two ant-like humans is one of the great

(Below) *Ray Harryhausen's giant octopus menaces San Francisco in* It Came from Beneath the Sea

(Left) *The evil harpies attack the blind soothsayer in* Jason and the Argonauts

moments of cinema. Of course, one must not overlook the contribution made to the eerie mood of these scenes by composer Bernard Herrmann's marvellous soundtrack. (Harryhausen deliberately made the statue of Talos move in a stiff, creaky manner, since it was supposed to be made of metal, he was therefore surprised at being criticized by some people who did not think the animation smooth enough.)

Also eerily effective were the scenes involving the blind man and his torturers – the two malignant-looking Harpies, half-human and half-bird. But the *coup de grâce* occurs in the climax of the picture when Jason and two companions sword-fight seven skeletons – one of the most complicated and difficult animation sequences of all time.

First Men in the Moon (Nathan Juran) which followed in 1964 was a watered-down version of H. G. Wells's classic novel and something of a disappointment. One cannot help feeling that it was not really an ideal choice for an animation film. Nevertheless, it does have its moments and the scenes with the moon creatures in their subterranean city manage to generate a true sense of wonder.

One Million Years BC was one of the few of Harryhausen's pictures that was not produced by Schneer. Instead it was produced by the British company, Hammer Films, famed for their low-budget horror films throughout the world. It was an unusually lavish production for Hammer as they

were celebrating their hundredth film. It was a remake of the 1940 Hal Roach version which, rather than using animation, had made do with photographically enlarged lizards plus a couple of mechanical models. In Hammer's version only one live lizard was used, the rest of the creatures were all animated. It is a mediocre film, even with the presence of Raquel Welch, and would not be of much interest if it was not for Harryhausen's contribution. His animation is as impressive as usual and in one sequence, where a young Tyrannosaurus Rex invades the seaside camp of a tribe of primitives, even excels itself.

1969 saw the release of *Valley of Gwangi* (James O'Connolly). Based on O'Brien's old project, it concerns a group of cowboys who penetrate a hidden valley in Mexico and discover that it is teeming with prehistoric life. After various adventures they return to the outside world taking with them a captured dinosaur. The inevitable occurs – they exhibit it; it escapes, goes on a rampage and is eventually destroyed. A very disappointing picture, the only touch of real originality it contains is in having the dinosaur cornered inside a church. Harryhausen's latest picture, *The Golden Voyage of Sinbad* (1973), marks, however, a definite return to his former high standards.

When asked how he became interested in special effects and model animation Harryhausen said:

'Of course *King Kong* stimulated my interest in photography and special effects. The film left such a strong impression on me I couldn't keep from going back to see it every time it was re-released. Before Kong I was interested in sculpture and paleontology. My hobby was, because of school projects, to build miniature dioramas depicting various phases of prehistoric life, similar to the ones you might see in a museum. I was also heavily influenced by the wonderful paintings of Charles R. Knight. His guides to the reconstruction of dinosaurs were considered the best. I've based most of my dinosaur restorations on his paintings, plus the actual skeletons themselves. But I think it was really the desire to see my clay models actually move that stimulated my interest in photography. I wasn't too interested in animation until I had seen *King Kong*.'

It was a thrilling moment for Harryhausen when he actually had the chance to work with O'Brien himself.

'Before I went into the army I worked for George Pal for about two years. This was about 1937 when he had first come to America. At that time he was making his *Puppetoons* for Paramount Pictures which were very stylized combinations of music and dimensional animation. We have always wanted to make a feature together but somehow our time schedules haven't worked out. Anyway, when I got out of the army O'Brien was just starting preparation work on *Mighty Joe Young*, with Merian C. Cooper. He saw and liked some of my sample footage on 16mm

film and I became his assistant. Most of my 16mm tests and scenes were from a project which I had abandoned several years before. I had also made several 16mm animated fairy tales which interested Mr O'Brien [these were released to schools in America where they are still shown]. 'It was a big moment for me, needless to say, when I worked with O'Brien. He had quite a lot of tragedy and disappointment in his life [apart from the fluctuations in his film career he had also suffered personally – in 1933, just before the release of *King Kong* his estranged wife shot and killed their two sons] but he was a very happy man and a very wonderful person. He had a great sense of humour. When I was in my teens he and his work were a great inspiration to me. It was certainly a fine experience to work with him and to know him.'

Harryhausen has his own explanation as to why so many of O'Brien's projects never saw completion.

'At that time I don't believe there was a very great interest in dimensional animated films. The success of *King Kong* did stimulate a certain amount of enthusiasm but little was known about the execution of the medium. I remember reading all sorts of misleading stories about a giant mechanical robot being constructed for the film. Then again, many of O'Brien's best ideas would require a substantial budget to carry them out properly. The major studios were really not equipped to produce his kind of film. It would have required a really interested independent producer.

'We design our films in a different way. And many times our stories are not as complex. In *Kong* and *Mighty Joe Young* most of the scenery was painted on large glasses. It was necessary to have a staff of excellent matte painters to keep these paintings progressively ready to shoot on and it became quite a costly proposition. You can get a wonderful mood with this effect but it's just too time-consuming. The alternative is to use real scenery and then matte the models into it.'

Harryhausen wanted to continue working with O'Brien after the completion of *Mighty Joe Young* but circumstances forced him to change his plans.

'We started a new film right after *Mighty Joe Young* with Jesse Lasky. O'Brien had written a story about a bull, a dinosaur and a boy [*El Toro Estrella*]. Lasky was interested in the project for Paramount Pictures but there was some difficulty in raising the finance and after many months of preparation and waiting it was finally called off. After that I went back to my fairy tales for a time. I think I had made two of them when I met a man who was very interested in animation and my experiments and he introduced me to a producer, Hal Chester, who wanted to make a picture about a monster from the sea . . . and that resulted in *The Beast from 20,000 Fathoms*. That was the first picture where I had sole charge of the

special effects.'

It was after the release of this film that Harryhausen began his long association with producer Charles H. Schneer.

'Our first picture together was *It Came from beneath the Sea*. After seeing *The Beast* Charles contacted me as he was interested in making something new and different from the normal type of adventure films. I was fortunate in becoming involved with a producer like him because he has such in interest in animation. Over the years we have had a very pleasant association.

'After *It Came from beneath the Sea* we did *Earth versus the Flying Saucers*. Flying saucers were a big news item at the time and Charles wanted to make a science-fiction film about them. We devised a story in collaboration with Curt Siodmak who also wrote the script. I found the subject matter rather a challenge as one is very limited with just a steel whirling top flying through the air. I thought it would be interesting to see just what kind of personality I could give an inanimate object by the use of dimensional animation.'

The destruction of Washington appeared very realistic in the film. Harryhausen explained why:

'Many shots were of the real buildings in Washington. We, of course, did have model duplications for the destruction sequences but our budget didn't permit high-speed shooting so the collapse of the buildings had to be animated frame by frame. That meant that each brick was suspended with invisible wires and had to change position with every frame of film. Dust and debris were added later. It was something I would never do again.

'*Twenty Million Miles to Earth* was based on a story outline idea I wrote a number of years before the picture was actually produced. I shelved it for a year or two then got together with my friend Charlott Knight who embellished it with stronger characterization. In designing it we used all the Roman ruins and monuments, including the real Colosseum. The creature was matted into the real scenes. The story in its original form was quite involved with mythology, particularly Norse mythology. We originally called the creature, which I designed, an *Ymir*, but as the story went through the many changes that they usually do, we decided to drop the name. In designing it, I tried to keep it close to a humanoid form combined with a dinosaur.

'*The Seventh Voyage of Sinbad* was our most successful picture. It was one of the first of this type of picture to be done in colour and required a great deal of experimentation while filming. The picture was unique, as in the past dimensional animation had mostly been used for dinosaur subjects.'

For this film Harryhausen coined the word 'dynamation' to describe

(Left) *Animated elephant confronts animated monster in* Twenty Million Miles to Earth. *The running man in the foreground is also a model*

his process and to distinguish it from ordinary cartoon animation.

'Next came *Jason and the Argonauts* which was my ideal. I'd always wanted to do a Greek mythology picture. It was quite successful though its costs were higher than most of our pictures. I think it pleases me the most though of course one is never completely satisfied. *Sinbad* was the top grosser but *Jason*, I think, was the more complete film in the sense that it had a strong story which appealed to adults as well as to younger people. It kept quite close to the original Greek myth with the added quality of interesting entertainment.

'The skeleton sequence at the climax of *Jason* was one of our most complicated. It took four and a half months to film the animation alone. We photographed the live action in Italy almost a year before. The live action always has to be pretty well thought out ahead of time but we try and shoot it in such a way that we can modify it if necessary. Animating the seven skeletons was probably my most difficult assignment. When you think of it – seven skeletons, each one with five appendages plus synchronizing them all with three people. And all ten of them hacking away at each other with their swords! Sometimes I would only average thirteen or fourteen frames a day. The seven heads of the Hydra in the same film were rather difficult to control too. The phone would ring and I would return from answering it wondering if a particular head was

(Right) *The weird 'Ymir' creature that Harryhausen designed for* Twenty Million Miles to Earth

going up or down. Flying creatures also consume a lot of time because you have to suspend them with an elaborate arrangement of wires. I like to avoid them if I can but they always seem to come into our pictures. We had several of them in the one I'm finishing now, *The Golden Voyage of Sinbad*.

'With *Mysterious Island* we were presented with a script by Columbia Pictures. They had started the picture some years before and, of course, we rewrote the plot to incorporate dynamation subjects which I knew would be very well suited to that story. It was very successful.'

After that came *One Million Years BC*:

'Hammer had bought the rights from Hal Roach and they approached me to supervise the special effects. The Hammer executives and I worked pretty closely together on it. We tried to keep fairly near the original story line of the old 1940 version. Of course, in the earlier version they didn't use animation, they used lizards and for one sequence a man in a dinosaur suit. But it had some good things in it.'

The scenery and live action in *One Million BC* was shot in the Canary Islands. The animated creatures were matted in with the real scenery, unlike *King Kong* in which the dinosaurs were filmed on an animation table amongst fake miniature scenery and through a series of glass paintings. O'Brien used four or five glasses on a vertical plane to give his

(Left) *The cyclops menaces Sinbad (Kerwin Mathews) in* The Seventh Voyage of Sinbad

paintings depth. This device, which he first used in *The Lost World*, was a forerunner of the multi-plane camera developed by Ub Iwerks for Walt Disney. Harryhausen has only occasionally worked with complete table-top scenery.

'We did in *The Animal World*. It wasn't in any sense as elaborate as the table-top miniatures in the *The Lost World* or *Kong*. It was very simple in comparison. We've developed quite a number of new, alternative techniques over the years due to economics.'

One such technique is combining miniatures and live action using a split screen, a technique which Harryhausen developed for *The Beast from 20,000 Fathoms*. It is a complicated system of mattes where the screen is split to combine a partial miniature plus the animated animal. It has variations depending on the scene – sometimes the miniature is in the foreground, at other times in the background. Others working in the field have since utilized this method but Harryhausen made use of it at least fifteen years before anyone else.

In *One Million BC*, which was supposedly a reconstruction of pre-historic times, primitive humans were shown living in a land where dinosaurs still existed. Did this obvious anachronism disturb Harryhausen?

'Not really. It has never been proved, actually. Every year there seems

to be new discoveries which push the existence of man further back in time. Besides, unless one is making a documentary film, there would be little drama in just watching battling prehistoric animals without the human element.

'*Valley of Gwangi* was one of O'Brien's projects which he started for RKO studios around 1942. After months and months of preparation the studio suddenly decided to make another film in its place. O'Brien made hundreds of drawings and paintings for the project but unfortunately most have been lost. When RKO went out of business they sold the rights of the script along with many other story ideas. Obie had given me a copy of the script and one day I found it while cleaning out my garage. I thought it might be worthwhile to try and revive it. So we sought out the owners of it, Charles Schneer and I, bought it and rewrote it. Our version didn't really bear much resemblance to the original. The main idea that interested me was the idea of cowboys roping a dinosaur. The tiny prehistoric horse that featured in the film was also part of the basic plot that O'Brien had devised years ago. It was more or less the springboard of the whole film.'

There's a sequence in *Gwangi*, when the dinosaur is being displayed in a circus, that contains an animated elephant. Is it more difficult to animate such a familiar creature?

(Below) *A scene from one of the most complicated animation sequences ever filmed (*Jason and the Argonauts*)*

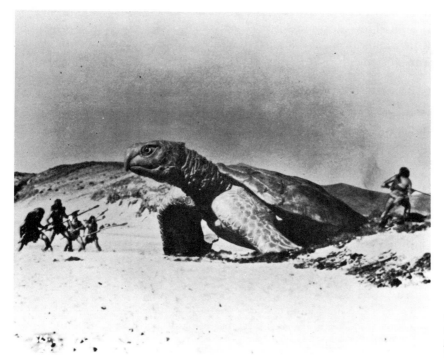

(Left) *A giant prehistoric turtle (animated) menaces a group of primitive humans in* One Million Years BC

'It is. One is criticized much more. For *Gwangi* we had originally ordered an eleven-foot-high elephant to do the tricks in the circus ring. Then the picture was postponed for two months and the circus went on tour and we lost our elephant. It's very difficult to find a very large elephant in Europe – we shot the picture in Spain – P. T. Barnum must have exaggerated the size of Jumbo. The elephant we finally received, after six months of waiting, was only about six foot high. This was, of course, impossible. This forced me to animate the remaining scenes when I would have preferred to use a real elephant like I did in *Twenty Million Miles to Earth*. But we had a similar problem in that picture because we could only find a nine-foot-high elephant and in order to make him look larger we had to get a very small man to put next to him. In one scene in that picture we showed the creature and the elephant *together* which wasn't easy because it's difficult to choreograph an elephant.

'I was involved with *Gwangi* for two years which was why I wasn't involved with any of Hammer dinosaur films that they produced after *One Million Years BC*. *Gwangi* wasn't as successful as I would have hoped. I think if the film had been released two or three years earlier it might have done far better, but as you know, it came out at a time when the permissive film was becoming the "in" thing. If you didn't have nudity in a picture nobody wanted to know. A naked dinosaur just wasn't

outrageous enough.

'After *Gwangi*, Charles and I started searching for new stories. A lot were submitted to us and we read a great deal of books that people thought might make interesting dynamation subjects but in the end I finally had to knuckle down and devise an outline myself. It is most difficult to find suitable material for the dynamation medium. Inasmuch as we deal mostly with visuals I made a series of large black and white drawings which visualized the high points of the idea. These were later developed into a script form and of course with many more ideas added. Most of my films are done that way; presented first on a story board. Obie used to work that way, that was how *Creation* and *Kong* were designed and I think it's the best method. In dealing with fantasy films I feel it is most important to start off with essentially a strong visual impression.'

Just how much control does Harryhausen have over his pictures?

'*Control* is not really the right word to use. A film is, of course, made by many people. It is a sort of mosaic art form. I would say I have a strong influence on the subject matter which we present. Film stories undergo many changes from rewrite to rewrite, for many reasons. There are many people to satisfy.'

Two aspects of these types of films often cause problems and these are the animation of human beings and the use of full-scale sections of the

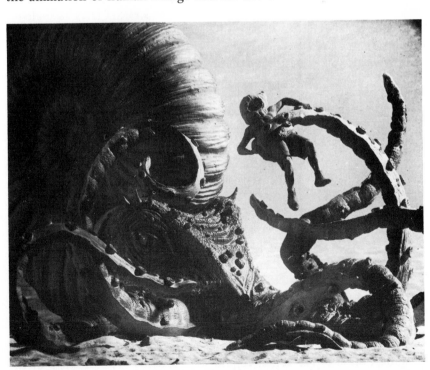

(Right) *One of the many exotic creatures that featured in* Mysterious Island

various creatures [such as the claw of the giant crab in *Mysterious Island*]. The difficulty of animating a human being is obvious but:

'. . . usually animated people are only ever shown in long shot, such as when they are snatched up by some flying creature. I animated a model of Raquel Welch for such a sequence in *One Million Years BC*. In *Mighty Joe Young* we animated a number of cowboys as well as some shots of the girl playing the piano in the nightclub though very few people realized it.'

As for full-scale mock-ups:

'I try to avoid them if I can because you have very little control over them unless you go into a very elaborate engineering job like they did with the bust of *King Kong*. Even that had its limitations and that was a very complicated piece of mechanism. The mouth could open and close and it was mainly used for close-ups of people struggling in Kong's jaws [most of these shots were later cut out but now there is a version of the picture available in which they have been replaced]. It was also used when Fay Wray first sees him through the trees and there's that big zoom-in on his face.'

Whatever happened to King Kong? The models of him, that is. At a cinema exhibition at the Round House in London a few years ago it was advertised that one of the Kong models would be on display.

'Actually', said Harryhausen, 'it was Mighty Joe Young. It was one of the models I had designed for the picture. It was rather tatty as someone had removed the fur. It was one of six models, four were about one foot high and the other two were slightly smaller. The actual models of King Kong were, I think, destroyed and converted to the Son of Kong. They were built on a much larger scale.' *Son of Kong* was, incidentally, a picture that greatly disappointed Harryhausen. 'It was a big let-down I thought. Then again, it would have been almost impossible to top *King Kong*.'

Apart from O'Brien, is there, or has there been, anyone else in his field who has impressed Harryhausen?

'There are several young fans of dimensional animation who have turned professional. Some of their work shows a lot of promise. The Japanese, of course, do their films in a different way. As far as I know they have seldom, if ever, used dimensional animation in their films. They usually use men in rubber suits shot with high-speed cameras. It is a quicker method which enables them to make so many films so quickly. But I think the final result is not as impressive.'

Unlike Disney's feature-length cartoons, which are almost always very successful and remain perennial favourites with people, Harryhausen's animation films have no guarantee of attracting such a large audience.

'Our medium requires a different type of story . . . you just can't compete with a cartoon. We've found in the past that this combination of animation and live action requires a specialist type of story in the

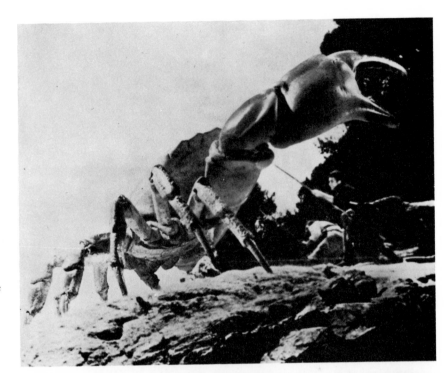

(Right) *Animated crab versus live actors in* Mysterious Island *(above); another shot from the same sequence (below), but this time the crab's claw is a full-scale mechanical model*

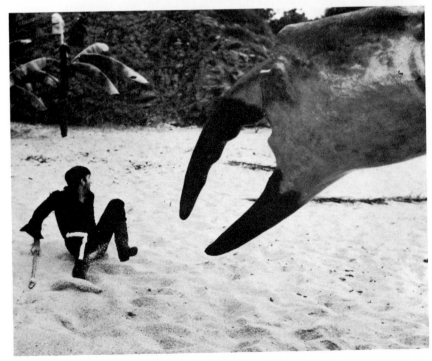

realm between science fiction and fantasy. Our first aim is entertainment. Our second aim is the production of exciting visual images and the stressing of the fantasy aspects. In the past, for instance, many Arabian nights films or mythological films only talked about the fantasy content but seldom showed it on the screen. As a result, many of the old Hollywood concepts ended up simply being treasure hunts, "girlie" shows, or cops and robbers in baggy pants. We try to put on the screen a more imaginative approach which many films only hint at. We *show* the fantastic instead of merely talking about it.'

(Right) *Ray Harryhausen pictured with part of his storyboard for* Mysterious Island

What, then, is the future for Harryhausen's type of picture?

'It is very hard to predict. Years ago, one used to be able to say that a picture that has this element or that element would have a fifty/fifty chance of being successful. But now, the craziest things seem to attract the public. People will pay a fantastic amount of money to see something that is terribly depressing, so everyone starts making super-depressing films and seldom anything else. There's no longer any dependable guideline. I think fantasy films will have a comeback because they're imaginative and adults like them as well as children. But everybody is so inundated with entertainment from the box. It used to be a big event to go to the cinema in my day. You couldn't wait until Saturday night to go and see a certain type of film that you were really into, but now people are terribly blasé about it. For me the cinema is essentially for entertainment, not for sending depressing messages. I can't imagine why people want to pay to look into a garbage can.'

When Harryhausen began his career there was no widespread interest in model animation but today the situation has changed. In America, and elsewhere, the profession has something of a cult-following which is large enough to support several specialized magazines. But model animation, as has been noted, is an extremely exacting technical operation and there are only a few with the necessary ability and dedication who succeed at becoming professionals – which is perhaps a good thing considering the limited amount of work available. Therefore the number of people who are professionally active in the field remains small and there is perhaps only one man who approaches the stature of Harryhausen, and that is Jim Danforth.

Like Harryhausen, Danforth was stimulated by *King Kong*, as well as Korda's *Thief of Bagdad*, and by the time he finished high school he had decided that he was going to make model animation his career. After leaving school he managed to get a job with a small film company called Clokey Productions. At the time he was eighteen years old. The following year he was involved with his first major special effects assignment when Clokey Productions were commissioned to animate a supposedly giant rabbit for a Dinah Shore TV Easter show. In between jobs at Clokey,

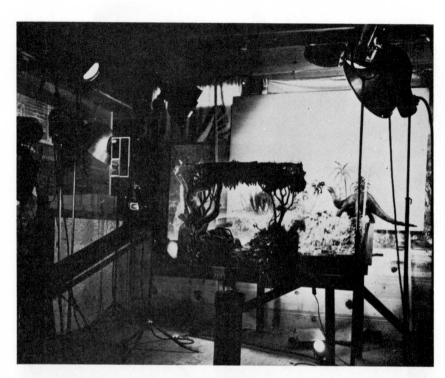

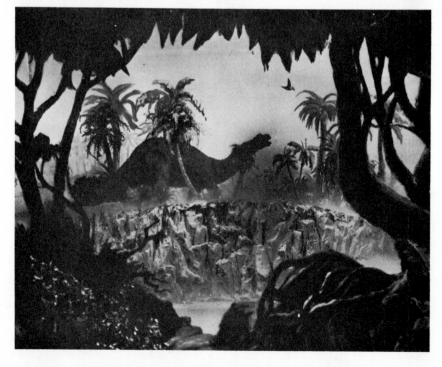

(Left) *A set-up used by Ray Harryhausen to produce a short animation test film during the late 1940s (note the glass painting in the foreground)* (above); *the same set-up as seen through the camera* (below)

Danforth also worked for Project Unlimited, the company formed by a group of special effects men, which was then handling the effects on Pal's *The Time Machine*. A year later Danforth joined Project as a full-time member. One of his first jobs was some miniature work on *Master of the World* (William Witney, 1961), a curious picture which contains some of the most glaring anachronisms in period detail ever seen on the screen. Soon after this Project Unlimited became involved with the making of *Jack the Giant Killer* (Nathan Juran), a major animation production which consumed the energies of most of their staff.

The story behind the making of *Jack the Giant Killer* is an interesting one. Apparently producer Edward Small turned down an opportunity to make *The Seventh Voyage of Sinbad* with Harryhausen, and when the picture turned out to be a huge success Small was naturally annoyed with himself. So he decided to make a picture that would be very similar to Sinbad in every way in the hope that it would prove to be equally successful. Though Harryhausen turned down an offer to handle the effects, Small gathered together many of the people who had worked on Sinbad, including the director, Nathan Juran, the leading man, Kerwin Mathews, and the villain, Torin Thatcher. But the film turned out to be a box office disaster and Small, according to Danforth, never wanted to hear the word 'animation' again.

Danforth, working with two other animators, was responsible for about half of the animation in the film, but had nothing to do with the design of the puppets which he thought looked terrible. 'And', he said, 'it's quite difficult to animate a puppet you don't find aesthetically pleasing. Especially when you have to look at it with intense concentration day after day.'[54]

The next film that Danforth worked on was Pal's *The Wonderful World of the Brothers Grimm* (Henry Levin, 1962), again for Project Unlimited, though he did not receive a credit on it. (Nor did he receive one for *Jack the Giant Killer*.) His work on *Grimm* mainly involved the animation of the dragon in the humorous sequence with Terry Thomas and also a few of the scenes in the elf sequence though most of that was done by Dave Pal, the son of George Pal. Danforth found working on *Grimm* particularly interesting because it was the first animation picture to be filmed for three-panel Cinerama. All the animation work was done on two specially constructed animation cameras which shot the frames in succession. 'A' panel was exposed, then the camera was moved to a click stop. 'B' panel was shot, then the camera was moved into a third position and 'C' panel was shot. Then it was racked back to the beginning again. In some cases six exposures were shot for one frame on the screen.

After that Danforth went to work for Film Effects of Hollywood on the making of *It's a Mad, Mad, Mad, Mad World* where he hoped to work

(Left) *Live actor versus animated replica in a scene, animated by Jim Danforth, from* The Seven Faces of Dr Lao

with Willis H. O'Brien, the man who had sparked off his interest in animation. Unfortunately O'Brien died just before Danforth was due to start work on the picture. His next film was another George Pal production, *The Seven Faces of Dr Lao* (George Pal, 1964). For his animation of a Loch Ness monster which grows from the size of a tadpole into a monster, and of other effects in the picture, Danforth was nominated for an Academy Award. (But the Oscar for special effects that year was won by Peter Ellenshaw for Disney's *Mary Poppins*.)

Various assignments followed *The Seven Faces of Dr Lao* including some work on the always interesting TV science fiction series *Outer Limits*. Then Project Unlimited were hired to do *Around the World under the Sea* (Andrew Marton, 1965), a film that failed to deliver the promise of its title. Working on this film was an unpleasant experience for Danforth whose ideas on how to manage the effects differed from those of his employers.

Shooting under water is very expensive, so I suggested that they simulate the underwater effect with drawings, as long as they couldn't afford to go first class. Well, I was voted down. They used a large wine vat about 28 feet in diameter and 10 feet deep which they set up on the parking lot. They tried to shoot in it, but they were continually plagued by problems. The vat was wood, and it was permeated with algae which started growing after a few days. So, one Friday,

they siphoned it off and put in clear, filtered water, but when we came back on Monday it was completely opaque again. They put in more chemicals and killed about four eels trying to make them work. They ended up stitching wires into the eels and puppeting them in the water like marionettes. The whole thing was ghastly. They wired the eels up to current to make them perform. They gave them a jolt and made them do things. The whole thing was making me sick.[55]

Despite these drastic measures they were still unable to get any suitable footage and eventually these scenes had to be filmed dry as Danforth had originally suggested. He painted a number of hazy scenes which were used as undersea backings and turned out to be quite effective. But after this Project Unlimited decided to disband and Danforth had to look elsewhere for employment. Fortunately he received an immediate offer from another company and spent the next three years working on animated TV commercials. Then came *When Dinosaurs Ruled the Earth* (Val Guest, 1971).

This picture was one of Hammer Films' sequels to *One Million Years BC*, but as Harryhausen was busy working on his *Gwangi* project the company had to find an alternative effects man. They chose Danforth. He spent almost seventeen months working on the animation, as well as five weeks on location in the Canary Islands and eight weeks doing the interiors at Shepperton Studios. This is a long time for the making of any film, especially a Hammer production, and by the time it was completed *Dinosaurs* had cost more than *One Million Years BC*.

Danforth was able to control more of the making of this picture than any previous one that he had worked on, but it was still nothing like the control that Harryhausen has over most of his films. For instance, Danforth had nothing to do with the script, that was written before he arrived in England, and though he designed the models the various types of animals that were to feature in the film were chosen by the Hammer executives. Danforth did, however, manage to cut out a lot of the animation sequences that Hammer wanted to do.

They had so many animation scenes planned that we'd still be working on it next year [said Danforth]. Just impossible. They wanted sea monsters fighting in the water to be picked up by a tornado and deposited on the beach. They scripted aerial shots of dinosaurs running across the plateau and scenes of pterodactyls blowing in the wind and crashing into the village. Just incredibly complicated things that couldn't have been done in the time and budget for that film.[56]

The film did finally go over its budget but as Danforth was never told what the limit was he does not consider himself responsible.

Dinosaurs did not contain any really elaborate set-ups along the lines of the skeleton sequence in Harryhausen's *Jason and the Argonauts*; there was to be a rather complicated sequence involving people and giant

ants but it was cut out of the film to save time and money even though the live action had already been filmed.

As far as *Dinosaurs* is concerned [said Danforth] we just did what rehearsal we needed at the time we were shooting the live actors. We used various devices, such as poles, to show the actor where the animal would be if he were in the scene. I try to explain each scene to the actors. You can, of course, just take the actor and say 'stand here, look ten feet in the air and turn and run on the cue,' and you'll get some sort of result. But it's much better if they know what the animal looks like, what the motivation of the shot is and what's going to happen.[57]

Mention animation to most people and they usually say something about it being jerky and unnatural. This jerkiness can occur in the most skilful of animation and is caused by 'strobing'. Strobing is when the eye tends to perceive individual poses *as* individual poses.

Smooth animation will strobe in certain cases because it doesn't have the blur that live action photography has because, of course, the model isn't actually moving during exposure time. I blurred the wings of the pterodactyl for about 80 per cent of the shots in *Dinosaurs* which I think makes the action more fluid. I didn't do much of this in the other sequences because it's very time consuming and more difficult with animals than with birds. If we could afford to do it in all scenes, animation would be a lot better than it is but it's economically impossible.[58]

Was Danforth influenced in any way by Ray Harryhausen in his work?

Though O'Brien's *King Kong* sparked my interest, I think that if it had been left only to the work that O'Brien did, I might not have carried on or might have only fooled with animation as a hobby. But seeing before me the fact that a man, in the current conditions, was doing work that was inspirational to me, and making a living at it, served as something to idolize and aim for. Ray was very kind in letting me come to the studio during the final stages of the effects work for *The Seventh Voyage of Sinbad* to talk to him and have a look round his shop. That was a big boost to me; it really helped me a lot. He was very, very influential in my going on and I learned a great deal from him, and I enjoy tremendously going on to see his films.[59]

Despite this Danforth has certain reservations about the way animation is used in Harryhausen's films.

I can remember – and this statement might be misconstrued – that when I heard that Ray was doing *The Seventh Voyage of Sinbad* I had mixed emotions. I knew that, as a fan of animation, I would enjoy it, but I also knew that it wasn't going to be the definitive Sinbad film. It would probably lack a lot of the elements inherent in the Sinbad stories which had, to some extent, been captured by the Fairbanks film, though it suffered from a lack of special effects. So I realized that it wasn't going to achieve a total blending . . . it would be an effects-oriented film rather than a people-oriented film, and I think that continues to be the problem. Of course I very much enjoyed the film but compared to Korda's

Thief of Bagdad it's a very pedestrian one. It would be nice, someday, for someone to make a really beautiful film using animation only where it needs to be instead of letting it rule the roost, the way it tends to in these films.[60]

8/The Science Fiction Films

In 1950 there began a boom in science fiction films, a medium that offers the special effects technician one of the best showcases for his talents. Science fiction films, like fantasies, and it is debatable whether or not there is a difference between the two, were rarely made in Hollywood during the 1930s and 1940s, apart from the horror/mad scientist type of film that Universal used to produce. But the latter half of the forties had brought about many changes in public thinking. The use of such weapons as the V2 rocket and the atom bomb in the latter stages of the Second World War had made acceptable to the average man concepts that had previously been confined to the minds of the science fiction writers. Also, by 1950, the Cold War was at its coldest and the world was having to live with the ever-present threat of atomic destruction. The deep, widespread feelings of insecurity this produced manifested themselves in many ways, such as the flying-saucer craze and the demand for science fiction films.

(Right) *The model spaceship used in* Destination Moon

Most of the science fiction films of the 1950s involved some sort of threat, either from outer space or as a result of an atomic explosion. But often the alien from 'out there' would visit Earth not as an enemy but on a mission of goodwill, which usually involved a warning about the use of atomic weapons. Strangely enough, the picture that actually started the boom belonged to neither category. Instead it was an unsensational, scientifically accurate (for the period), almost documentary-like description of a trip to the moon. It was called *Destination Moon* (Irving Pichel, 1950) and the man behind it was George Pal.

George Pal was born in 1908 in Cegland, Hungary. Always interested in art and design he was accepted, at the age of seventeen, by the Budapest Academy of Art where he intended to study architecture. But a clerical error put him on a fine arts course instead and by the time the mistake was discovered the young Mr Pal was well on the way to being trained as an artist/illustrator. Pal made the most of this fluke of fate and used it to fulfil one of his earliest ambitions: he learned the craft of cartooning. After leaving the Academy he began as an apprentice anima-

tor at the Hunnia Film Studio in Budapest. Also at the studio was a young man called John Halas who would later move to England and become famous, along with partner and wife Joy Batchelor, for animated films such as *Animal Farm* (1955). Dissatisfied with the wages and conditions at the Hunnia studio, Pal, in 1931, migrated to Germany and managed to get a job with the famous UFA studio in Berlin. He enjoyed his work there but after Hitler's rise to power he decided that perhaps Berlin was not the place to be if you were a Hungarian and so he moved to Paris in 1934. He arrived in Paris with plans for producing films that featured dolls animated by stop-motion photography. He interested a cigarette manufacturer in the idea who provided the finance for Pal to produce a short advertising film (in primitive colour) showing an animated packet of cigarettes. Shortly after its release to European theatres Pal became famous and was soon deluged with work.

The best offer came from a Dutch advertising company which persuaded Pal to move to Holland and set up his own unit there. For the next four years he produced many of these prototype 'commercials' as well as several films that were strictly entertainment. Pal called his creations 'Puppetoons'. But once again Hitler caused Pal to make a drastic decision. In 1939 he abandoned his flourishing business and emigrated, with his wife and son, to New York.

George Pal had not been very long in New York before he was summoned to Hollywood by the president of Paramount Studios. Knowledge of his work, it seems, had preceded him to America and instead of being a sacrifice his decision to leave Holland turned out to be a boon to his career. Paramount signed Pal to produce a series of animated short films which they hoped would compete with the Disney type of cartoon. They provided the backing which enabled Pal to set up his own studio in Los Angeles which was called George Pal Productions. Soon Pal and his team, which consisted of about twenty artists and woodworkers, were producing the first of two series of films which were called *Puppetoons* and *Madcap Models*.

These films were usually about eight minutes long in running time, although it took the studio an average of forty-five days to produce each one. Every film required approximately 30,000 single-frame shots, and 9,000 hand-carved wooden figures. To make the wooden faces of the characters move on the screen it was necessary to carve at least twenty-four changes of expression for each second of action. The bodies of the puppets were also made of wood but the limbs consisted of multi-stranded wire which enabled them to be bent into any position. Wire pegs, placed in the puppets' feet and fitted into holes drilled into the floor of the set, provided upright support.

The subjects of the films varied, some were humorous, others were of

a more serious nature. An example of the latter type was *Tulips Shall Grow* (1942) which concerned a 'screwball army', made up of nuts and bolts, goose-stepping in an obvious parody of the Nazis. But by 1947 rising production costs had made the *Puppetoons* too expensive to produce and Pal began to explore other areas of film production. The first result of this was a film called *The Great Rupert* (Irving Pichel, 1949). Basically a live-action film starring Jimmy Durante, it featured a realistic-looking animated squirrel, the Rupert of the title. So realistic was Rupert that many people who saw the film thought that he was a real live, well-trained squirrel. The film, an unpretentious comedy aimed at the family market, was a moderate success and the company that had produced it, Eagle Lion Films, provided Pal with the backing for a more ambitious project, his first science fiction film, *Destination Moon*.

Destination Moon was based on a book called *Rocketship Galileo* written by one of the most famous of science fiction writers, Robert Heinlein. Heinlein himself was invited to act as a technical adviser on the film, along with rocket expert Hermann Oberth who had worked on Fritz Lang's 1928 space classic *Die Frau im Mond* (*Woman in the Moon*). Another expert involved with the picture was astronomical artist Chesley Bonestell. Unlike most of the space travel films that followed it in the 1950s, *Destination Moon* was as scientifically accurate as possible. In

(Right) The 1950 Hollywood version of the moon's surface, with light bulbs for stars from Destination Moon*)*

charge of mechanical effects was Lee Zavitz, and director of animation was John Abbott.

Visually, *Destination Moon* is very impressive, especially in the scenes that take place on the moon. Great care was taken in the construction of this set and the talents of Bonestell and art director Ernst Fegte were combined to produce a quite remarkable effect. First Bonestell selected a suitable crater to stage the action from a photograph of the moon's surface. It had to have a special shape and be in a certain position so that the camera would be able to show the Earth from the required angle. After selecting a crater called Harpalus, Bonestell proceeded to make a model of it on a table in plasticine. From this he did an oil painting, approximately twenty feet long by two feet high, in exact detail and showing the required perspective. The next step was a blow-up photograph of this painting from which the artists in the studio art department painted a scenic backing, twenty feet high, to go all around the sound stage. A floor was then constructed, the art director giving it the cracked appearance of a dried-up river bed which looked effective even though it has now been proved to have been a wrong guess. This 'moon surface' was curved up to bring the foreground of the scene into the correct perspective with the backing. Behind the first backdrop another one was erected, this time made out of black velvet and studded with car headlight bulbs to produce the effect of a dark sky with stars. Two thousand bulbs were used during the film, connected with 70,000 feet of wiring.

A major production problem was to try and recreate the airless conditions of the moon's surface within a sound stage. Dust and cigarette smoke would immediately destroy the illusion so every care had to be taken to ensure that these were not present at any time during filming. Smoking was banned on the set and high-speed blowers were in continual use to keep the air as clear as possible. It was also difficult to reproduce the harsh appearance that sunlight has in a vacuum. To achieve this it was necessary to use great banks of 'brutes', the largest type of arc light, putting as many as possible around and above the set. Even then the technical advisers were not completely satisfied with the result.

Heinlein had hoped that the actors would wear real pressure suits during filming which, apart from adding to the authenticity of the scenes, would have kept them relatively cool under the hot lights. But this proved to be unfeasible as the piano wire, necessary for the weightless effects, had to penetrate the suits so that it could be attached to the special harnesses that the men wore. As a pressure suit full of holes is impossible, an alternative had to be used. This turned out to be studio-built suits with lamb's wool padding to give an inflated appearance.

'A situation', according to Heinlein, 'roughly equivalent to doing heavy work at noon in desert summer, in a fur coat while wearing a bucket over your head.'[61]

A dramatic moment in the picture occurs when one of the crew members drifts helplessly away from the space ship during the voyage through space. He is rescued by another crew member who uses a bottle of compressed oxygen to propel himself and his companion back to the ship. Filming these scenes naturally presented enormous difficulties to Lee Zavitz and his men. To show four men drifting beside the rocket-ship out in space, plus the various pieces of equipment they were handling, required a great number of wires and safety lines. In some scenes thirty-six wires were used as well as dozens of safety lines, none of which could be allowed to be picked up by the camera. One special effects man spent most of his time painting the wires with a sponge stuck on the end of a long pole to prevent them from becoming shiny. If, while viewing the rushes the following day it was discovered that any of the wires could be seen, the scenes had to be redone.

Once again the actors had a hard time of it, often suspended for up to two hours on their wires just to get two seconds of completed film. Each man was attached to an overhead travelling crane and was guided by several men who acted as 'puppeteers', manipulating giant cradles of the type used to control marionettes, only these were made out of heavy welded pipe frames. Underneath them was a safety net – just in case.

The oxygen bottle, the 'star' of this sequence, was actually made out of balsa wood. Inside it was a small flask of carbon dioxide which was used to create the oxygen vapour effect, but even this caused problems. If the gas was used for more than a couple of seconds it formed snow-like particles which fell straight down and destroyed the illusion of a gravity-free environment.

Another big problem was caused by the design and construction of the control room. Heinlein insisted that it should be as realistic as possible but this meant difficulties for the cameraman who was restricted in camera set-ups. This was overcome by building the control room like a jigsaw puzzle so that every section of it could be removed when required so that the camera had access. Unlike the usual movie set, it had to be constructed out of steel, which made it extremely heavy and difficult to move around. This created further problems when it was discovered that the set would have to be tilted on its side to enable the crew members to appear to float horizontally, via the piano wires, for certain scenes. To do this Lee Zavitz and the art department had to design and build a special rig three storeys high to enable the control room set to be rotated. Carpenters built a platform around it and the camera was mounted on a giant boom, the latter being so impressive that

Cecil B. DeMille himself visited the studio to see it.

A full-scale rocket, 150 feet high, was used for the scenes prior to the take-off. It was taken in pieces to the Mojave desert and erected along with a gantry crane. But when the gantry is pulled away and the rocket lifts off to the moon the animation department has taken over. Not surprisingly, considering Pal's previous experience with three-dimensional animation, these scenes are extremely well executed. In fact, the five minutes of animation footage in the picture took longer to film than the eighty-five minutes of live action.

Perhaps the most unusual special effects trick in *Destination Moon* was used in showing the four spacemen suffering from the effects of rapid acceleration as their rocket takes off. To compress each actor's face the make-up man fitted them with a thin membrane which was glued to their skin. A series of levers behind each man enabled the membranes to be stretched when required, thus distorting their faces rather horrifically. To add to this acceleration effect, the couches in which the men lay contained large inflated bladders which would suddenly be deflated when the rockets were supposedly firing, creating the impression that the men were being pushed back into the cushions. Unfortunately, the air leaving the bladders produced a sound that one would not expect expect to hear in a spaceship. This meant extra dubbing of the soundtrack and even more expense.

Impressive as the effects may be, *Destination Moon* makes rather dull viewing nowadays. The direction and script are both somewhat bland, although perhaps the film as it stands is preferable to the alternative version planned at one point by the financial backers. According to Heinlein, certain people wanted to liven up the story by calling in the services of a musical-comedy writer.

For a time we had a version of the script which included dude ranches, cowboys, guitars and hillbilly songs on the moon . . . combined with pseudoscientific gimmicks that would have puzzled even Flash Gordon.[62]

But despite the fears of the backers the film was a great success when released in 1950, which encouraged Pal to begin immediately on another science fiction project, this time financed by Paramount Studios. *When Worlds Collide*, a science fiction novel written in the 1930s by Philip Wylie and Edwin Balmer, was bought by Paramount in 1934 as an ideal property for DeMille to film, but he turned it down in favour of *Cleopatra*. Pal, however, saw the possibilities in the idea and chose it as the basis of his next film. Pal's *When Worlds Collide* (Rudolph Mate, 1951) became a *tour de force* of special effects, which were handled by Paramount's top man at the time, Gordon Jennings. The picture cost $963,000 much of the money being spent on special effects.

The plot of *When Worlds Collide* concerns the destruction of the world

by a wandering star called Bellus and the escape of a group of people in a spaceship who manage to land on the Earth-like planet that orbits the star. The highlights in the special effects, and in the picture itself, occur with the construction and take-off of the space 'ark', and the various catastrophes that take place as Bellus nears Earth. The 'ark', unlike most rockets, leaves the ground by means of a long ramp that leads up the side of a mountain like a roller coaster – a miniature set, of course, but very impressive. Of the destruction scenes the most memorable is the one of New York being swamped by a tidal wave. For this, eight blocks of New York were painstakingly re-created in miniature within a Paramount sound stage, some of the buildings being as tall as six feet. Unfortunately, the picture was spoilt by its ending which showed the survivors walking out of the spaceship into a landscape, obviously consisting of painted backdrops, that resembles a Walt Disney cartoon. Nevertheless, the picture was another success for Pal and earned an Oscar for Jennings and his team.

Pal's next film, *War of the Worlds* (Byron Haskin, 1953), took special effects from mere star status and made them into a super star. This is demonstrated by the breakdown of the budget: $1,400,000 for the effects and $600,000 for the live action. Filming the effects took six months while only forty days were spent filming the actors.

The picture was based on H. G. Wells's classic novel about Martians landing in England and overrunning the country. Pal shifted the location from England to California and updated the story to the 1950s. Although he liked the original illustrations of the Martians' war machines – tower-like devices that marched about on three-stilt legs – he thought they should be more modern in appearance. So he decided upon pillars of electricity and requested Gordon Jennings to prepare a prototype of the model. Jennings and his men worked for a month before they had a working model to show him. They built three manta-ray-shaped machines, forty-two inches in diameter, out of copper so as to maintain the reddish colour always associated with Mars.

I wish we'd never seen the illustrations of the stilt-like legs at all! [said Pal]. We'd have saved a lot of grief. For the original plan was to use a high-voltage electrical discharge of some one million volts fed down the legs from wires suspended from an overhead rig on the sound stage. A high-velocity blower was used from behind to force the sparks down the legs. We made tests under controlled conditions on our special-effects stage and they were spectacular. I couldn't have been more delighted. But there was one problem. It would be too easy for the sparks to jump to damp dust, dirt, metal, or what have you. It could have killed someone, perhaps set the studio on fire. So we reluctantly gave up the idea although a great deal of hard work had already been done on them.[63]

A safer alternative was devised which involved the machines being

(Left) *The Martian war machines in George Pal's version of* War of the Worlds

apparently supported on semi-transparent beams of 'force'. These were superimposed onto the film later with an optical printer.

The models of the war machines were beautifully designed and look very effective in the picture, despite their lack of fiery legs. Unfortunately each machine was supported by fifteen wires and occasionally these can be seen on the screen. The wires were necessary, not only to support the models but also to feed electricity and electronic signals to control the snake-like appendage that contained the heat ray. The latter, designed by Jennings, consisted of a red plastic tip behind which was an incandescent bulb and a small fan. The fan, mounted in front of the globe, alternately blocked and passed light to the red tip as it spun. The result was an ominous, pulsating effect, which, when coupled with the ticking soundtrack, was quite chilling to behold. The spectacular fire rays that emanated from the machines were created with burning welding wire. As the wire melted, a blow torch set up behind blew the sparks out. All in all, these models were among the most original to appear in any film up to that date.

A similar amount of painstaking care was taken in the construction of a miniature section of Los Angeles for the film's climactic scenes. 'Miniatures are becoming a worse headache with each picture made. I've learned that even bobby-soxers can spot them in most films these

days,' said Pal at the time of the film's release. 'As a result we built miniatures more carefully than ever before. We strove for lifelike authenticity by making them larger.'[64] One of the buildings which was shown being destroyed by a war machine, the Los Angeles city hall, was eight feet tall. Jennings and his team blew it up with small charges of dynamite. Pal described some of the procedure involved in combining live action in the Los Angeles scenes with the special effects.

We photographed a street on our back lot and with this we matched four or five Ektachrome still shots of Bunker Hill in downtown Los Angeles. These were rephotographed on Technicolor film. A hand-painted matte, done on an eight by ten inch blow-up, then reduced to regulation 35mm film frame size, of the sky, background, flame effects and the Martian machines was then matched with the live action. This was accomplished in the optical department with large, expensive, custom-built optical printers under the direction of Paul Lerpae, a veteran in the business. Altogether, for *War of the Worlds*, the optical department matte painted between three thousand and four thousand celluloid frames for us. In one brief flash in the picture an army colonel was disintegrated by a Martian machine. It took exactly one hundred and forty-four mattes of his inked-in figure to accomplish this illusion.[65]

One of the many other spectacular sequences that the picture contains shows the attempt by the American army to stop the Martians by drop-

(Right) *Part of the model replica of Los Angeles used for the destruction scenes in* War of the Worlds

ping an atomic bomb on them. The bomb is exploded but after the smoke clears the war machines are shown to be untouched, secure within their force fields. For this effect, Jennings and his team came up with a clear plastic bubble five feet in diameter. The machines were first photographed alone on the set then the bubble was photographed and later superimposed over the machines with an optical printer. The result was an indistinct 'shell' that seemed to flicker around the machines. The atomic explosion itself was achieved inside the studio by Paramount explosive expert Walter Hoffman (eighty-one years old at the time). He created the mushroom cloud by exploding a drum full of coloured powders. On the second attempt the cloud reached a height of seventy-five feet within the sound stage.

The art directors on the film were Hal Pereira and Albert Nozaki. It was the latter who designed the Martian creature which makes a brief but effective appearance in one sequence where the hero and heroine are trapped in the ruins of a house. The creature was shaped like a humanoid octopus with a bulbous head, and long arms that ended with three suction-capped fingers. In the middle of the head was a single giant eye. Charles Gemora, a sculptor, was hired to build the creature. He constructed it out of papiermâché and rubber and painted it a brilliant red. Apparently, while Gemora was showing the finished costume to Pal in his office, the creature fell on the surprised sculptor, knocking him to the floor. Pal was so amused he gave the sculptor the job of wearing the costume in the film.

The hand and part of the arm of one of the Martians is seen protruding from beneath one of the wrecked war machines during the film's closing scenes. In this case the realistic-looking limb, painfully crawling along a hatch-cover, was mechanically operated with air-filled rubber tubes under the 'skin' used to simulate pulsing arteries. The impact of this scene is unfortunately dissipated by the film's male lead, Gene Barry, when he takes the pulse of the Martian limb, after all signs of life have obviously left it, and solemnly announces that, 'It's dead!'

Once again George Pal had another big success on his hands, and once again the special effects team, headed by Jennings and consisting of Wallace Kelly, Paul Lerpae, Ivyl Burts, Jan Donela and Irmin Roberts, earned an Oscar for their work. The director, Byron Haskin, was also a special effects veteran, having once been in charge of the special effects department at Warner Brothers (see page 138). Haskin and Pal were to work with each other again in films like *The Naked Jungle*, *The Conquest of Space* (1955) and *The Power* (1967). It is interesting to note that in *Robinson Crusoe on Mars*, a film that Haskin directed in 1964, the flying saucers that menace the hero bear a remarkable resemblance to the Martian war machines.

(Right) *Byron Haskin directs Paul Mantee in a scene from* Robinson Crusoe on Mars

Other films of a fantasy/science fiction nature that Pal produced in the years that followed include *Tom Thumb*, *Atlantis the Lost Continent* (1959), *The Time Machine* (1960), *The Wonderful World of the Brothers Grimm* and *The Seven Faces of Dr Lao*. Pal also directed all the above films except *Grimm*, which was directed by Henry Levin. *Tom Thumb* was made in Britain and made use of the talents of veteran British optical effects man Tom Howard. *Atlantis* featured some spectacular effects, notably those concerning a death ray, a fish-shaped submarine and the destruction of Atlantis by a combination of volcanic activity and tidal waves. Made at MGM, the effects in the picture were handled by A. Arnold Gillespie and his staff. Just as spectacular was *The Time Machine* which showed London being devastated during an atomic war as well as some rather more unusual scenes involving time travel. The latter was the work of the director of photography, Paul Vogel, who had to devise a method of showing the succession of days and nights speeding up as the time traveller (played by Rod Taylor) moves into the future. Vogel achieved this by having huge circular shutters built in front of each 'brute' (a large arc lamp) used to light the scene. These discs, roughly seven feet in diameter, were divided into four segments. One segment was left clear to indicate daylight, another had a pink gelatin filter to indicate sunrise, another had an amber gelatin to indicate evening. To simulate the

effect that each day was passing in a matter of seconds, as the Time Traveller sped into the future, these discs were turned by hand from below by means of a chain and gear arrangement. Simultaneously, the arcs were raised and lowered by see-saw devices to contrast the high light of midday with the low light of the evening. Creating these lighting effects on the set itself instead of having to produce them with an optical printer saved thousands of dollars.

Other special effects on *The Time Machine* were handled by Gene Warren, Tim Barr and Wah Chang. A sequence they handled is the one showing the Time Traveller and his machine being entombed in rock as he continues to speed into the future, then later showing the rock melting away as a result of thousands of years of erosion. The sequence was shot using the blue-backing travelling matte system to permit double printing of the rock background. As the erosion of time gradually liberates him, the rocks melt away by means of animation. However the rocks around the machine were the real thing and had to be pulled away precisely on cue by means of concealed wires.

Anyone who has seen *The Time Machine* will always remember the frightening Morlocks, huge shaggy creatures with glowing eyes. Their make-up was designed by MGM make-up director William Tuttle. The actors wore green latex 'skins' and had their faces distorted by grotesque masks which were fitted with electrical eyes, the 'eye' lights being controlled by tiny switches that they held in their hands.

Warren, Barr and Chang, who had formed themselves into the company called Project Unlimited, again worked for Pal on his *The Wonderful World of the Brothers Grimm*, a film which contained a lot of three-dimensional animation, as did Pal's next film *The Seven Faces of Dr Lao*.

Pal's last film to date was *The Power*. This long interval between films is explained by the fact that Pal's projects are invariably expensive to set up and with the film industry in its present state financial backing is hard to come by. In recent years he has attempted to make several films, on subjects varying from Rip Van Winkle to an adaptation of William F. Nolan's science fiction thriller *Logan's Run*.

Returning to the early 1950s, along with Pal's first films, an important science fiction picture of the period was *The Day the Earth Stood Still* (1951). Directed by Robert Wise it was one of the first films about alien visitors, and also one of the best. Michael Rennie played Klaatu the messenger from outer space who lands his flying saucer in Washington, accompanied by a robot called Gort. The special effects are minimal apart from the shots of the saucer flying above the city – animated travelling matte – and the disintegration of a tank and a few soldiers. But what is most impressive is the flying saucer itself and the giant robot. Designed

(Right) *Gort, the robot policeman, emerges from the flying saucer in* The Day the Earth Stood Still

by Lyle Wheeler and Addison Hehr the saucer possesses an unearthly beauty – smooth and featureless, it really looks as if it comes from another world rather than a Hollywood workshop. Actually it consisted of a wooden framework, wire, plaster of paris and silver paint. Inside it was hollow, except for two panes of plastic erected just inside the opening of the dome to give the impression of a complicated interior. The only solid part was the ramp which folded out from the saucer. This had to take the weight of the actors so it was built on a metal framework and covered with sheet metal. Flimsy though the saucer may have been (it was so light it almost took off from the studio back lot during a gale) it measured 350 feet in circumference, stood 25 feet high, and cost $100,000 to build.

One of the most impressive scenes shows the saucer melting open and extending the ramp prior to Klaatu's emergence. As the saucer has no visible seams or joins the effect is quite eerie. It was achieved by sealing the slits in the mock-up saucer with a soft plastic compound, then coating the plasticized seams with silver paint. The result was that no seam was visible until the three stage hands hidden in the saucer pushed open the dome from within and extended the ramp.

Gort, the giant robot, was created by a man wearing a very complicated suit that made him appear over eight and a half feet tall. To construct the

suit a mould was first made and around it a fibreglass cloth was sewn into place. The cloth was sprayed with a solidifying lacquer. After becoming solid the fibreglass, which had dried to conform to the shape of the mould, was removed from the figure. It was cut into segments and liquid rubber was poured over each segment until it was of a sufficient thickness to appear solid yet still pliable. The head was made of sheet metal. Another head was made for the close-ups of Gort's visor opening and emitting the disintegrating rays. The man who wore the suit, Lock Martin, was the doorman at Grauman's Chinese Cinema in Hollywood. The director gave him the role because he was the tallest man he knew but like many unnaturally tall men Martin was relatively weak. In the scene where he carries Patricia Neal into the flying saucer he is never seen actually picking her up.

The year 1951 was a great one for creatures from outer space, for it was the same year that *The Thing* (Christian Nyby) was released (also known as *The Thing From Another World*). Unlike Klaatu, whose mission was a peaceful one, the Thing was evil and destructive despite being a human-oid vegetable. He was played by James Arness of *Gunsmoke* fame in green make-up and unvegetable-like claws. So embarrassed was Arness by his appearance during the making of the film that he refused to eat with the rest of the cast. The few special effects there are in *The Thing* are well done, especially at the climax where the creature is trapped in a wire net and electrocuted, becoming smaller and smaller as he burns. This was achieved by using a series of actors of diminishing sizes, and in the final scene the costume was worn by a midget. As ludicrous as it may sound from the above description the picture, produced by Howard Hawks, was a well-made, exciting thriller.

Possibly the best of the space-travel pictures made during the 1950s was *Forbidden Planet* (Fred McLeod Wilcox, 1956). The special effects were remarkable and were the work of A. Arnold Gillespie, Warren Newcombe, Irving G. Ries, and Joshua Meador. The production was designed by Cedric Gibbons and Arthur Lonergan. The film begins with a sequence showing a flying saucer from Earth hurtling through space and entering an alien solar system. Here the eclipse of an enormous red sun is seen with the saucer silhouetted by the corona – a breathtaking panorama which is almost equal to the astronomical simulations in the later classic *2001: A Space Odyssey*. The saucer then lands on the planet Altair IV, achieved by some expert model work, and as the dust settles there is a cut to a full-scale saucer mock-up filmed within an MGM sound stage. The alien scenery which surrounds the saucer is actually an enor-mous painted cyclorama, 350 feet in length. No sooner have the crewmen disembarked than they are met by a robot called Robby. Robby was one of the most elaborate robots ever built for a film production. More than

two months of trial and error labour were needed to install the 2,600 feet of electrical wiring that operated all his flashing lights, spinning antennae and the complicated gadgets that can be seen moving inside his transparent dome-shaped head. Robby was so expensive that MGM felt obliged to use him again in another feature film, *The Invisible Boy* (Herman Hoffman, 1957), as well as in several TV programmes. Just who had the unattractive task of being *inside* Robby during the making of *Forbidden Planet* is unknown.

The special effects were to become even more breathtaking as the film progressed. Beneath the surface of Altair IV are the remains of a great civilization, giant machines that are still in operation. The Earthmen are taken on a guided tour over part of this vast complex and one stunning shot shows them as tiny figures standing on a catwalk spanning a huge shaft in which massive pieces of machinery are moving up and down, accompanied by an awesome display of electricity. Of course the shaft and the machinery are all part of a miniature set, but a relatively large one – about thirty feet high and ten feet wide at the top. An extra wide camera lens was used to exaggerate the perspective of the shaft, making it seem to plunge for miles. The men on the catwalk were matted into the film. A full-scale section of the ramp was built in the sound stage and the camera positioned as high up as possible to make the men seem tiny.

An important part of the film concerns the activities of an invisible creature who makes several attacks upon the Earthmen and their spaceship. All that can be seen of him are his footprints which appear out of nowhere, an effect achieved by a similar technique to the one used by John Fulton to show the footprints of his invisible man (see page 72). The only time the monster is seen is when it is bombarded by the ray guns of the Earthmen and a fiery red outline briefly appears. If the image seems to recall something out of a Walt Disney cartoon this is not surprising as the man responsible for this sequence was Joshua Meador, a Walt Disney animator on loan to MGM.

Also impressive is the interior of the spaceship which looks suitably futuristic as well as functional. A crew of nineteen men worked for a month to install the twenty-seven miles of electrical wiring needed to work all the various flashing lights, dials and controls. The cinematographer of *Forbidden Planet* was George Folsey who remembered working on a science fiction film as early as 1922 for the Biograph Studios in New York. All he could remember about it was the title – *The Man From Mars* – and that it featured unearthly creatures with huge heads and talons. It is interesting to note that it was an early attempt at 3-D photography although the result was not very satisfactory.

Monsters of all shapes and sizes paraded through science fiction films during the 1950s. Some were well executed, others reflected only too

(Left) *Two different views of the relationship between robots and humans: Robby the Robot, star of both* Forbidden Planet *and* The Invisible Boy, *in battle action* (above) *and receiving first-aid from Richard Eyer* (below) *in* The Invisible Boy

well the cheapness of their budgets. Among the best were those created and animated by Ray Harryhausen (see page 161). *The Beast from 20,000 Fathoms* was the film that began the cycle of films that concerned the awakening of a prehistoric monster, a phedosaurus in this case, usually caused by an atomic explosion, which goes on a rampage and wrecks a city or two. Directed by Eugene Lourie, who was to specialize in films involving special effects, and featuring Harryhausen's skilful animation, *The Beast* was an effective film, unlike some that followed. Other Harryhausen monsters included a giant octopus, which featured in the film *It Came from beneath the Sea*, and a strange creature that resembled a dinosaur with a feline face in *Twenty Million Miles to Earth* – this unique creature begins only a few inches tall but steadily grows larger as the picture progresses.

Other monsters that thundered, crawled or flew out of the Hollywood special effects departments during the fifties included giant ants in *Them!* (Gordon Douglas, 1954), giant scorpions in *The Black Scorpion*, a giant spider in *Tarantula* (Jack Arnold, 1955), a giant praying mantis, in *The Deadly Mantis* (Nathan Juran, 1957), a strange, ludicrous-looking bird from outer space in *The Giant Claw* (Fred F. Sears, 1957) and even a blob which featured in a film called, naturally, *The Blob* (Irvin S. Yeaworth, 1958).

Hollywood did not have a monopoly on monsters – it had competition from a Japanese studio called Toho. In 1954 Toho Studios released a film called *Gojira* which was about a giant prehistoric monster that is aroused by an atomic explosion and performs the inevitable ritual of knocking down a city. In America the picture was released, along with some extra footage featuring an American actor, as *Godzilla* (Inoshiro Honda) – and a star was born.

Gojira, or *Godzilla*, was the creation of a Japanese special effects man, Eiji Tsuburaya. Tsuburaya, even as a youth, had always been intensely interested in movie making:

When I was a youngster I 'borrowed' coins from my father's shop to buy a movie camera I had seen in a store window. I realized that if I were caught with the camera I would be punished, so I took it apart, examined it and threw it away. Then I built my own.[66]

He entered the film industry as a scenario writer and was later employed in the studio laboratory, a job he used as a stepping stone to becoming a cameraman. Later he branched into special effects.

Several years before the Second World War I was called upon to create and photograph a monkey-like monster which was supposed to fly through the air. I managed the job with some success and the assignment set the pattern for my future work.[67]

As he moved up the ladder of responsibility he took on more duties until

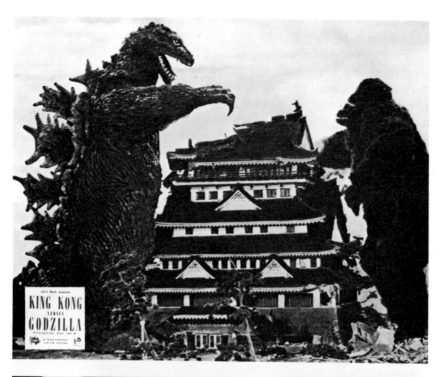

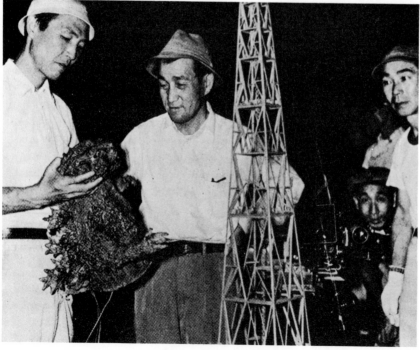

(Left) *Godzilla faces a Japanese version of King Kong (both are men wearing costumes)* (above); *Eiji Tsuburaya (centre) and his assistants inspect a mechanized section of Godzilla (below)*

eventually he was in charge of some sixty craftsmen, technicians and cameramen and had the whole rear section of the Toho lot, including two huge tanks for the water scenes, under his control.

Tsuburaya's monsters, unlike O'Brien's or Harryhausen's creations, are not models animated by stop-motion photography but are either actors in costume or mechanized miniatures. Much use is made of high-speed filming which makes the movement of the creatures and the destruction of the miniature sets seem much more realistic when finally projected onto a screen. Also the Japanese technicians excel in building skilful miniatures, which gives these films a quality appearance that belies their relatively low budgets.

After the success of *Godzilla/Gojira* there was a veritable flood of this type of film from Toho Studios. *Gigantis the Fire Monster* (Inoshiro Honda, 1956) lumbered out of the sea to join Godzilla, and was followed by *Rodan* (Inoshiro Honda, 1957), a giant flying reptile which immediately set about destroying Tokyo. King Kong himself, actually a weak facsimile, was revived to fight it out with Godzilla in a film called, logically enough, *King Kong versus Godzilla* (Inoshiro Honda). In the version distributed in Japan Godzilla won the battle but for American release the ending was tactfully changed and King Kong won.

Strangely enough, over the years, Godzilla and his friends have gradually changed from being monsters to becoming Japanese folk heroes. In recent films it is likely to be Godzilla, or a member of his family, who protects Japan from some new menace. Tsuburaya was once asked were the name of Gojira originated, and replied:

Actually there was a tough looking fellow working on the Toho lot with the nickname Gojira. We just used *his* name. It certainly fitted well.[68]

One of Tsuburaya's most interesting films was *The H-Man* (Inoshiro Honda, 1959) which contained some fascinating and somewhat eerie special effects. As usual an atomic explosion was the cause of all the trouble but instead of a rampaging monster the villain is a pool of pulsating green jelly. Tsuburaya succeeds in giving this unlikely thing a personality of its own, making it seep under doors and climb walls in an extremely chilling manner. But most effective are the scenes in which the 'thing' attacks people, with the result that they shrivel away to nothingness. Tsuburaya and his assistants achieved the mobile jelly with a special chemical compound. In front of the camera they forced it under pressure through the cracks and under the doors in various sets. The wall-climbing sequences were just as ingeniously contrived. Tsuburaya simply had the workmen construct the sets upside down and with the camera grinding in the normal position he filmed the jelly running downhill. To show the victims being dissolved by the creature Tsuburaya and his men fashioned life-sized dummies from airtight rubber bags and

substituted them for the live actors. As the cameras filmed at high speed the air was let out of the figures. Projected on the screen at normal speed the effect is surprisingly realistic.

Although Tsuburaya died in 1970 his creations are still alive and well at the Toho Studios, in the capable hands of technicians who trained under the old master. And these days there is competition to contend with, such as Majin and Gamera, both products of the Daiei Motion Picture Company whose effects department is headed by Yonesaburo Tsukiji. Majin and Gamera are just two of the 'characters' unleashed on the world by Tsukiji. Majin is a giant living idol and Gamera is an eighty-ton prehistoric turtle – who is jet-propelled!

From the giant to the minute; some of the most interesting science fiction films have dealt with the very small, or rather the contrast between the very small and things of normal size. One of the first of these films was *Dr Cyclops* (see page 65). *Cyclops* was directed by Ernest B. Schoed-sack, the co-director of *King Kong*, and starred Albert Dekker as the evil Dr Thorkel who shrinks a group of people in size using a radioactive substance. The effect of tiny people in giant surroundings was achieved by a combination of Farciot Edouart's rear projection work, split screen, and giant sets. The mechanical effects were handled by Wallace Kelly.

The classic example of this type of film was *The Incredible Shrinking Man* (Jack Arnold, 1957). Radiation is again the culprit. However the victim, played by Grant Williams, continues to shrink in size throughout the film and finally fades completely from view at the end. The special effects were remarkable, not so much for their technical execution, though it was above average, but for the way they were utilized. As with *Dr Cyclops* giant sets were used to create an illusion of smallness but travelling mattes were also used to good effect, performing the function that rear projection did on the earlier film. Optical effects were done by Roswell A. Hoffman and Everett A. Broussard and the sets designed by Alexander Golitzen and Robert Clatworthy. The travelling mattes were handled by Clifford Stine. (It was Stine who did the truly stunning effects in the Jack Arnold science fiction film, *Tarantula*, which has already been mentioned. The matte work involved in showing the giant spider scuttling across desert plains and over hills has never been equalled. Stine was also the second unit cameraman on Stanley Kubrick's *Spartacus* and was responsible for filming those impressive scenes of the vast Roman army marching in formation prior to the final battle. With skilful split-screen work Stine succeeded in making the army appear to be twice as large as it actually was.)

The most spectacular of the films dealing with characters of a reduced size was *Fantastic Voyage* (Richard Fleischer, 1966). Made at a cost of $6\frac{1}{2}$ million it was also one of the most expensive science fiction films

(Right) *Two scenes from* The
Incredible Shrinking Man
*create the illusion of an
undersized man: the figure of
Grant Williams has been
matted into a shot of an
ordinary-sized door – and cat
(above); the shrunken man
battles with the spider* (below)

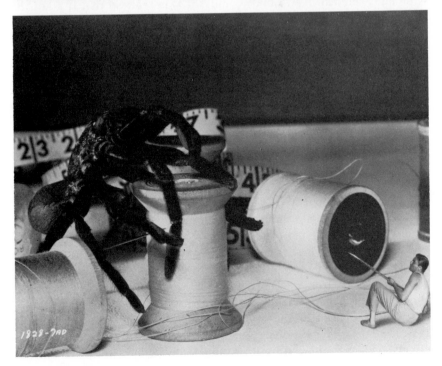

ever made, until *2001* came along with a budget that doubled that figure. *Fantastic Voyage* is about a team of scientists who are shrunk in size, along with a submarine, so that they will be able to travel through the bloodstream of another scientist and perform a delicate operation inside his brain. The script is ludicrous and full of cliché situations but the film is always fascinating to watch, chiefly because of the incredible sets and effects. Raquel Welch's ample screen presence also adds to the visual proceedings.

Richard Fleischer had also directed *20,000 Leagues under the Sea* for Walt Disney twelve years previously and there are similarities between the two films, especially since Harper Goff, the designer of the submarine used in *Fantastic Voyage*, also worked on *20,000 Leagues*.

All the sets used in *Fantastic Voyage* were enormous, the biggest being the set used for the Combined Miniature Deterrent Forces head-quarters, the military complex where the shrinking process takes place. The interior set was 100 feet by 300 feet in area and cost $1,250,000; the Los Angeles Sports Arena was used for the exterior shots and scenes of the connecting corridors. As the Arena was in normal use at night the film crew had to remove every trace of their presence by five o'clock each evening.

The submarine, called *Proteus*, cost $100,000, was 42 feet long, 23 feet wide and weighed over 8,000 pounds. It was built so that it could be dismantled when necessary for various shots inside the sub. All the inner body sets were built large enough to hold the full-scale submarine.

In the film the submarine and its crew are shrunk to microscopic size, drawn up into a syringe and injected into a capillary in the arm of the dying scientist. The illusion of shrinking was created with a travelling matte – the submarine was photographed at varying distances and then a series of hand-drawn mattes were produced and when superimposed on the laboratory background scenes the sub appears to decrease in size. A travelling matte was also used to show the sub being pumped out of the syringe along with a Niagara Falls-like deluge of fluid into the capillary. The capillary set was actually 100 feet long and 50 feet wide, constructed of specially invented and welded combinations of flexible resin and fibreglass, with hand-painted scenic effects. The 100 feet of the set were extended with a painted backing to give the illusion of infinite length. Cinematographer Ernest Lazlo and his lighting experts bathed the scene in a golden amber light to create the impression of plasma, adding pink and violet specks from rotating colour wheels outside the tube, to simulate the movement of cells on the outside of the capillary walls. This 'painting with light' was one of the more unusual aspects of *Fantastic Voyage*. Instead of using conventional painted sets, Lazlo decided that much better effects could be achieved by reflecting coloured lights into the various

translucent materials used in the building of the sets. This technique was used throughout the picture and the beautiful, abstract result is very effective.

At one point in the film the miniature adventurers have to replenish their air supply by penetrating into a lung to siphon off oxygen. The set, which is supposed to represent one of the millions of balloon-like sacs which make up a lung, is quite remarkable. Like the capillary it was made of flexible resin, fibreglass plus a secret mixture. It was cast in many irregularly curved and scrolled segments and was 300,000 cubic feet in surface area. A good touch was the inclusion of many craggy particles the size of small boulders to represent dust and smoke inhaled by the scientist. The walls of this giant set were rigged to move in rhythm to simulate breathing.

Another spectacular set was that of the heart, through which the submarine has to travel by way of a short cut (the scientist's heart is artificially stopped for thirty seconds to enable the tiny sub to get through in safety). This set was originally sculptured by artist Jim Casey who spent three months carving it from his models, which included a real human heart brought in by medical artist Frank Armitage. It was carved out of a piece of styrofoam 15 feet long, 5 feet high and 7 feet wide, all the muscles and valves scientifically and medically correct, made of rubber and hooked up so they moved like living tissue. The entire heart was finished with latex, giving it a living appearance, as anyone who has seen the picture will testify. The final heart set was created by art director Dale Hennesy and was 130 feet wide by 30 feet high.

The brain, or cranial set, was 100 by 200 feet and 35 feet high – 5 million times the size of an actual brain. The cobweb effect of rope-like bridges was created by spun fibreglass hand-sprayed with geometric precision to conform with anatomical drawings. Other organic sets included the eye (two sections 17 feet long and 5 feet high), the pulmonary artery (40 feet long and 8 feet in diameter), and the lymphatic node (25 feet in diameter and 14 feet high). All the sets were designed in a deliberately abstract fashion so as not to upset those with weak stomachs among the audiences.

A lot of the action in the film is supposed to take place within various fluids but as it was impractical actually to submerge the huge sets in water most scenes were filmed 'dry'. In other words, when the characters appear to be swimming they are actually hanging from wires attached to overhead tracks. This was supervised by Peter Foy, a 'flying' specialist who has previously worked on a stage production of *Peter Pan* and a TV series called *Man in Space*. To create an effect of fluid-like motion cinematographer Ernest Lazlo made use of an old stand-by – he filmed these scenes at high speed, seventy-two frames a minute, three times

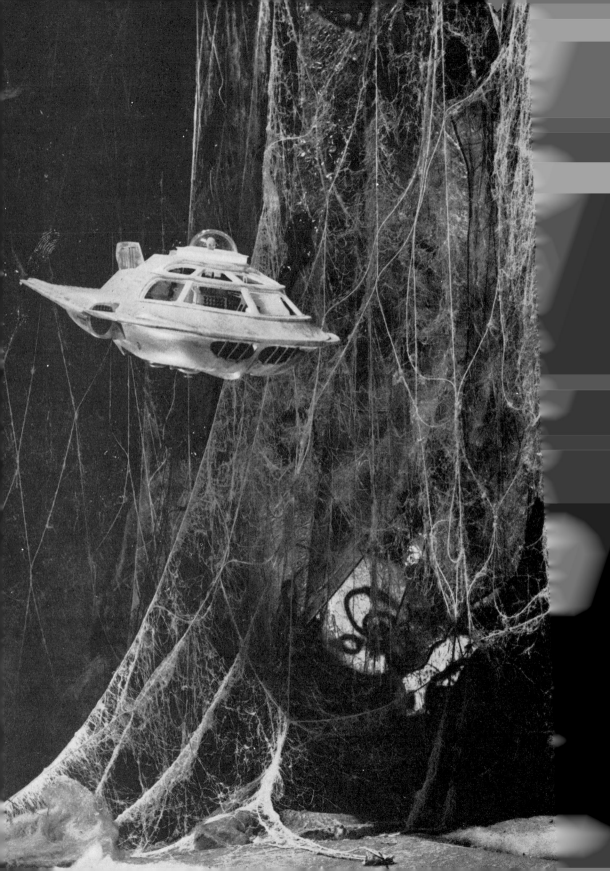

(Left) *One of the impressive sets built for* Fantastic Voyage

(Right) *Cinematographer Ernest Lazlo at work inside the 'brain' set of* Fantastic Voyage

faster than normal. Projected on the screen at the normal rate it is impossible to tell that the action is not taking place underwater.

The other effects in *Fantastic Voyage*, such as the travelling mattes and the miniature work, were handled by L. B. Abbott and his staff consisting of Art Cruickshank and Emil Kosa. Abbott was the head of the effects department at 20th Century Fox studios from 1957 to his recent retirement and was involved with several science fiction subjects, many of them produced by Irwin Allen. Allen has had a long association with science fiction films and his productions include *The Lost World* (the second version, 1960), *Journey to the Centre of the Earth*, and *Voyage to the Bottom of the Sea* (1961, which he also directed). Abbott also supervised the effects in Irwin Allen's many science fiction TV shows such as *Time Tunnel, Voyage to the Bottom of the Sea, Lost in Space* and *City beneath the Sea*. Abbott has been awarded four 'Emmys' (American television's version of the 'Oscar') for his work in these series and was nominated for an Oscar for *Journey to the Centre of the Earth* (Henry Levin, 1959). (He later received Oscars for *Dr Dolittle* (Richard Fleischer, 1967), *Tora! Tora! Tora!* and *The Poseidon Adventure*.)

Voyage to the Bottom of the Sea was a big success for Allen and led to the long-running TV series of the same name. The picture has many spectacular effects but suffers from a wildly implausible script, a fault

with many of Allen's productions. The plot concerns the crew of the submarine *Seaview* and their special mission, which is to put out a fire that is raging in the upper atmosphere, a threat to all life on Earth. An atomic missile is to be shot into the fire from the *Seaview* with the aim of dispersing the burning gases. Implausible as it was, the blazing Van Allen Belt makes an impressive sight in the film. To create this effect in Technicolor and Cinemascope a flame-thrower was used that sent a roaring jet of fire twenty feet in length. Several shots of this flame were combined in an optical printer with the result that the whole sky seems to be on fire. By the time the composite had been completed and matted in with the foreground action, the original shots of the flame-thrower had been run through the optical printer fifty-seven times.

The picture itself begins with an exciting shot of the *Seaview* surfacing nose first out of the Polar sea. To produce this action Abbott and his team built a scale model submarine and launched it in the studio tank on the back lot. The craft was carefully positioned below water at the right trajectory for the action. By means of a trip-release and a winch with a line on the tail of the sub, the craft's natural buoyancy was accelerated for the jump-up effect. Within the model itself high-pressure water hoses were connected to ballast portholes to produce, at the proper time, the effect of water ballast issuing forth as the craft surfaces. A detergent was added to the water to help create the effect of foaming turbulence.

The *Seaview* itself is of an unusual design which includes a transparent nose. The overall effect is interesting although it probably caused nautical engineers to groan in horror. Three models of the sub were built: on the surface a twenty-foot model was used, an eight-foot one for underwater shots and for a sequence with a live octopus a four-foot model was used. There was also a full-scale section, which showed part of the conning tower and deck, used to represent the sub when berthed.

One exciting sequence in the film shows an underwater avalanche of ice boulders threatening the *Seaview* as it navigates under the polar cap. Abbott had the 'boulders' constructed on metal frames covered with wire mesh. Over these were placed layers of cheese cloth which were then coated with wax. These miniature icebergs ranged in size from four inches to twenty-four inches in width and each one had to have its relative buoyancy built in so that the smaller boulders would not fall faster than the larger ones. The scene was shot at high speed from a camera mounted in the studio's diving bell, a metal tank which has two large convex glass ports. The icebergs were arranged on planks overhead and dropped into the water by technicians. Several takes were made which required divers to retrieve the various icebergs and set them up again for further shots.

In filming the scenes where the octopus attacks, one scene had to

(Right) *Water cannons send tons of water crashing into the 'upside-down' set in* The Poseidon Adventure

show the octopus clinging to the glass nose of the *Seaview* as seen from inside the sub. A small live octopus, having a tentacle spread of only twenty inches was induced to cling to a pane of glass mounted in front of a camera. This provided shots of its suction-cup-studded underside. Shooting this from a distance of five feet with a six-inch lens resulted in a close-up of six inches of the creature's mid-section. This was matted into the live action scenes filmed on the interior set.

Irwin Allen's latest film success, *The Poseidon Adventure*, although not technically science fiction, embodies both the situation common to that genre and spectacular shots of studio-tank miniatures, once again under the control of L. B. Abbott. The major set-piece of the film is the sequence where a giant wave hits the *Poseidon* ship and it capsizes. Apart from the exterior model shots the capsize was also simulated within a giant set representing the ship's dining room (modelled on the Queen Mary's first-class dining room). Parts of the set, which was 118 feet long, 60 feet wide and 28 feet high, could actually tilt a whole thirty degrees – the remainder of the capsize effect was created by tilting the cameras. The same set was used to show the dining room upside-down; it was designed in such a way that only the furnishings had to be reversed (such as attaching the tables to the ceiling and so on) to complete the illusion.

The scenes where the ocean crashes in through the window involved 125 stunt men and women. First an explosion shattered the fake glass, then six water cannons, operated by compressed air, were fired at the people. More water was supplied by three high-pressure pumps. These effects were under the control of A. D. Flowers. *The Poseidon Adventure,* the only major film released in 1972 to contain any large-scale special effects, was an obvious choice for the Academy Award.

Science fiction films became fewer in the 1960s and those that were produced tended to be much more lavish and expensive than their 1950s counterparts. The emphasis on monsters and invasions changed to more adult themes. Probably the most popular series of science fiction films in recent years has been that of the 'Apes'. *Planet of the Apes* (Franklin J. Schaffner, 1967) was the first one, based on a novel by Pierre Boulle called *Monkey Planet*. The plot of the film concerns an astronaut (Charlton Heston) and his companions who go through a time barrier and land on Earth in the far future when apes have taken over from man as the dominant species. The special effects are minimal, though well handled by L. B. Abbott and team, but most of the visual interest is provided by the unusual sets and the make-up.

Art director William Creber was responsible for the unique design of the apes' village:

We explored all ideas, even of shooting in Brasilia and using a strange, modern aspect. Arthur Jacobs [the producer] didn't buy that at all though he liked the sketches. We looked at some of the work of Gaudi [a European architect], and a Turkish city of cave dwellers called Gerome Valley, and these concepts came through a little, but we really had no structural idea in mind. The studio at the time had been experimenting with a substance called polyurethane foam, and one day some fellows had attempted to build something with this foam by spraying it on cardboard and it had the exact look we were after. So we sculptured the buildings using $\frac{1}{4}$in models, with welded rods, covered with cardboard, then we sprayed them with the foam. Towards the end we didn't have enough equipment, and we weren't making good time so we had to go into plaster and cement construction, plus the foam. It worked pretty satisfactorily though.[69]

The make-up of the apes was designed by John Chambers, a veteran who has worked on many of the science fiction/fantasy TV series such as *Star Trek* and *Lost in Space*, as well as on feature films like *The List of Adrian Messenger* (John Huston, 1961). There were several problems involved in the creation of the ape make-up, such as voice projection so that the actors could properly enunciate their lines and speak them clearly enough for sound recording. The actor's own lips had to synchronize with the outer lips so that when any given word was spoken the ape's lips would properly form this sound visually. Noses caused

(Right) *Maurice Evans and Charlton Heston on one of the sets designed by William Creber for* Planet of the Apes

difficulty as well – in the earlier models the actors breathed through the apes' nostrils but this did not work because Chambers found that he had to raise the ape's nose to look right. So he designed a passage through the apes' upper lip through which the actors could breathe easily through their noses.

The make-up took an immense amount of time to apply to each actor. At least five hours were needed but Chambers and his helpers managed to reduce the time down to an average of three hours. There was no time to remove the make-up at mealtimes but it was necessary to ensure that the actors ate well otherwise they would have weakened under the strain of their heavy schedule. The make-up allowed them to open their mouths but at first they had to use a mirror to show them where to put the food. The food had to be pushed right through the apes' outer mouth and into their own. Eventually they learned to do it without mirrors. Solids were cut into small cubes, drinking was done with straws, and those who wanted to smoke had to use very long cigarette holders.

The actors were kept as happy as possible although the temperatures on location in Arizona reached 120 degrees. They sat in special refrigerated trailers between takes which kept them cool. For use on the make-up a special paint was developed which transmitted the heat and perspiration of the actor through it, thus preventing over-heating. The paint had

a plastic base which allowed it to be sprayed at low pressure. It consisted of small particles of paint that stuck onto the rubber but never completely joined up to form a solid mass, with the result that it left tiny breathing areas invisible to the human eye. According to Chambers none of the actors had any complaints during the shooting of the picture.

Planet of the Apes was followed by *Beneath the Planet of the Apes* (Ted Post) in 1969 which was set in the same period as the original, but the film that came next in the series, *Escape from the Planet of the Apes* (Don Taylor, 1971), had two of the ape characters popping up in present-day America. The fourth Ape film, *Conquest of the Planet of the Apes* (J. Lee Thompson, 1972), has moved back into future, although only twenty years or so. The obvious advantage of setting the films in contemporary or near-contemporary settings is the savings in set construction and elaborate special effects (it is interesting to note that the subterranean New York sets in *Beneath the Planet of the Apes* were originally built for *Hello Dolly*).

A film maker who believes that science fiction films (his own, at least) should make great use of special effects is Douglas Trumbull. Trumbull is one of those fortunate special effects experts who has progressed to directing his own films – all by the age of twenty-nine. Like most effects men, Trumbull began with an interest in art and architecture. At college architecture was dropped from his course of study so that he could devote all his time and energy to painting. After leaving college he worked with various advertising agencies doing technical illustrations before getting a job with Graphic Films, in Hollywood, who needed strong representational artists for animated promotional films for NASA and the Air Force about space.

One of these films, *To the Moon and Beyond*, was seen by Stanley Kubrick at the World's Fair in 1964. Kubrick later remembered Trumbull's work when he was preparing to make *2001* and hired him as a special effects supervisor. He worked on *2001* for three years and was mainly responsible for the spectacular light show at the end of the film which utilized the 'slit-scan effect', a technique developed by Trumbull (see Chapter 9 on *2001*). Other films that Trumbull worked on were *Candy* (Christian Marquand, 1968) and *The Andromeda Strain* (Robert Wise, 1970). During this period Trumbull also supported himself by making commercials and titles and, at the same time, slowly developed his idea for a science fiction film which he would call *Silent Running*.

Silent Running concerns the attempts of a dedicated ecologist, played by Bruce Dern, to preserve the last remaining specimens of plant life which are stored in a huge space freighter in outer space. The order comes through from Earth to destroy the vegetation but Dern rebels, kills his fellow crewmen and takes the freighter off into deep space, his

(Right) *A spectacular scene from Douglas Trumbull's* Silent Running

only companions being three little robots. Frankly, the plot is very illogical and the picture as a whole suffers from an overdose of whimsy (two of the robots are called Huey and Dewey), but it cannot be denied that the effects are of a very high quality. They become even more impressive when one considers that the budget for *Silent Running* was only a fraction of that for *2001*.

Trumbull himself wrote the original treatment for *Silent Running*. It was based on an idea he had about small robots – called drones – and grew into a vague situation about a man alone on a spaceship accompanied by three of these robots. Building from this outline, Mike Cimino, Derek Washburn and Steve Bocho wrote the screenplay. To give the drones mobility Trumbull made use of four legless young people. He had been inspired by seeing *Freaks*, a film made in 1932 and directed by Tod Browning (who had directed *Dracula*), in which there appeared a legless actor who had been capable of great versatility in his movements despite his handicap. This gave Trumbull the idea of putting such a person in a robot shell which would obviously be too small for any ordinary person.

Trumbull began by checking with the Veteran's Administration in Los Angeles and was introduced to George McCart who had lost his legs in Vietnam. He was too heavy to be a drone but turned out to be a good

engineer-designer and helped Trumbull and his staff to design the drone outfits. He also helped them to find others who might be suitable. After interviewing a lot of people Trumbull picked three youths and a girl to work in the film. They were Cheryl Sparks, Larry Wisenhunt, Mark Persons and Steve Brown.

The drone bodies were made of very lightweight plastic that weighed twenty to thirty pounds. Despite this the operators still had difficulty in working for very long at a stretch and had to be wheeled about the set in trolleys to conserve their strength. The suits came apart very simply so that between takes the operators could take refreshments. But getting them suited up in the first place was a complicated operation that took at least fifteen minutes each time.

Although *Silent Running* was a Universal film it was not made at that studio but filmed in three different locations. The spaceship interiors were shot inside a decommissioned aircraft carrier called the USS *Valley Forge* which was waiting to be scrapped. The interiors of the domes, which are used to house the vegetation on the spaceships, were done inside a large hangar at Van Nuys Airport. The models and the miniatures were built and photographed at Trumbull's workshop in Canoga Park, a suburb of Los Angeles. The live action filmed on the carrier and in the hangar was completed in thirty-seven days. Then seven months were spent shooting the miniatures and creating the optical effects.

The model of the space freighter, named the *Valley Forge* after the aircraft carrier, was twenty-six feet long. It was, in Trumbull's own words.

A very complicated space-frame structure of real stressed members that we copied roughly from the Expo Tower in Osaka at the 1970 World's Fair. It's really a beautiful shape and very delicate . . . move it at all and pieces come off. We can't even move it out of the workshop building. American Airlines was interested in making it a mobile display but it would cost about 30,000 dollars to ruggedize it enough to move it around like that. It would cost us 3,000 dollars just to take it the twenty-five miles to Hollywood. The real spine of the ship is a steel bar through the center, and the core of the living quarters and controls section is plywood with styrene plastic over it. All the fine detailing on the outside of the ship is parts from 650 German army tank model kits. Little hatches and doorways and such, all glued on.[70]

For the scenes that take place supposedly within the vegetation-filled domes Trumbull made good use of the front projection process. First an eight-foot-diameter dome was built and still photographs taken of it from all angles. From these stills front projection plates were made, which were used to project a geodesic pattern onto the large front pro-jection screen which stood behind the forty-foot-diameter green area consisting of trees, ferns, a pond and so on. Scenes of outer space, such as the stars and the planet Saturn, which was used for an important

sequence, were also projected on the screen. Hence a perfect illusion was created of seeing through the superstructure of the dome into outer space.

Other special effects men who worked with Trumbull on *Silent Running* were Richard O. Helmer, James Rugg (responsible for most of the special effects in the *Star Trek* TV series), Marlin Jones, Vernon Archer, R. L. Helmer, John Dykstra and Richard Yuricich.

Trumbull's current project is another science fiction film which will be released by MGM. Details to hand are scarce except that it will be set 500 years in the future, will be entitled *Pyramid* and, according to Trumbull himself, 'It will be fantastic!' One can only hope that on this occasion the script will equal the technical expertise. The best of the science fiction films have always used special effects to complement a strong story rather than merely act as a showcase for them.

9/ The Ultimate (Special Effects) Trip

2001 : A Space Odyssey (1968) is, without doubt, the greatest *special effects* picture made to date. Whatever reservations one might have about it as a dramatic entity it has to be admitted that it is a visual feast. Never before have special effects been presented so lavishly, or so successfully; never before has the potential of miniatures been so fully realized. The models that soared and whirled through *2001* were so meticulously constructed, so skilfully photographed and so ingeniously comple-mented by Kubrick's brilliant choice of music, that special effects will never be the same again. *2001* created such a vivid and unforgettable impression of man in space that the actual moon landing, which took place in the following year after the picture's release, seemed an anti-climax.

Stanley Kubrick had long possessed a reputation for being a perfection-ist in movie-making circles so it should have been no surprise that he would bring this same quality to bear in his attitude to special effects. So involved, in fact, did Kubrick become with the effects in *2001* that the picture overran its original shooting schedule by at least a year, and the budget rose from $4,500,000 to $10,500,000. But at least, in this case, we can see where the money went to, unlike many other big-budget pro-ductions.

One of Kubrick's inspirations for *2001* was a film produced by the National Film Board of Canada called *Universe*. The special effects team who worked on that picture, consisting of Colin Low, Sidney Goldsmith and Wally Gentleman, created a number of startling techniques that were later utilized by Kubrick. One of their more ingenious ideas was to produce an illusion of panoramic spectacle, such as swirling galaxies, by photographing with powerful lenses interacting chemicals on glass slides a mere three inches in diameter. Kubrick had originally wanted the Canadian team to do the effects in *2001*, in fact Wally Gentleman did do some preliminary work for Kubrick, but for various reasons (mainly economic) it was decided to make the picture in Britain and Kubrick finally settled for a mixed team of British and American effects experts.

(Right) A scene inside the moon ship from 2001: A Space Odyssey *(above); a technician at work during the making of the Canadian documentary* Universe, *which was a source of inspiration for Stanley Kubrick (below)*

One of the Englishmen on the picture was Wally Veevers (see page 88).

'I had done a picture for Kubrick previously, *Dr Strangelove* [1964], and he was a great admirer of my work as, of course, I was of his. He phoned me from New York to tell me that he had a special effects picture to make and he told me two things about it . . . he was going to make it in England and he wanted me on the picture. I was still under contract to Shepperton at the time and they didn't want to release me. Eventually they allowed me to go with Kubrick for three months . . . and I stayed with him for three years.

'To start in the industry as an apprentice on *Things to Come* and to finish, more or less, in charge of a picture like *2001*, which is the present-day *Things to Come*, was a wonderful thing. Kubrick is a wonderful director to work with but terribly demanding. I reckon of the two years I worked with him he took five years of my life. He drained *everything* out of you. I, and most of the other boys on the picture were working day and night.'

This tremendous pressure was mentioned by another of the effects supervisors – Con Pederson:

. . . the days were long, ten to twelve hours, the weeks were long, six to seven days, and the months were long . . . on and on, no respite. The routine was very intense.[71]

An elaborate command-post was set up at the Boreham Wood studio during the making of *2001*.

It was a novel thing for me to have such a complicated information-handling operation going [said Kubrick] but it was absolutely essential for keeping track of the thousands of technical details involved. It took an incredible number of diagrams, flow-charts, and other data to keep everything organized and to be able to retrieve information that somebody might need about something someone else had done seven months earlier. We had to be able to tell which stage each scene was in at any given moment – and the system worked![71]

Stanley Kubrick was born in New York City, the son of a doctor, and became obsessed with photography at a very early age. While still at school he was selling his work to magazines – at the age of sixteen he sold a photograph to *Look* magazine. The magazine bought more of his material and were so impressed by him they hired him as soon as he had left High School. Kubrick was very successful as a photo-journalist but motion pictures soon became his dominant interest and he left *Look* to make two short subjects which he financed out of his own savings. He then went on to make two feature films, this time borrowing the money from relatives, called *Fear and Desire* and *Killer's Kiss* (1955). By then he had also become a fully-qualified cameraman and served as his own director of photography on *Fear and Desire*. *The Killing*, which he made in 1956, attracted the attention of the critics and his reputation was further

enhanced by *Paths of Glory* which followed in 1957. In 1960 he directed *Spartacus*, taking over from Anthony Mann who had left the film because of a disagreement, and in 1962 began the cycle of films that have made him internationally famous with *Lolita*. This was followed by *Dr Strangelove* in 1964 and then *2001*, on which work began in December 1965 and was not completed until March 1968. Since *2001* Kubrick has made the controversial *A Clockwork Orange* and is currently filming a little-known William Makepeace Thackeray novel called *Barry Lyndon*.

It was Kubrick's demand for perfection and his dissatisfaction with the more conventional techniques that made the effects in *2001* out of the ordinary, and his attitude infected all his effects men.

'I worked on the model side of *2001*,' said Wally Veevers, 'the shooting of the models and the matte work as well as the working of the models and the various effects we had to get into things. I didn't have anything to do with the slit-scan device . . . that was Trumbull's project. Kubrick, for example, would come and say: "I've got a thing here, it's a diamond-shaped thing with eight facets and it's rotating . . . now I want to be able to track in on it and on each facet there have got to be three pictures going into each other. Now, how are you going to do it, Wally?" And I would have to work out how to do it. That particular sequence [which occurs near the end of the film when the surviving astronaut is beginning to enter the "star-gate"] took twelve days to shoot.

'I had all my models running on tracks so that everything would be dead smooth. When you come to consider that the space station was nine feet across and we were only moving it three-eighths of an inch a *minute* while shooting it rotating, you can appreciate why it *had* to be dead smooth. The same applied to the model of the spaceship *Discovery* which was 54 feet long [a smaller 15-foot long model was used for some shots] and moved along a track that was 150 feet in length. It took four and a half hours to move along the track and we had to shoot it more than once, for matting purposes, and it had to travel at exactly the same speed each time.'

To matte in the shots of the spaceship crewmen, who were to be seen through the various windows, involved a mixture of old and new techniques. 'We used no conventional travelling mattes at all,' said Kubrick, 'because I feel that it is impossible to get original-looking quality with travelling mattes.'[73] Instead, a shot would be made of the spaceship model moving along its track all properly lit but with the window areas blacked out. Then, when it had completed its route it would be set up at the beginning again, the film would be wound back and another identical shot would be made. But this time the exterior of the model would be covered with black velvet and a scene of the interior action would be front-projected onto a glossy white card exactly filling

(Overleaf) *The Jupiter ship* Discovery *in* 2001 *was in fact a model fifty-four feet long*

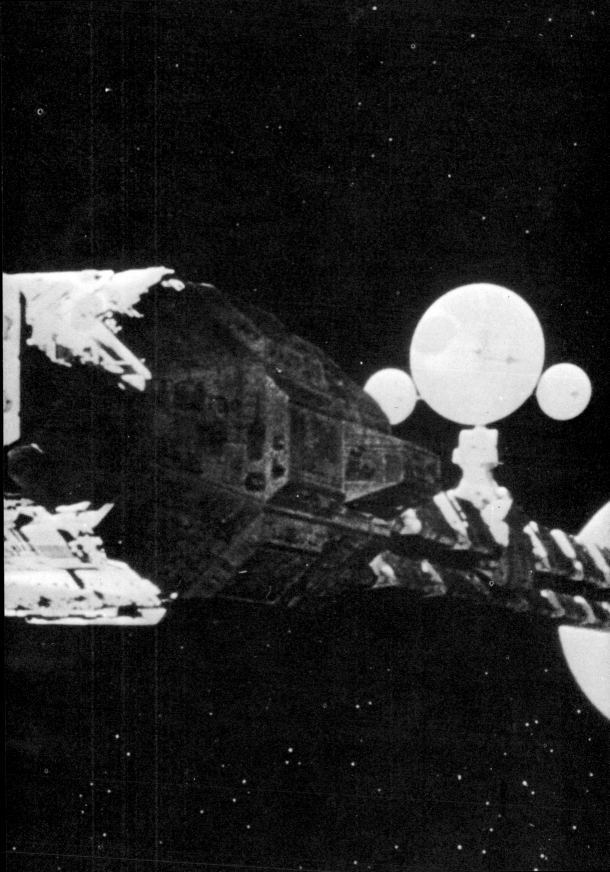

the window area. Basically, apart from the front projection (which is covered later in this chapter), this was a throw-back to the matting techniques used by the silent-film cameramen who, as described in Chapter 2, also used to combine various image components on the one original negative.

'Everything was motorized in those scenes,' said Veevers. 'For example, in the sequence where the moon ship descends into the underground moon-base . . . as the moon ship was being lowered on the landing platform there was a projector being lowered parallel to it at exactly the same speed, projecting the scenes of the people who appeared to be looking out. Incidentally, the landing station was actually twenty feet deep.'

For the many shots of the various spacecraft moving against starry backgrounds it was again decided not to make use of the conventional travelling matte techniques, such as the blue-screen process. Instead all the mattes were drawn by hand – another technique that has its origins in the silent era. This meant that all the shots of the spaceships were meticulously rotascoped, *frame by frame,* onto animation cels which were used to produce mattes to blank out the corresponding areas on the star-background footage.

Apart from the exceptional miniature and matte work *2001* also owes part of its impressive appearance to several full-scale engineering marvels, such as the ferris wheel contraption built to represent the centrifuge inside the giant Jupiter-mission spaceship. It was thirty-eight feet in diameter and able to rotate at three miles an hour. It makes its first appearance in the film when we see one of the astronauts exercising inside it. In a number of shots the astronaut, played by Gary Lockwood, seems to run up one side of it and down the other – simple enough if the filming was actually taking place out in space but as we know the picture was made on Earth the effects are quite striking. Actually the running Lockwood stayed at the bottom of the set as it rotated while the cameraman, suspended in a seat mounted on gimbals, constantly adjusted the camera to keep Lockwood in the picture. In one of the most difficult shots using that particular set Gary Lockwood was strapped into his seat and had to hang upside-down pretending to eat glued-down food while Keir Dullea, who played the other astronaut, climbed down the ladder leading from the centrifuge at an angle of 180 degrees opposed to Lockwood. As Dullea began to walk around the centrifuge towards Lockwood, the centrifuge slowly rotated until the two of them were together at the bottom, while the camera was now at the top of the centrifuge.

A similar effect was created with another rotating set in the scene where a stewardess appears to walk upside-down while carrying out her duties on the moon ship. Actually she was walking on a tread-mill

(Above) *The three stars of 2001 – on the left Gary Lockwood, on the right Keir Dullea, and in the centre Hal 9000, the computer*

while the rest of the set – including the camera – rotated 180 degrees.

Another ingenious trick was used to show the astronaut making an emergency entrance from outside the ship into an airlock. Propelled by an explosive blast of air the astronaut, Dullea, hurtles into the chamber and bounces back and forth between the walls in a truly alarming fashion. One imagines, while watching the sequence, that the hapless actor was induced into actually letting himself be fired into a real vacuum chamber. But the secret lies in the fact that though the sequence appears to have been filmed horizontally it was really filmed *vertically*. That is, the set was built on its side with the camera at the bottom pointing upwards. The actor was then lowered towards it on wires, the wires being obscured from view by his own body. The apparent explosiveness of his entrance was, of course, achieved by filming the scenes at low speed.

This device of concealing wires by always making sure that the person or object they are supporting is always between them and the camera was used several times during the making of the picture. One example is in the sequence where the spherical space 'pod' pursues the drifting astronaut and grabs hold of him with its mechanical hands. Both 'pod' and astronaut were in fact hanging by wires from the studio ceiling, with the 'pod' lying on its side and the camera filming it from below. Another example is in the sequence where the astronaut appears to float

inside the huge brain complex of the computer, Hal 9000. Again the camera was at the bottom of a set, in this case one that was three storeys high, pointing up at the actor who was being suspended, face down, by unseen wires attached to his back.

Another breathtaking aspect of *2001* was the beautifully realistic appearance of both the moon and Jupiter and several of its moons. Earth's moon was in fact created by using a series of actual astronomical photographic plates, this method being adopted after many unsuccessful attempts to build a moon model. Jupiter, on the other hand, was a model. Originally it had been planned to use Saturn but the problems involved in reproducing the mysterious rings that surround the planet proved insurmountable, so Jupiter was chosen as the alternative (Douglas Trumbull did make use of Saturn in his own film *Silent Running* with less than satisfactory results). A special device was used to reproduce the planet – called the Jupiter Machine, it was capable of optically scanning flat artwork and transforming it into a perfectly accurate sphere. Jupiter's moons were achieved by projecting artwork, from slides, onto twelve-inch opaque globes from two sides.

Trumbull's slit-scan device, mentioned earlier, was used to create the famous 'light show' that is supposed to represent the surviving astronaut's journey through time and space.

It's called 'slit-scan' for want of a better name [said Trumbull]. It's what I call a streak photography process, in which the shutter of the camera is open for a long period of time while some image is being accumulated on the film. The 'corridor' in *2001* was really planes of light that come from infinity to very near. There is just a simple light source that starts at infinity and moves up very close during the exposure of a single frame, with the camera keeping it continually in focus. At the same time the light is being modulated in a very complex pattern so that it scans the light onto the film in a dimensional effect. It's like photographing car headlights at night with the shutter open – you get streaks of light. If you had the cars blink their lights on and off you'd get streaky dots. And if they all drove in a certain pattern, you'd get a pattern of streaky dots. My slit-scan device takes that concept to a very complicated extreme. The whole thing shoots automatically, in total darkness. It runs itself up and down on tracks, opens and closes its shutters and cycles the optical matte, all automatically.[74]

As noted elsewhere, *2001* was the first major feature film to make use of front projection. This relatively new process (see page 127) was used in several sequences, the first one being the 'Dawn of Man' sequence at the beginning of the film. *All* the background scenery in the scenes involving the man-apes was produced by front projection using a screen that was ninety feet long by forty feet high. The resulting composites are impossible to detect, being completely realistic and a far cry from what would be got from using either rear projection or travelling matte. The back-

(Above right) *Both the space 'pod' and the man were actually hanging on their sides from the roof of the studio – the starry background was matted in later.* (Below) *As in the shot above, the wires supporting the actor are obscured by his own body*

grounds were actually photographs taken of scenery in South-west Africa that had been transferred onto large transparencies (8 inches by 10 inches) and projected onto the screen by a special projector designed and built by Tom Howard and Kubrick. The screen was covered with a highly reflective material that reflected the light back towards the camera in straight lines (the eyes of certain animals have similar reflective properties, which is why the eyes of the leopard in that sequence appear to glow so strangely – its eyes were bouncing back the light in the same way as the front projection screen).

The process was used in the scenes where the spherical moon ship is descending towards the moon base – in the foreground two spacemen can be seen standing on a high rocky area overlooking the moon base. The two spacemen were filmed in the studio while the moon base, the surrounding lunar scenery and the descending spaceship (all models) were projected onto the screen behind them. No matte-line or 'jiggling' mars the effect – the illusion is perfect.

Front projection was also used in the scene where Dr Floyd, played by William Sylvester, makes a 'picturephone' call to Earth while on the space station. While he is making the call inside the telephone compartment the Earth can be seen through the window behind him – whirling in a circular pattern because of the rotation of the space station. Although the view of Earth appears to be very realistic it was actually the work of an artist called John Rose. His artwork had been transferred onto a transparency and projected onto the 'window' screen by a rotating projector.

The final impressive shots in *2001*, of the serene, god-like 'star child' approaching Earth, were created with a fibreglass doll, which had originally been shaped in clay by a young sculptress. The eyes, made of glass, were movable and could be operated by remote control. The doll, which was two and a half feet tall, was superimposed over the glowing bubble which was then matted in the the shots of the Earth and surrounding stars. The result is breathtakingly beautiful.

Not surprisingly, *2001* won the 1968 Academy Award for the best special effects. Kubrick had wanted each of the four effects supervisors, Wally Veevers, Douglas Trumbull, Tom Howard and Con Pederson, to receive an Oscar but was informed by the Academy that they only awarded up to three Oscars, in various categories, for the effects in any one picture. Rather than drop one of their names, Kubrick accepted the award himself, on behalf of all four supervisors, as designer and director of the effects.

According to Arthur C. Clarke, who was Kubrick's collaborator on the script: '*2001* reflects about 90 per cent on the imagination of Kubrick, about 5 per cent on the genius of the special effects people, and perhaps

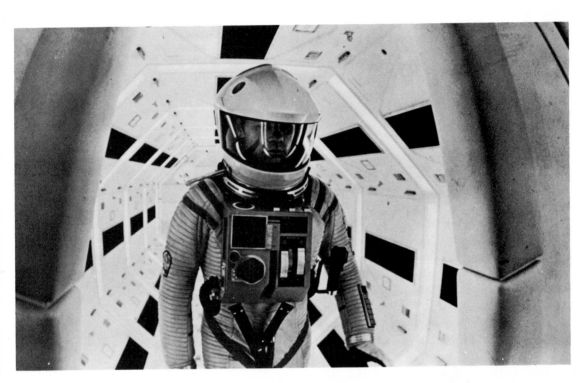

(Above) *Gary Lockwood, in full costume, walks through one of the many impressive sets built at Boreham Wood Studio for* 2001

5 per cent on my contribution.'[75] Clarke has perhaps underestimated the contribution of the effects men but there is no denying the fact that *2001* is the result of one man's vision and his demand for perfection.

2001 lifted the field of special effects onto a completely new plane of achievement. It proved that, given a director with the drive of Stanley Kubrick, a team of top experts, and a considerable amount of time and money, special effects can be used to create unique and powerful images. Unfortunately, with the film industry in its present grim state, it may be a long time before we see its like again.

10/Special Effects Today

Special effects men need a variety of skills to do their work but above all they must have that certain spark of creativity, that ability to cope with a new challenge swiftly, effectively and, usually, cheaply, that sets them apart from mere technicians.

'You read a script', said Les Bowie, 'and it contains really difficult problems in special effects . . . and you spend two days thinking about them before you suddenly say: "I know how to do that!" And you go back to the production manager and tell him . . . and you should be paid half of your fee for those two days because that's when the real work is done . . . while you're trying to come up with a brainwave. After that it's just a matter of trying to get the right equipment, the necessary people, and organizing it right.'

Cliff Richardson gave an example of the type of ingenuity that is constantly required from a good special effects man.

'For *Arabesque* [Stanley Donen, 1966] they had this set built in the studio at Pinewood which was supposed to be an airport lounge. On one side there were a number of large windows and of course you can't get this "breakaway" glass [made of a synthetic resin with an additive to make it brittle] made in anything like the size these windows were. You'd have to make it very thick to be able to handle it and you'd still probably break it while you were lifting it . . . a glass-works might be able to do it but you couldn't do it in a studio workshop. Anyway the idea was that the director, Stanley Donen, wanted one of these windows to be shattered by a bullet fired from outside. It was supposed to be raining outside and when the window breaks, the wind and rain were to blow into the lounge. The wind was also supposed to blow loose a number of these vertical venetian blinds that they had in front of the windows. After that the bullets were to go into some wooden panels on the other side of the room. So I fixed up a gag scene that would fill all these requirements . . . but without having to use any glass in the window.

'First of all I arranged to release a few of these venetian blinds so that they came loose at the bottom and were supported only by their tops.

This left them free to dangle so if you put a wind machine on them they would blow in. That was all quite simple, it was done with a nylon thread fitted to a spring to pull, when it was released, the thread out of all the eyelets along the bottom of the blinds which then left them hanging free. The glass was more of a problem. I had one whole pane taken completely out. It was impossible to see that it was missing because of the venetian blinds. The blinds weren't timed to blow in until *after* the bullet hit so it wasn't necessary to show the window pane at all. I fixed up over the window a trough on hinges filled with pieces of resin glass . . . and this all worked on the press of one button. One button released the spring which pulled the thread out of the blinds and at the same time tipped the trough up and let all the broken glass fall. And outside there was a chap who operated the wind machine to blow the wind and rain and stuff into the room. Then there was another switch for firing the bullet hits in the wall.

'But Stanley Donen just couldn't see how I was going to effect a breaking window if there was no glass in the window. I suppose he had a right to be dubious . . . I tried to explain it all to him but he wasn't convinced. He walked over to the window and put his hand through the empty space and said, "But there's no glass, how are you possibly going to fake it?" So I finally told him to stand in a certain position in the studio where the camera was to be set up and said to him that we would have a rehearsal so that he could see exactly what was going to happen. He agreed to this and when he was ready I pushed the button and there was a crash of glass and the blinds blew up and the rain came in and the bullets went off in the wall. I looked over to Donen who was standing next to Eric Rattray, the production manager. I saw Donen turn and say something to him and then Eric gave me the thumbs-up sign.

'In another sequence in that same film I had to show an electric charge travelling along a crane which has cut into a high-voltage cable, and then show the operator being electrocuted. To do this I used a chemical which we call titanium garniture. Actually it's the garniture out of fireworks . . . particles of titanium in a medium to burn it. And it's about the best thing I've seen to represent an electrical discharge because you get a lot of sparks. If we want a series of them going, like we did in that particular scene, we use a length of igniter cord, which is a kind of fuse. It looks like a length of thin plastic cord and what we do is either stick or tie paper tubes full of the garniture onto it at intervals. It's reasonably safe, one of its main advantages is that it goes out very quickly, but it still occasionally burns a hole in someone's clothes.

'One of the first gimmicks I remember making was for a scene in which the actress receives a bouquet of flowers, she lifts them to her nose and as she smells them they wilt and droop in her hand. For this trick I con-

cealed in the stalks of the flowers a tube containing a piston which was attached to a bunch of thin steel wires. Artificial flowers were then made with hollow stems which easily slid over the steel wires. By pressing a button concealed in the foliage, the piston was released and the wires withdrawn by a spring allowing the flowers on their hollow stems to collapse by their own weight.'

One of the more difficult tasks for an effects man is to simulate the movement of tentacles belonging to such creatures as giant octopuses, one of which featured in Hammer's *The Lost Continent* (Michael Carreras, 1968), a film that Richardson worked on.

'We made the tentacles work realistically by using rubber or plastic convoluted tubing. The convolutions are partly compressed and then restricted along one side with a narrow strip of spring steel. When air is forced into the tubing the convolutions on the opposite side of the steel strip expand, causing the tube to take the form of a coil. Then, by withdrawing the air and causing a vacuum, the tube will uncoil again.

'An interesting chemical reaction was used to good effect in one film for a scene in which a crook is shot while trying to escape with a suitcase of dollar bills. The actor had to fall in front of an open furnace, the suitcase bursting open and scattering the bills. The director wanted to see the bills curl with heat before bursting into flames. To do this the bills were treated with a solution of carbon bisulphide and phosphorous. The former is a very volatile chemical and therefore evaporates rapidly leaving the phosphorous in a very finely divided state on the paper which will then ignite spontaneously in the atmosphere.'

Richardson, despite his reputation for creating large-scale scenes of destruction, enjoys working with miniatures, though he admits the opportunity rarely arises these days.

'Jobs involving miniatures have been among the most interesting I've done. They usually give one an enormous scope for imaginative ideas.'

He had the chance to indulge in some miniature work during the making of *The Seventh Dawn* (Lewis Gilbert, 1964) when he was asked by the director to create storm conditions in a section of river that was at least fifty feet wide. Richardson had to explain to the director that to make that amount of water turbulent would be a vast undertaking, an almost impossible engineering feat, in fact. He suggested that they use a model shot instead. The director was not too happy about using miniatures but told Richardson to go ahead. When the film was sent back to England for developing the director wired the studio to ask how the model shot had turned out. 'What model shot?' they wired back.

A special effects man's relationship with the director of the film he is working on is obviously very important. Most effects men say that the best directors to work for are the ones who are willing to listen to advice.

Effects men are, after all, hired as specialists in their field and therefore expect to be treated as such. Richardson has found most directors pleasant to work with although he has his particular favourites, such as Lewis Gilbert, Dick Thorpe, Robert Parrish and Stanley Donen.

'Donen was a good man to work with because if you had an idea about anything he liked you to talk to him about it.' Most directors require a demonstration of what an effects man can do before they will hire him. 'My son John worked on Michael Winner's *Scorpio*. We became involved with that when we went up to Winner's office and talked to him about what he wanted in the picture. It turned out that he mainly wanted us for bullet hits. They had a place at Fulham which they were using as sort of offices and construction shops so we went along there to give him a demonstration. We did these bullet hits and he made a remark something like: "Oh, that's no bloody good. I saw smoke." It wasn't actually smoke he saw . . . we were using an old pair of trousers and when the squib exploded it caused a puff of dust to come out of the material. We then did another one by radio control. We fixed John up with one in his jacket and said to Winner that John was going to walk across the floor, and we gave the transmitter to Winner and said to him that whenever you want to just press this switch. So John walked across and Winner pressed his switch and there was a bang, a hole appeared and the blood came pouring out of the jacket and he was very impressed by that.'

A director with a reputation for being somewhat headstrong with whom John Richardson became involved was Sam Peckinpah. Richardson worked with him on *Straw Dogs* (1971).

'Sam Peckinpah was a hard man to work with,' said the younger Richardson, 'and although he often said to me, "Where were you when I made *The Wild Bunch*?" we had our moments! If he remarked that an effect was "groovy" I knew I had achieved something that pleased him.'

Richardson had several difficult assignments in that film, one of which was in the scene where Major Scott is killed by a shotgun at close range. The blast had to lift him off his feet and fling him backwards at the same time as exploding squibs simulated the shotgun pellets entering his chest and coming out through his back. Peckinpah wanted to shoot the scene with three cameras, front, back and side angled, which meant that Richardson was unable to use the usual methods for this type of effect, such as pull-off wires or a trampoline. Instead, he built a special lift-off device which was powered by compressed air and acted as a springboard.

In another scene Richardson had to create a really bloody effect when a man shoots himself in the foot with a shotgun. To achieve this Richardson filled a boot, which was obviously not worn by the actor during the

scene, with steak and fake blood (the latter is sold in England under the brand name of Kensington Gore). Several squibs were fitted in among the steak and when exploded resulted in quite a gruesome mess. Richardson was not surprised by the type of effects that Peckinpah required him to create. 'Having previously seen Sam's *The Wild Bunch* I gathered that he would like lots of blood,' said Richardson. Large quantities of breakaway glass were required for repeats of smashing windows and scores of different 'breakaway' drinking glasses were made for the bar scene, which only lasts for about two seconds on the screen, where the villain forces the barman's hand down onto a shattered glass. 'Breakaway' glass breaks exactly like real glass but hasn't got hard sharp edges which could cause an injury. The special effects man usually has to demonstrate this by pushing his face through a pane about fifteen inches square.

Effects men often have to work long hours arranging various tricks that, when they finally appear on the screen, are featured so briefly that they do not seem worth the effort.

'Generally I think the effects technician is apt to be disappointed when he sees the finished film,' said John Richardson, 'because having in mind all the thought and experimentation he has put into it, the result, in many films, seems to fall short of expectations. But the thought of what one has achieved, usually under the most adverse conditions, carries its own rewards.'

An example of the sort of ingenious effect that probably escapes the attention of most members of the audience can be found in one scene of Billy Wilder's *The Private Life of Sherlock Holmes* (1969). It involves an old gentleman asleep in an armchair in an exclusive club. In his hand he is holding a cigar with about four inches of ash on the end of it. This ash falls off at precisely the same moment that someone holds an ash tray under it.

'For this trick', said Cliff Richardson, 'I made a hollow wooden half-cigar which was covered with tobacco leaf to look like the real thing. Inside was fitted a metal tube containing a piston attached to a spring-loaded metal plunger which projected from the end of the cigar sufficiently to support the weight of the ash. The ash was made from polystyrene foam carved and painted to look authentic. One end of a fine-sheathed steel cable, such as is used for operating bicycle brakes, was attached to a release catch inside the cigar, the other end being taken to a small electro-magnet. The pressing of a switch by an assistant stationed off camera caused the magnet to withdraw the plunger and allowed the ash to fall on cue.'

For the same film Richardson designed and built the special walking stick carried by Sherlock Holmes that converts into a chisel, a saw and a hammer. Director Billy Wilder was much amused by it and insisted on

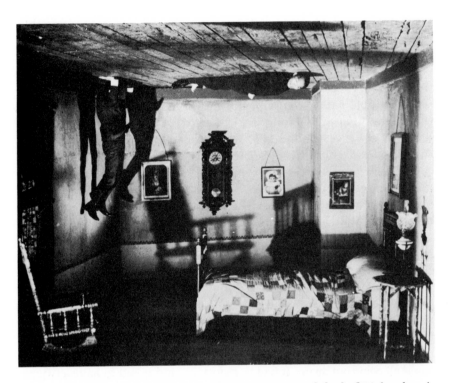

(Right) *The upturned room, part of a sequence that never appeared in the final version of* The Private Life of Sherlock Holmes

demonstrating it to all visitors on the set. But a good deal of Richardson's work never appeared in the final version of the film. Nor, for that matter, did a lot of other people's work, as the film was drastically shortened before release. One sequence that ended up on the cutting-room floor was entitled '*The Case of the Upturned Room'* which involved having to build an entire room full of furniture upside-down.

Another effects man who worked on the film was Wally Veevers and he too lost a good deal of his effects by the time the final version was ready.

'One of the scenes that went featured a model of an ocean liner about forty-five feet long. We took it out to sea and filmed it under realistic conditions . . . so realistic that the two men operating the model from inside became rather seasick.'

Veevers believes in building his miniature boats as large as possible:

'The reason is what I call the "freeboard", the distance between the water and the top of the deck. When you look at a ship like the *Queen Mary* from a tug the bloody thing is like a skyscraper but you never get this effect with an ordinary model because you can never get the camera down low enough. You can't get this impression of size with a model unless you build it very big. Even a forty-five-foot model, which sounds big, still only has about three feet of freeboard, if that. Another thing is

that I don't like faking water. I prefer to use a real sea where possible, and a real sky instead of a backing. I've always been against that sort of thing . . . tanks, wind machines, etc. I'd prefer, as we have done in the past, to matte a model ship into a real sea, which is what we did with the Grecian galleys in *Alexander the Great* [Robert Rossen, 1955].'

The trouble with using large-scale 'models' in realistic conditions is that if anything goes wrong it can turn out to be quite an expensive disaster, as Veevers found out while preparing to film another effects sequence for *Sherlock Holmes.*

'We built a full-size Loch Ness monster to use in the film . . . and filmed it in Loch Ness itself. Prior to my being on the picture they had arranged for Vickers to supply a two-man submarine and they were going to build the monster to fit on top of the sub. Now when I came onto the scene the submarine was still in Canada and there wasn't even a proper drawing of it available, only a rough outline. It was going to be flown over from Canada on a specific day and I was going to have my monster ready to go on top of it when it arrived . . . and that was only part of my problems. I was given seven weeks to build it . . . it had to be very strong but also very light, as light as I could possibly make it. So we eventually built this blessed thing . . . we built it out of wire mesh and condolite and used a plastic crocodile skin all cut up so that when water entered it it could all come out again. It had to have ribs, and it had to have a fifteen-foot-high neck which had to move, as did the head, and Wilder also wanted steam to come out of the mouth. The actual head and chest were made out of wickerwork, we had that done in London . . . it had to be made out in the street because the factory wasn't big enough. Everything worked automatically, the head, the neck, etc., I used air to drive it all.

'Now they had claimed that the submarine was capable of supporting this structure and also doing four knots. But when the submarine arrived it was useless. Not only couldn't it do four knots without carrying any extra weight, it couldn't even travel in a straight line when it was on the surface. It just wasn't designed to carry anything . . . it was a submarine built for observation work and for recovering torpedoes and that sort of work. It had lights, etc. I think if we'd put anything on top it would have sunk straight to the bottom.

'Fortunately I had anticipated trouble of this sort and had built a special pontoon to support the monster if necessary. For floating chambers I used fuel tanks from trucks . . . I put water in these and I could sink the pontoon to any depth I wanted. Billy Wilder had insisted that the monster have three humps, so in the humps I put in reserve air tanks in case anything went wrong.

'Anyway we took it out into the Loch for some test shots. We towed it

(Right) *The Loch Ness monster bears down on Sherlock Holmes and his friends (above); the reality – Loch Ness is actually a studio tank (below)*

with a converted trawler. We had it on the end of a line that was two inches wide and 1,000 feet long. We towed it at nine knots because Wilder wanted it to go as fast as possible . . . and we had three-foot waves hitting this thing, slamming into the chest. While we were doing the test swarms of people came to watch. There was so much traffic the police couldn't control it . . . and there were all these children yelling ''Dad, Dad! There's the monster!''

'When Wilder finally saw the test he decided he didn't want the three humps, he just wanted the neck and head to be seen protruding from the water. He wanted the change made over the weekend so I spent a whole Sunday taking the top off. I just left the neck on the pontoon and balanced it so that it wouldn't capsize. Of course, all my floating bags had been in the humps but there was nothing I could do about them. So on the Monday we towed it out into the Loch again and as the boat turned round quickly to come back the weight of the sagging towline unbalanced the monster and the whole damn thing sunk!

'That was the end of that. We never got it up again. We lifted it up to 500 feet while it was still attached to the tow rope but Vickers told us, ''For God's sake, don't do anything with it . . . we'll send the sub down.'' So we let it sink back to the bottom. The sub couldn't find it. I actually went down in the sub . . . it's like a desert down there at the bottom of Loch Ness . . . all silt and pitch black. We tried to raise it again with the tow rope but we didn't have a chance. You have five tons of equipment sink into that silt and of course you can't lift it up. When we tried the metal swivel connecting the rope to the pontoon snapped.

'Eventually we had to build another monster, which is the one that appeared in the film. We built it in a studio tank, just the neck which moved on a track. That wasn't an easy scene either . . . I had to lift a 17½-foot boat with three people in it and toss them out. You try and work that out with a series of counterweights and pivots . . . but it was heart-breaking really to lose the original monster. A lot of boys worked very hard on that. We could have got it up actually if we hadn't waited for the bloody submarine. Whether or not there ever was a real Loch Ness monster there certainly is now.'

Veevers feels that special effects in most films today, especially in Britain, suffer not only from a lack of money but also from a lack of proper understanding and appreciation from producers.

'*2001* was great because Kubrick insisted that everything had to be perfect. You take the picture *Things to Come*. Now that was superb really when you come to analyse it because it was a *special effects* picture and the money was spent on special effects. *2001* was also a special effects picture and again the majority of the money was spent on special effects. But I have people who come up to me and say, ''Wally, I have a

special effects picture I'm going to make . . . it musn't be like *2001*, we want it *better* than *2001*. We have £5,000 in the kitty for the effects. At best we might be able to run to £7,500.'' Now this is a film which will probably cost about £300,000 [approximately $900,000], and they talk about £5,000 for the effects! And people ask why special effects can't always be as good as those in *2001*. You can't do it!'

'It's a shame because they ruin these films that are supposed to be special effects films but they just don't know what they want. I think the special effects should be planned carefully from the beginning without worrying about the money side of it. I once had a job to do for a person who was always tight on money, and I said to him . . . ''Listen, the best thing you can do is to forget about how the money is going to be spent. You tell me how much you've got in the kitty and what you want and I'll do it for that price.'' It was a submarine picture and we had several sub shots to do. He had two subs built and he let me have them and he said, ''There you are, two subs, now go ahead.'' And he left me alone and didn't come back to me at all, and I did the thing and it came out, funnily enough, *underpriced*. Ever since then he has never argued about how much things are going to cost.'

As has been noted in previous chapters violent action has become increasingly fashionable in the commercial cinema during the last ten years or so, which has meant that practically all special effects men have had to become involved with explosives, fires and so on, no matter what type of effects they had previously chosen to specialize in.

'When anything came up in the way of special effects that I didn't know how it was done,' said Les Bowie, 'we used to get the film in. We would run it and mark the various reels with bits of paper. Then we would run these particular sections more slowly on a movieola, frame by frame if necessary, until we discovered how the effects were done. When they saw a thing like *Bonnie and Clyde* over here in England they wanted everybody to be shot like Bonnie and Clyde. So we had to look at the film and we said, ''Ah, well . . . capsule gun there, a few bullet holes there, and some bullet hits here . . .'' and we broke it down that way. I've been forced to change the type of work I do in special effects more than once . . . it depends on the type of film in vogue. At the moment it's all action stuff with explosions. I hadn't had any training with explosions but I was a soldier and so I had a respect for it. But the younger men working in the field today don't have this respect, they see something done once or twice and then they say that's easy and go ahead and do it. But it's dangerous, people playing around with explosives like that.

'I learned a lot about explosives from the Americans when Bill Warrington and I were working on *Swiss Family Robinson* [see page 106]. In one scene we were using these mortar pots which aren't very danger-

(Left and right) *Four stages of an explosion. In this sequence from* Duffy *Cliff Richardson blew up a boat by remote control from a helicopter*

ous. They were packed with sand, peat and coloured powders that made them look spectacular when they went off. We were tamping gunpowder into them at the prescribed weight that would be just enough to lift all this stuff up into the air. They looked dangerous but they weren't. The scene we were filming was of all these pirates going up this hill trying to invade the stronghold of the Robinson family that was on the top of it. But all these stunt men who were playing the pirates were obviously becoming too blasé about these mortar pots that were going off. The pots hardly made any sound . . . the actual bangs were going to be added to the soundtrack later. These stunt men weren't even acting scared so a certain Bill Warrington went up to one of these pots and really stamped the gunpowder and the other stuff into it. ''I'll fix them,'' he said. So in the midst of all this play-acting this particular pot suddenly went whampff!! A terrific explosion that deafened everyone. ''Ah, yes,'' said Bill with a straight face, ''you've got to expect that sort of thing. You can't trust these things, you know.'' And from then on they all acted very well.'

'It certainly kept them on their toes,' agreed Warrington.

'But', said Bowie, 'I would never ask a stunt man to be involved with any explosion or fire trick that I wouldn't do myself. There's a story about the late Pat Moore. He was working in a farce which had this war scene

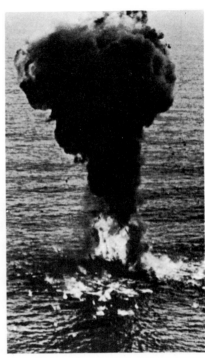

in it where everything had to be blown up. It was to be a very complicated set-up with debris flying everywhere and stunt men throwing themselves about. So Pat was behind this little wall right near the danger area with his wires and switch all connected up and ready. He was about to start when he looked round and found the director right behind him. "What are you doing here?" Pat asked him. And the director said, "Well . . . I looked around for the safest place and obviously that's where the special effects man is." And Pat said, "It's not safe here, I've run out of fuse wire. I've only got a short piece . . . I wanted it to be four times longer."'

Another man who is familiar with these situations is Cliff Richardson, a specialist in explosions.

'I've always said with explosives it's a case of "how much and where" . . . how much you want to use and where you want to put it. I always depends on the situation . . . you go into the situation first then work out what it calls for. On *The Dirty Dozen* [Robert Aldrich, 1966] I had to blow up the château and the underground shelter at the end of the film and the director, Bob Aldrich, asked if he could have some artists in a certain position and I would say to him, well . . . no, I would prefer them five yards further back. Most directors listen and go along with you though often they would like the artists to be as close as possible. But

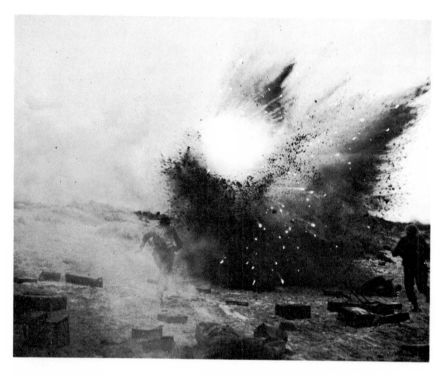

(Left) *A typical spectacular explosion created by the effects men for a war film* (Dunkirk, *starring John Mills and Richard Attenborough)*

it's only by experience that you know where people are safe and where they are not. I have a standing joke when I'm asked by newspaper reporters where I am when all these big explosions are going off. I always tell them that I should be at the other end of the longest piece of wire I can find. But actually there is very little danger if you know what you're doing. It's surprising how close you can stand to a hole in the ground with several pounds of gelignite in it . . . which will blow a ton of earth into the air. Because, providing there are no stones to hit or fall on people, the explosion always goes up in a funnel shape and you can quite safely stand near its base. I've done this, I've tried to prove it to people but sometimes they're hard to convince.

'In scenes with explosives involving actors or actresses I've always found it a good policy to talk to the artist concerned first and tell them exactly what you're going to do and what you're going to use. I find this gives them quite a lot of confidence. I had, on a picture called *Judith* [Daniel Mann, 1965], a lot of buildings to blow up near Sophia Loren. I used to go to her and say to her, "Well, this is going to make a lot of noise but don't worry, it's quite safe . . ." and she was fine, you know. If they have confidence in you and trust you everything is okay.'

Fire effects, like explosives, also demand skilled handling.

'I don't mind working with fire but you've got to respect it,' said Les

Bowie, 'though some people in the business are too cautious about using it. I'm fed up with those ridiculous gadgets that consist of tiny gas bottles attached to an apparatus that an actor can wear to make him look as if he was on fire. I can always spot them in a film and I don't like them. I don't think that they are necessary. There are plenty of safe ways of protecting actors when they're on fire. For instance, if you put alcohol on their clothes it creates a vapour barrier between the material and the flames. But there are all kinds of ways. I recently had a job where I burnt a little girl. I had her burning on the run, on fire from tip to toe . . . no stunt man, I used the little girl herself. Set fire to her in front of her mother and everything. I had explained to her beforehand how I was going to do it and how it would be perfectly safe. The mother was quite happy about it.

'You don't have to actually set fire to people to create the effect that they are burning. For example, in the film *Twist of Sand* [Don Chaffey, 1968], Bill Warrington had to show actors trapped in some water that was supposedly covered with burning oil. What he used were gas jets under the water to create the barriers of flame with a clear channel in between which is where the actors were placed. If you have your camera down low enough you can shoot through the flames and it looks as if the people are trapped in the midst of it. In scenes like that you don't

(Below) *A relatively safe fire 'gag' from* Diamonds Are Forever, *involving the actor himself (Putter Smith) instead of a stunt man*

put petrol on the water. Underwater gas jets are best because when the gas reaches the surface it doesn't float away like burning oil or petrol, it stays in the same area which means you have it under full control. You can do it on dry land as well . . . you have a gas jet in front of of the camera and another further away and have your man or girl run between them.'

Whatever fuel is used for fire effects, certain chemicals are usually added to provide 'colour', as ordinary flames often appear transparent on film. Apart from gas, other fuels used by effects men include petrol, diesel oil or paraffin. The last is one of the safest and was chosen by Cliff Richardson to fuel a special fire-creating device that he and his son designed and built recently. They christened it, logically enough, the 'Dante'.

'During the filming of *The Battle of Britain*', said Richardson, 'on which I was the supervisor of the physical effects, the script called for a number of fire sequences. One in particular [mentioned on page 148] was to be shot in St Katherine's Dock adjacent to Tower Bridge, an area with an enormous fire hazard. The operation was very successfully carried out but it did emphasize the fact that the British film industry was sadly lacking in modern equipment for simulating controlled fires of this magnitude. Oil-burning equipment which has been in service on many

(Below) *Three stunt men on fire in a scene from* Tora! Tora! Tora!

films since about 1950 was used for part of this effect but it was obvious to me that more up-to-date equipment which would give a better result was essential. Knowing that my next film was to be *The Adventurers* [Lewis Gilbert, 1970], which would also involve many fire sequences, gave me the incentive to seriously tackle this problem.'

After a great deal of experimentation with various types of atomizing jets, pumps and fuel mixtures, Richardson and his son, in conjunction with I.E.S. Projects Ltd., constructed a prototype of the 'Dante'. Consequent tests proved so successful that four more units were built and were soon utilized in the making of a film, *Cause for Alarm* (an eight-minute documentary made in 1972).

'The "Dante" ', explained Richardson, 'is an extremely portable unit mounted on a two-wheeled carriage. It comprises a Volkswagen motor driving a specially modified pump. Two standpipes, each with shut-off cocks, are breeched into the suction side of the pump which enables different fuel mixtures or flame colourizing agents to be drawn from two fifty-gallon drums simultaneously. Alternatively fuel can be drawn directly from a large-capacity bowser [petrol tank]. The weight of the unit is only 300 pounds but the pump has sufficient power to allow for its operation at ground level even if the fire effect is required on the roof of a building 100 feet high. This is an advantage as no lifting equipment is required.

'The operation of the "Dante" is simple. With the jet primers burning and the motors running, the fuel valves are opened and the flames reach maximum height in approximately five seconds. Jets of varying design result in flames of different height and width. General practice is to use four jets per unit and this arrangement will, in suitable weather conditions, create a wall of fire some sixty feet wide. In some of our tests a flame fifty to sixty feet was attained.

'The fuel normally used is paraffin which is more economical in cost and safer than petrol as there is much less likelihood of spilt fuel igniting. Average consumption is about thirty gallons per minute per unit. A big advantage is the brief time it takes to operate the "Dante". For example, on the words "turn over" the valves are opened and by the time the camera is up to speed and "action" given, the fire is at maximum height. On the word "cut" the motor is disengaged and the fire stopped but is immediately ready to operate again for "Take 2" if necessary. In other words the entire shooting unit is not kept waiting while fuel trays are replenished, empty gas bottles replaced or combustible material prepared to feed the fire.'

One of the most recent films that the 'Dante' was used in was John Huston's *The Mackintosh Man*.

'Our main job was to make this mansion in Ireland appear on fire.

(Left) *A simulated fire created by Cliff Richardson. The building is not really burning: fuel jets create the illusion*

We took two of our units out there and everyone was very impressed. The fire is probably the most exciting thing in the picture. The building we used was an empty shell and I asked John Huston whether he wanted to see just a few flames coming out or did he want to see the whole lot on fire, and he said: "Oh, the whole lot." And that's what he got. We had flames forty feet long coming out of those windows. The next morning I asked him whether he had been happy with it and he said: "It was magnificent, fantastic . . . I take my hat off to you."

'I had a tricky fire scene in *The Assassination Bureau*' [Basil Dearden, 1968], said Les Bowie, 'when the hero blew a mouthful of brandy into the face of a villain and set fire to him. We built a special mask for the stunt man to wear. And I had a similar fire effect in *Fahrenheit 451* [François Truffaut, 1966] when we had to set fire to the Cyril Cusack character. Funny thing in that film was that the actor that they had cast for the lead role had a phobia against, of all things, fire. He couldn't even strike a match yet he was the one who was supposed to be the main fire-raiser. We had a lot of fire scenes in that film . . . we built all the equipment too, the flame throwers, etc.

'The thing is never to panic if anything goes wrong with a fire effect, and this applies to other potentially dangerous effects too. I had an assistant once who on a particular job had lit a fire before he was sup-

(Right) *An electrical holocaust from* Goldfinger, *triggered by James Bond*

posed to. Then he got panicky and tried to beat it out with his hands. We were using petroleum jelly and naturally it stuck to his hands, so then he tried to rub it off against his clothes and set them alight too. We managed to put him out okay and fortunately, since he was wearing overalls, he wasn't burnt much at all except for a few blisters. You should always wear big, loose gloves when dealing with fire effects so that if anything goes wrong you can just slip your hands out of them.'

One of the most common jobs for an effects man these days is arranging car crashes.

'The number of car accidents I've arranged must be incredible,' said Bowie. 'I've lost count of the Jaguars alone that I've blown up. And as for cars plunging over cliffs . . . again the number is very high. Actually these cliff-falls are rather difficult scenes to set up. There's a lot of preparation involved. It's not just a case of pushing a car off a cliff and simply filming it as it falls. The car usually has to do something pretty spectacular and exaggerated on the way down, such as the wheels falling off, or something similar, and these all have to be arranged beforehand. You also have to make sure that the car will travel down a pre-determined route . . . we usually manage this by having runners set in the ground which the camera doesn't pick up. And then there's got to be an explosion at the bottom. If the production is a real cheapie the film is sometimes

(Left) *The rigging of car crashes is a common assignment for special effects men today – such as this one from* On Her Majesty's Secret Service

cut when the car reaches the bottom and then the explosion is filmed later, but on most films we have to do the whole thing in one take. There are many ways of doing this, usually we have a wire attached to the car that is doubled back so that when the car reaches the right place the explosives are detonated automatically. Or you can use a gadget which is a plunger in a spring and which needs a hell of an impact to depress it. This is attached to the front of the car so that when it hits the ground it acts as a detonator. Usually you have to have a series of explosives rather than just one big bang . . . more dramatic that way.

'But you mustn't allow yourself to be harassed on these, or any other jobs by either directors or first assistant directors. First assistants are great for harassing you . . . and if they're new boys they can screw up a job as easy as anything. You must be tough enough not to be distracted by anyone. Sometimes that isn't easy, especially if there's that awful moment which sometimes happens when you've worked on a job for ages and you've got everyone waiting for you . . . and the thing doesn't go off. Then you've got to stand up and say, "Well, I'm sorry about this, but what happened was . . ." Or you've got a great big set-up all ready and the director says, "Okay, light up, Les." And you discover you haven't got any matches. That sort of thing really does happen. Another source of trouble is mix-ups over cues. You know . . . the "ready when you are,

Mr DeMille", type of thing. When you have big, complicated jobs you have to be very careful with signals, etc. You can't rely on radio sets either.'

'One film I worked on', said Bill Warrington, 'had a classic case of confusion over cues. There was this group of actors dressed as pirates on a boat who were supposed to dive overboard when the director yelled "pirates". And then he was going to yell "fire it" to let an effects man know he was to set off his explosives in the boat. But this effects man was young and rather too keen to show that he was on the ball and everything. So when the director yelled "pirates" he mistook it for "fire it" and pressed his button. Everything blew up on the boat . . . and *then* you saw the pirates dive overboard . . . in panic.'

'Earlier this year', said Bowie. 'I was working on a film down in Dartmouth and we had to show this very expensive yacht being blown up. Naturally, as we'd only hired the yacht for one day, we couldn't really blow it up. Instead what we were going to do was let the yacht go past and then I was going to explode a raft load of debris. There was a hell of a lot of explosive on the raft, three hundredweight in fact. So of course everything had to work perfectly and a lot of planning had gone into the set-up, it was all timed with the tides, etc. Now the man who was actually going to set off the explosive was out of sight of the camera crew so I had to stand on this rocky promontory where he could see me and I was going to signal. I told him I would raise my hands when everything was ready with the camera crew and only when I dropped my hands was he to fire it. And I said to the cameraman "For heaven's sake, don't let me raise my hands then tell me you've changed your minds."

'So I raised my hands when they said they were ready and had all the cameras running . . . and then they said, "Wait! . . . one of the cameras isn't up to speed." And I was stuck! I couldn't lower my hands because I knew my assistant would take it as the signal to fire. I was stuck like that for a half an hour and my arms were aching like hell. By that time I assumed that my assistant must have realized that something was wrong so I slowly began to lower my arms. It took me five nerve-racking minutes to lower them to the point where I realized that he wasn't going to fire the thing, then I let them drop. No explosion. That sort of thing happens all the time.

'But special effects don't necessarily involve big jobs. Sometimes we're called into a production to perform some minor task that only takes half a day or a day to complete. For instance, during the making of *The Adventures of Barry McKenzie* [Bruce Beresford, 1972] all I had to do was to fix up a gag for this scene where a group of Australians put out a fire by drinking cans of Foster's Lager and urinating on the flames. I fixed them up with football bladders full of beer.'

11/The Future

'Of course, everything has changed a great deal now,' said A. Arnold Gillespie, the man who had been in charge of the MGM special effects department since the 1930s. 'The type of material that is being written nowadays doesn't call for the facilities of the various studio departments. But I have dreams that it will all come back. The public are getting a little fed up right now with the types of film that are around. But there's very little call for special effects now, though the optical departments are still called upon . . . but miniatures are very rare. There's very little matte painting either. Once and awhile something comes along. We made one recently with rabbits. It was supposed to take place in Australia but they decided to change the locale to Arizona. These rabbits are given a poison in the film which is supposed to kill them but instead they grow and grow and become carnivorous. At one time they were supposed to grow as large as rhinos but they finally decided to cut them down to the size of large dogs. The trouble is they don't have the money to spend on special effects these days.

'No, it's gone. But I hope that one day it will all come back, providing we have any studios left for it to come back to. I know in our studio, MGM, the matte painting department has been closed, the art department has been closed and the optical department is now part of the laboratory, and they're kept going mainly by commercials for TV, etc. Now most special effects men are free-lance, they're called in when they're needed. And the major studios are going . . . Columbia and Warner Brothers have merged and possibly 20th Century and MGM will do likewise. So it's grim but still I have not given up hope.'

A similar impression of the decay of the big studios is given by American film maker William Rotsler who described a recent visit to MGM studios.

The auction last year decimated the prop and wardrobe departments to the point where they'd have to rent from outside if they were to do a period picture. Great sheds and barns, once bulging with everything you could imagine, now stand empty. Totally empty.

One lot is completely gone, bulldozed over. Gone is a western town, a European street, docks, fishing village, an enormous cyclorama background sky, the gorgeous 1890 street of *Meet Me in St Louis* [Vincente Minelli, 1944] with those beautiful buildings. Gone are the huge steps from *Julius Caesar* [Joseph Mankiewicz, 1952], and German barracks and airplanes and *Showboat's* [George Sidney, 1951] showboat.

The lot we did go on was number 2 which has the Andy Hardy street, all weedgrown and deserted looking. Nothing is kept up because it, too, is just waiting for the roar of the bulldozers. A midwestern 'anywhere' town square, a European street, a castle, a monastery, a Spanish (or anything) cluster of buildings, churches, a railroad station, lots of huge marvellous gates, villas of several different periods, all of which you have seen again and again in films. There is a small bridge you've seen a hundred times leading to a farm house you've seen seventy-five. Many big fancy houses . . . on one side 17th or 18th century, and on the other side, 15th or 16th.

There is a huge complex of 'New York streets', all very real, all very deserted. Paint peeling, windows broken like a riot just happened, huge plate-glass windows shattered, rags flapping in 4th-storey, blank-eyed rectangles, 'marble' becoming peeling paper. Bits of intricately-carved ornamentation from a cornice lying in the street. Blank windows looking very blank indeed.[75]

Most of the other studios are also selling off their lots to property developers, or are undergoing drastic reorganization, such as the merger between Warners and Columbia. The full-time studio no longer makes economic sense; for instance, it costs 20th Century Fox approximately $3 million a year in rent and other expenses to keep its seventy-six-acre lot operational. The main exception is Universal Studios which, although fully involved with TV production, has also taken the ingenious step of turning its 420 acres into a sort of movie Disneyland.

In 1972 over a million people paid to tour over the Universal lot. As well as the sets from the old Frankenstein and Dracula films, the public can see such things as the full-size mock-up airliner used in *Airport*. There is also a special effects display where a touch of a button can send rain pouring down, cause a tree to be blown out of the ground or set a house on fire. After a few minutes the rain stops, the tree rights itself and the asbestos-protected house stops burning – and everything is ready for the next show. Unlike many of the other studios, Universal still has a special effects department, although it is very different in structure from what it was when John P. Fulton was in charge. The present head of the department is Roland Chiniqui.

The studio situation in Britain is similarly grim. Of the three remaining only Pinewood is not threatened by the property developers. But Pinewood, although the most successful among the British studios, no longer has a special effects department. Instead, it rents out facilities to two free-lance effects men who remain at the studio to handle any jobs required

by production companies who have not hired their own effects man. Pinewood, remember, was where Arthur Rank was going to establish 'the largest and best special effects department in the world' in the late 1940s. At Elstree they still have the optical department headed by Tom Howard, although he in fact only uses the studio as a base and is really a free-lance. Of the three studios, Shepperton has the largest resident staff of effects men, headed by Ted Samuels.

Even free-lance special effects men are having their difficulties these days. In Britain, during the 1960s, due to an influx of American financial backing for film production, British technicians experienced a boom period. But by the end of the decade it was over and the film industry in both America and Britain was hit by a recession. There are nearly a hundred effects men registered in Britain today, many of whom came into the business during the 'boom' years. It is doubtful whether a third of them are regularly employed now, according to veteran Bill Warrington who was himself a casualty of the times.

'The last picture I did was *Cromwell*' [Ken Hughes, 1970], said Warrington, 'then I turned my back on the business. All the kids were cutting each other's throats for work . . . someone would say I only want £25 a day, another would say, I'll do it for £20, another says only £15 . . . to me the whole thing was going down the drain. Ninety-odd people in special effects, why should I have to fight for a day's work after all these years? And the production managers these days play one effects man against the other. So that was the end for me.'

Warrington has gone into another line of business but admits he misses special effects and would like to return to them, despite all the problems. His long-time associate, Les Bowie, is more optimistic about the future of effects.

'There are going to be great changes over the next ten years in film making. Film on film is going to become a backwater, instead it will be videotape on film. Now, that might not be much good for the average cameraman but it's going to be very good for art directors and special effects men . . . because we deal with the *visual* parts of moving pictures which are essential in either the cinema or television. And as this trend of cutting production costs down to an absolute minimum continues special effects men are going to become much more vital. To re-create anything that no longer exists, such as old London, you've either got to build a huge, expensive set, or you can do it with special effects. I can see a lot of the old techniques, such as matte paintings and hanging miniatures, coming back into the business in a big way. No, I'm quite optimistic about the future of special effects.'

Appendices

APPENDIX I
Notes on some Movie Magicians

The following appendix contains additional information about many of the people who are mentioned in this book, as well as information about others who have made important contributions to the special effects field. The list of credits is by no means complete but merely includes the more well-known films that the various people have been involved with. (Nationality is American unless otherwise stated.)

ABBOTT, L. B.
Head of the special effects department at 20th Century Fox. Credits include *The Fly* (1958), *The Diary of Anne Frank* (1959), *The Lost World* (1960), *Voyage to the Bottom of the Sea* (1960), *Cleopatra* (1963), *The Sound of Music* (1965), *Our Man Flint* (1965), *The Sand Pebbles* (1966), *Dr Dolittle* (1967), *Planet of the Apes* (1967), *Patton* (1969), *Tora! Tora! Tora!* (1970), *The Poseidon Adventure* (1972).

ALLEN, IRWIN
Producer/director whose various films and TV projects over the years have utilized special effects to a large degree. Born in New York in 1916, he studied journalism and advertising at Columbia University. Went to Hollywood at the age of twenty-two as editor of *Key* magazine. Within a year he was writing, directing and producing a one-hour radio show which was a big success and eventually ran for eleven years. As a result the Atlas Feature Syndicate offered him his own Hollywood news column. Called 'Hollywood Merry-Go-Round' it was soon appearing in seventy-three newspapers around the world. In 1944 he started a literary agency and was soon representing such people as P. G. Wodehouse and Ben Hecht. With the arrival of TV he created the first celebrity panel show which, like his earlier radio show, was also very successful. In 1951 he began producing films for RKO – *Double Dynamite* and *Where Danger Lives* followed by *A Girl in Every Port* in 1953. While still at RKO Allen made a film version of Rachel Carson's famous book *The Sea around Us* which he directed as well as writing the screenplay. The film won him an Academy Award in 1953. By this time he had dropped all his other activities and was concentrating on film production. He then filmed for Windsor Productions and made, for Warner Brothers, *The Animal World* in 1956 (a slick, pseudo-documentary, the best feature of which was the animation contribution by Willis H. O'Brien and Ray Harryhausen) and

The Story of Mankind (1957). He directed as well as produced them. In 1960 he re-made *The Lost World*, followed by *Voyage to the Bottom of the Sea* in 1960, and Jules Verne's *Five Weeks in a Balloon* in 1962. In 1964 he returned to TV and produced, for 20th Century Fox, a TV series based on his film *Voyage to the Bottom of the Sea*. Other science fiction TV series followed – such as *Lost in Space*, *The Time Tunnel*, *Land of the Giants* and *City beneath the Sea*. The pilot episode of the latter series was released outside the USA as a feature film entitled *One Hour to Doomsday* (1968) – and its TV origin was more than a little apparent. Allen's TV series share a common disregard for logic and scientific facts but do possess a sort of zany attraction. Talking about one of his TV series, Allen once said: '. . . if I can't blow up the world within the first ten minutes, then the show is a flop.'[77] His latest film production is the successful, Academy Award-winning *The Poseidon Adventure* (1972).

BALLANGER, RON (British)
Films include *The Heroes of Telemark* (1965), *Those Magnificent Men in their Flying Machines* (1965), and *Oh! What a Lovely War!* (1969).

BLACKWELL, GEORGE (British)
Films include *The Dam Busters* (1955), *Moby Dick* (1954–6) (uncredited), *Masque of the Red Death* (1964), *The Secret Invasion* (1964), and *She* (1965). Now retired.

BUTLER, LAWRENCE W.
Films include *The Thief of Bagdad* (1940), *That Hamilton Woman* (1941), *Jungle Book* (1942), *The Devil at 4 O'Clock* (1961), *Man with the X-Ray Eyes* (1963), *In Harm's Way* (1964), and *Marooned* (1969).

COCTEAU, JEAN (French)
French film maker (also poet, novelist, essayist, playwright and graphic artist) whose surreal, supernatural films often contain impressive photographic effects. One of Cocteau's most impressive effects occurs in *The Blood of a Poet* (1930) when the poet seems to enter a mirror. This was achieved by substituting a vat of water for the mirror. The camera was placed on its side, the various props were nailed above the vat and the actor then dived into it. The cutting was so skilful that the illusion is extremely effective. A variation of this same device was later used in *Orpheus* (1950) when there is a close-up of Orpheus putting his hands into a mirror. In this case mercury was used instead of water. *The Blood of a Poet* also includes an impressive sequence in which a statue comes to life – particularly stunning is the close-up of one of the plaster arms with veins slowly appearing in it. The special effects in that film were handled by Georges Perinal, who was assisted by Preben Engberg. In his book *Jean Cocteau*, René Gilson says of Cocteau's films: '. . . the trick shots are used as a means of expression, and not to make an impression. By intentional sobriety and abstinence from wild and facile fantasy, or from staginess, by new inventiveness and ingenuity, these shots are true to the tradition of Méliès.'[78] But the comparison to Méliès is not really a legitimate

one, as Méliès used trick effects as ends in themselves whereas Cocteau, as Gilson points out, only ever used effects to create or complement a mood.

COSGROVE, JACK

Described by the *American Cinematographer* magazine as: 'One of the pioneers of trick photography and has done much to further special effects; and also has many beautiful oil paintings to his credit.' After leaving school Cosgrove worked in a leading society-portrait studio in Kansas City for four years until, in 1927, he won the national photographic contest conducted by *Screenland Magazine*. This took him to Hollywood and he made his start in pictures working for Cecil B. DeMille. He later became head of the RKO special effects department. Worked on *Gone With the Wind* (1939), *Rebecca* (1940), and *Spellbound* (1945).

CRUICKSHANK, ART

Optical effects expert. Worked with L. B. Abbott at 20th Century Fox on several pictures. Credits include *Fantastic Voyage* (1966), *Planet of the Apes* (1967), *Dr Dolittle* (1967), and *Patton* (1969).

DAY, PERCY (French)

Born in France, he began his career as an apprentice to a photographer at the age of fifteen. Later trained as an artist and then went into films. Worked on several French films before moving to England where he gained the reputation of being the greatest exponents of the matte painting shot. Joined Alexander Korda in 1946 and was head of the effects department at Shepperton studios until his retirement at the age of eighty-four.

DUNN, LINWOOD

One of Hollywood's top optical effects experts. He began his film career in New York in 1923. In 1926 he joined the Pathé company and went to Hollywood to photograph serials. He joined RKO Studios in 1929 and during the following years he was an optical effects cameraman, a director of photography and finally head of the RKO photographic effects department until the time of RKO's closing and subsequent sale to Desilu Productions in 1957. In collaboration with his long-time associate, Cecil Love, and the Acme Tool and Manufacturing Company, he designed the first modern special effects optical printer for the US armed forces' photographic units. These printers subsequently became the standard for all Hollywood major studios and film laboratories. Films he has worked on include *Citizen Kane* (1940), *West Side Story* (1961), *It's a Mad, Mad, Mad, Mad, World* (1963), and *Hawaii* (1966). Still active in the industry, he is involved with a company called Film Effects of Hollywood.

FABIAN, MAXIMILIAN

MGM miniature specialist. Worked on *San Francisco* (1936), and *Mrs Miniver* (1942).

FREUND, KARL (German)

The cameraman who was most responsible for the visual impact of German

films during the 1920s. Born in 1890 he became an assistant projectionist at the age of fifteen and worked his way up from there to the position of cameraman. In 1920, with Guido Seeber, he filmed *The Golem* which involved some very impressive trick photography. He later worked on Lang's *Metropolis* (1927). Went to America in the late 1920s and joined Universal. One of his first assignments was to film *Dracula* (1930), the picture that ushered in the horror/fantasy cycle in America. Also for Universal he photographed John Ford's *Air Mail* (1932) and directed *The Mummy* (1932). On all three of the above films he worked with John P. Fulton. During the next two decades Freund worked on a large number of films for Universal, MGM and Warner Brothers. He went into TV production in the early 1950s and retired in 1959. He died in 1970 at the age of eighty.

GANCE, ABEL (French)
French film pioneer and innovator. Experimented with weird optical effects in his 1915 film *The Madness of Dr Tube* (*La folie du Dr Tube*) which utilized distorting lenses and trick photography to show the insanity of a scientist experimenting with breaking up light waves.

GILLESPIE, A. ARNOLD
Worked on both versions of *Ben-Hur* (1925 and 1959), both versions of *Mutiny on the Bounty* (1935 and 1963), *The Wizard of Oz* (1939), *Mrs Miniver* (1942), *Thirty Seconds over Tokyo* (1944), and *Forbidden Planet* (1956). He has over 300 credits on pictures as a special effects man and approximately 280 credits as an art director.

GORDON, BERT I.
Producer/director who specializes in low-budget effects films, such as *The Cyclops* (1956), and *The Magic Sword* (1962).

HAMMERAS, RALPH
Nominated for an Academy Award in 1928 for his 'engineering effects' in *The Private Life of Helen of Troy*. Was credited as effects director on *Just Imagine* (1930). Other films he has worked on include *Deep Waters* (1948), and *20,000 Leagues under the Sea* (1954).

HASKIN, BYRON
Born 1899. Early professions included cartooning, advertising and industrial photography. Entered the film industry as a cameraman for the Pathé Company. In 1920 he became an assistant director for Selznick, then a camera assistant, and finally, in 1923, a fully-fledged cameraman. In 1927 he directed two pictures for Warner Brothers and Columbia respectively – *Ginsberg the Great* and *The Siren*. He returned to cinematography after this and did not direct again until 1947. In 1934 he assisted cameraman Hal Mohr, together with Fred Jackman and H. Koenekamp, with the filming of *A Midsummer Night's Dream*. Around 1936–7 Haskin took over as head of Warner Brothers' special effects department, a position he held until the late 1940s. In 1947 he returned to directing with *Too Late for Tears* and in 1953 was

hired by George Pal to direct *The War of the Worlds*. Films he has directed since then include *The Naked Jungle* (1954), *Long John Silver* (1955), *The Conquest of Space* (1955), *From Earth to the Moon* (1958), *Robinson Crusoe on Mars* (1964), and *The Power* (1967) (co-directed with George Pal).

HITCHCOCK, ALFRED (British)
The special effects in a Hitchcock picture are usually of a higher standard than those found in the pictures of most other directors. Hitchcock, like Kubrick, has always been involved with all the facets of his productions, and has been aware that careless special effects can damage a whole picture. As far back as *Blackmail*, made in Britain in 1929, Hitchcock used special effects to good advantage. In *Blackmail* he used the Shuftan Process (see page 27) for a sequence inside the British Museum. Talking about this to François Truffaut, Hitchcock made the comment that: '. . . the producers knew nothing about Shuftan Process and they might have raised objections, so I did all this without their knowledge.'[79] The miniatures in Hitchcock's pictures are also of a very high standard, such as the model of the 'Manderley' mansion in *Rebecca* (1940). It is interesting to note that the famous staircase in *Vertigo* (1958) was also a miniature – filmed lying on its side. Other special effects techniques have been exploited by Hitchcock with above-average ingenuity over the years, such as the rear projection process. An example is given on page 50 in the description of the novel way a transparency screen was used during the making of *Foreign Correspondent* (1940). Other examples include the sequence at the climax of *Saboteur* (1940) when the villain falls from the upraised hand of the Statue of Liberty. Rear projection process was also used to good effect in *The Birds* (1963) in the scenes where the schoolchildren are attacked by the crows while running down the hill. *The Birds* as a whole is full of extremely well-executed special effects of varying types. Lawrence Hampton handled the mechanical effects while the optical effects, such as the rear process scenes and also the large amount of travelling matte shots that the picture contains, were under the control of the great Ub Iwerks. Hitchcock also knows when *not* to take advantage of special effects. During the making of *Psycho* (1960) the effects men built a plastic torso, capable of spurting blood when slashed with a knife, for use in the sequence where Janet Leigh is murdered in the shower stall. But Hitchcock decided to rely on editing alone to achieve his effect – with highly successful results. Hitchcock can also claim the rare distinction of having made an entire picture within the confines of a studio tank. The picture was, of course, *Lifeboat* (1943).

During his career he has worked with most of the top effects experts, such as Lee Zavitz – *Foreign Correspondent* (1940); Vernon Walker – *Mr and Mrs Smith, Suspicion* (both 1941), and *Notorious* (1946); Fred Sersen – *Lifeboat* (1943); Jack Cosgrove – *Spellbound* (1945); H. Koenekamp – *Strangers on a Train* (1951); John P. Fulton – *Rear Window* (1954), *To Catch a Thief* (1955), *The Man Who Knew Too Much* (1956), and *Vertigo* (1958); A. Arnold Gillespie – *North by Northwest* (1959); and Ub Iwerks – *The Birds* (1963).

HOAG, ROBERT R.
In charge of optical effects for A. Arnold Gillespie at MGM from the late 1950s.

Credits include *The Big Circus* (1959), *Ask Any Girl* (1959), *Green Mansions* (1959), *The Wonderful World of the Brothers Grimm* (1962), *Mutiny on the Bounty* (1962), *The Greatest Story ever Told* (1965), *Ice Station Zebra* (1968), and *Soylent Green* (1972).

HORSLEY, STANLEY
Succeeded John P. Fulton as head of the Universal effects department. Son of David Horsley, pioneer film producer.

IWERKS, UB
Films include *The Living Desert* (1953), *20,000 Leagues under the Sea* (1954), *The Parent Trap* (1961), and *The Birds* (1963).

JACKMAN, FRED
Miniature expert. Formed his own independent special effects organization in the late 1930s. Worked on *Noah's Ark* (1929). Still active in the 1960s doing TV work (filmed *Here Comes the Bride*).

JENNINGS, GORDON (see Chapters 3 and 8)

JOHNSON, J. McMILLAN
Films include *Portrait of Jennie* (1948), *The Greatest Story ever Told* (1965), and *Ice Station Zebra* (1968).

KELLOG, RAY
For many years the head of the effects department at 20th Century Fox (on his retirement he was replaced by L. B. Abbott). Worked on *The Rains of Ranchipur* which was the 1955 remake of *The Rains Came* (1939).

KOSA, JNR, EMIL
Worked with L. B. Abbott at 20th Century Fox (see credits for Abbott).

LEBLANC, LEE
A matte painter who worked for many years under Ray Kellog at 20th Century Fox. Was hired by A. Arnold Gillespie to take over the MGM matte painting department when Warren Newcome retired (in 1958). As well as matte painting he also assisted Gillespie in handling other types of special effects. Films that he received a credit on include *Watusi* (1958), *The World, the Flesh and the Devil* (1959), *Ben-Hur* (1959), *Atlantis, the Lost Continent* (1959), *King of Kings* (1961), and *Mutiny on the Bounty* (1962). He retired in 1963.

LOHMAN, AUGUST
Films include *Moby Dick* (1954–6), *The Rebel Set* (1959), *The Horse Soldiers* (1959), *The Last Voyage* (1960), *From Hell to Eternity* (1960), *Captain Sinbad* (1963), *Major Dundee* (1964), *Barbarella* (1967), *Candy* (1968), and *Soylent Green* (1972).

LOURIE, EUGENE
Like Byron Haskin, Eugene Lourie has been a special-effects orientated

director and most of his directing assignments have been concerned with films of a science fiction nature. During his career in the film industry Lourie has not only worked as a director but also as an art director, a production designer, a second unit director, script writer, TV director and a technical consultant. Born in 1905 he went to Paris in 1921 where he studied painting and design. He worked on three early French films as a costume designer before moving to the USA in 1942. The films he has directed include *The Beast from 20,000 Fathoms* (1953) (he was also the production designer), *The Colossus of New York* (1958), *Behemoth the Sea Monster* (1958), and *Gorgo* (1960) (for which he also wrote the story with Daniel Hyatt). As a production designer his credits include *This Land Is Mine* (1943), *Flight from Ashiya* (1963), and *Krakatoa – East of Java* (1969) (he was also effects supervisor on this). As an art director he has worked on *Limelight* (1952), *Battle of the Bulge* (1965), *Royal Hunt of the Sun* (1969), and *What's the Matter with Helen?* (1971).

LYDECKER, HOWARD J.
Was resident effects man, along with his brother Theodore, of the Republic studios for many years. Films he worked on include *Women in War* (1940), *Flying Tigers* (1942), *HMS Defiant* (1962), *Flight of the Phoenix* (1965), and *Dr Dolittle* (1967).

MENZIES, WILLIAM CAMERON
Although he is best known as the director of *Things to Come*, Menzies was also one of Hollywood's top production designers and was, in fact, described as 'probably the most influential designer in the Anglo-American cinema'. Scottish-born, Menzies was brought into the film industry by cinematographer Arthur Miller in 1918, when Menzies was twenty-one years old, to work on a picture called *The Naulaka* (1918). Miller had met Menzies in a restaurant he used to visit regularly – at that time Menzies was attending an art school for half the day and spending the rest of his time working in an antique shop. One of his tasks on *The Naulaka* was to help construct a mock-up of the interior of the Taj Mahal, composed entirely of cardboard cut-outs. Menzies soon established himself as a highly inventive and imaginative set designer and was hired by Douglas Fairbanks in 1923 to design the sets for his *Thief of Bagdad* epic. In 1928 Menzies won the first Academy Award to be given for art direction (called 'Interior Decoration' at the time). He received it for his work on *The Dove*. In 1929 he was nominated for another Academy Award, this time for *The Iron Mask*, and in the same year designed the sets for D. W. Griffith's *Lady of the Pavements*. He worked again for Griffith the following year on *Abraham Lincoln*. In the 1930s, as well as continuing with his designing, Menzies turned to directing. In 1932 he co-directed, with Ray Taylor, *Chandu the Magician* and in 1934 Alexander Korda invited him to Britain to direct *Things to Come*. In 1939 he designed the sets for *Gone With The Wind* and also worked again for Korda on the second version of *The Thief of Bagdad*. He returned to directing in 1944 with *Address Unknown*. Other films he directed include *Drums in the Deep South* (1951), *The Whip Hand* (1952), *Invaders from Mars* (1953), and *The Maze* (1954). His last major assign-

ment was as associate producer on *Around the World in 80 Days* (1956) (also the last film that Ned Mann, Menzies long-time associate, was involved with). Menzies died in 1957 at the age of sixty.

POMEROY, ROY J.
One of the pioneers in the development of a travelling matte process. With Fred Moran he handled the parting of the Red Sea in the 1923 version of *The Ten Commandments*.

SAMUELS, TED (British)
Present head of the special effects department at Shepperton studios, England. Has worked on *Road to Hong Kong* (1961), *The War Lover* (1962), *Tomb of Ligeia* (1964), *The Best House in London* (1969), and *The Asphyx* (1972).

SEAWRIGHT, ROY
Effects man at the Hal Roach studio during the 1930s and early 1940s. Worked on *Topper Takes a Trip* (1939), and *One Million BC* (1940).

SERSEN, FRED
Specialized in studio tank work. The giant tank at 20th Century Fox was named after him. Worked on such films as *The Rains Came* (1939), *The Black Swan* (1942), *Lifeboat* (1943), and *Crash Dive* (1943). Won two Academy Awards for his work.

WALKER, VERNON L.
Worked on *Citizen Kane* (1940), *Swiss Family Robinson* (1940), *Days of Glory* (1944), and *Notorious* (1946).

WELDON, ALEX
Films include *The Longest Day* (1960), *El Cid* (1961), *55 Days in Peking* (1962), *Battle of the Bulge* (1965), *Krakatoa – East of Java* (1969), *Patton* (1969), *Lost Horizon* (1972), and *Oklahoma Crude* (1973).

WILLIAMS, FRANK D.
His patent application in 1918 for a travelling matte process that he developed was the earliest to be made in the USA. He later opened the Frank Williams Laboratory which specialized in process photography. It was while working for Williams that John P. Fulton first became interested in special effects.

YOUNG, FRANK WILLIAM
He joined the Hal Roach studio as a cameraman after the First World War. In 1927 he went into partnership with his brother Elmer Young, who was one of the pioneer animators of the industry, and opened the Kinex Studios. During the following four years they made forty-eight films featuring animated dolls. Young was then hired by Universal to shoot an expensive miniature of New York, the first miniature to be filmed in Technicolor. His brief assignment stretched into a year and a half which he spent in the

effects department working under John P. Fulton. He later returned to the Roach studio to build an optical printer and process (rear projection) projector. Among the films he worked on was *One Million BC* (1940).

ZAVITZ, LEE
A mechanical effects expert whose credits include *The Hurricane* (1937), *Gone With the Wind* (1939) (he burned Atlanta), *Rebecca* (1940), *Foreign Correspondent* (1940), *Destination Moon* (1950), *Around the World in 80 Days* (1956), *From Earth to the Moon* (1958), *On the Beach* (1959), *The Alamo* (1960), *The Train* (1964), and *Castle Keep* (1969). He also contributed to many of John Ford's early films. The two most unforgettable pictures he worked on, he said, were *Foreign Correspondent* and *Destination Moon*. He is now retired and busy trying to catch salmon in Canada.

APPENDIX II
The Academy Awards

The Academy of Motion Picture Arts and Sciences, the membership of which consists of those involved with the Hollywood film industry, was formed in 1927. Awards were first handed out at the annual Academy banquet in May 1929. To qualify for award recognition a film has to be shown in a commercial theatre in the Los Angeles area for not less than a week. All members of the Academy are eligible to vote.

The category of special effects was not included in the Academy Awards until 1939 – although in 1928 (the year that the awards began) there was an award given for 'Engineering Effects'. In 1931 the category of 'Scientific or Technical' Awards was introduced and in 1938 there was a special award honouring the achievements of both special effects and sound effects men. Between 1939 and 1948 the names of all the people who were on the effects of both the winning and nominated films were listed in full, but from 1949 to 1956 only the names of the various studios that produced the films received a mention (although the individual effects men still received their awards). This was a reaction to the situation caused by the 1948 winner *Portrait of Jennie* on which six different effects men received a credit. Today the Academy will make an award on any one of five categories of special effects (which now comes under the heading of *visual* effects) but they will only award up to *three* effects awards to any *one* picture.

1927–8 'Engineering Effects'
 Winner: *Wings* (William Wellman) Roy Pomeroy.
Nominated: *The Private Life of Helen of Troy* (Alexander Korda) Ralph
 Hammeras.
Nominated: *The Jazz Singer* (Alan Crossland) Nugent Slaughter.

1930–1 'Scientific or Technical' (new category).
 Class II – to Fox Film Corporation for the effective use of Synchro-
 Projection Composite Photography.

1938 'Special Award'
 For outstanding achievements in creating special photographic
 and sound effects in the Paramount production of *Spawn of the*
 North (Henry Hathaway). Special effects by Gordon Jennings,
 assisted by Jan Domela, Dev Jennings, Irmin Roberts and Art

Smith. Transparencies by Farciot Edouart, assisted by Loyal Griggs.
'Scientific or Technical'
Class III – to Byron Haskin and the special effects department at Warner Brothers.

1939 'Special Effects' (new category).
 Winner: *The Rains Came* (Clarence Brown) E. H. Hansen, Fred Sersen.
Nominated: *Gone With the Wind* (Victor Fleming) John R. Cosgrove, Fred Albin, Arthur Johns.
Nominated: *Only Angels Have Wings* (Howard Hawks) Roy Davidson, Edwin C. Hahn.
Nominated: *Private Lives of Elizabeth and Essex* (Michael Curtiz) Byron Haskin, Nathan Levinson.
Nominated: *Topper Takes a Trip* (Norman Z. McLeod) Roy Seawright.
Nominated: *Union Pacific* (Cecil B. DeMille) Farciot Edouart, Gordon Jennings, Loren Ryder.
Nominated: *The Wizard of Oz* (Victor Fleming) A. Arnold Gillespie, Douglas Shearer.

1940
 Winner: *The Thief of Bagdad* (Ludwig Bergen, Tim Whelan, Michael Powell) Lawrence Butler, Jack Whitney.
Nominated: *The Blue Bird* (Walter Lang) Fred Sersen, E. H. Hansen.
Nominated: *Boom Town* (Jack Conway) A. Arnold Gillespie, Douglas Shearer.
Nominated: *The Boys From Syracuse* (Edward Sutherland) John P. Fulton, Bernard B. Brown, Joseph Lapis.
Nominated: *Dr Cyclops* (Ernest B. Schoedsack) Farciot Edouart, Gordon Jennings.
Nominated: *Foreign Correspondent* (Alfred Hitchcock) Paul Eagler, Thomas T. Moulton.
Nominated: *One Million BC* (Hal Roach, Hal Roach Jr., D. W. Griffith) Roy Seawright, Elmer Raguse.
Nominated: *Rebecca* (Alfred Hitchcock) Jack Cosgrove, Arthur Johns.
Nominated: *The Sea Hawk* (Michael Curtiz) Byron Haskin, Nathan Levinson.
Nominated: *Swiss Family Robinson* (Edward Ludwig) Vernon L. Walker, John O. Aalberg.
Nominated: *Typhoon* (Louis King) Farciot Edouart, Gordon Jennings, Loren Ryder.
Nominated: *Women in War* (John H. Auer) Howard J. Lydecker, William Bradford, Herbert Norsch, Ellis J. Thackery.

1941
 Winner: *I Wanted Wings* (Mitchell Leisen) Farciot Edouart, Gordon Jennings, Louis Mesenkop.
Nominated: *Aloma of the South Seas* (Alfred Santell) Farciot Edouart, Gordon Jennings, Louis Mesenkop.
Nominated: *Flight Command* (Frank Borzage) A. Arnold Gillespie, Douglas Shearer.

Nominated: *The Invisible Woman* (A. Edward Sutherland) John P. Fulton.
Nominated: *The Sea Wolf* (Michael Curtiz) Byron Haskin, Nathan Levinson.
Nominated: *That Hamilton Woman* (Alexander Korda) Lawrence Butler,
 William H. Wilmarth.
Nominated: *Topper Returns* (Roy Del Ruth) Roy Seawright, Elmer Raguse.
Nominated: *A Yank in the RAF* (Henry King) Fred Sersen, E. H. Hansen.

1942
 Winner: *Reap the Wild Wind* (Cecil B. DeMille) Farciot Edouart, Gordon
 Jennings, W. L. Pereira, Louis Mesenkop.
Nominated: *The Black Swan* (Henry King) Fred Sersen, Roger Heman, George
 Leverett.
Nominated: *Desperate Journey* (Raoul Walsh) Byron Haskin, Nathan Levinson.
Nominated: *Flying Tigers* (David Miller) Howard J. Lydecker, Daniel J.
 Bloomberg.
Nominated: *The Invisible Agent* (Edwin L. Marin) John P. Fulton, Bernard B.
 Brown.
Nominated: *Jungle Book* (Zoltan Korda) Lawrence Butler, William H. Wilmarth.
Nominated: *Mrs Miniver* (William Wyler) A. Arnold Gillespie, Warren
 Newcombe, Douglas Shearer.
Nominated: *The Navy Comes Through* (Edward Sutherland) Vernon L. Walker,
 James G. Stewart.
Nominated: *One of Our Aircraft Is Missing* (Michael Powell) (British) Ronald
 Neame, C. C. Stevens.
Nominated: *Pride of the Yankees* (Sam Wood) J. Cosgrove, Ray Binger,
 Thomas T. Moulton.

1943
 Winner: *Crash Dive* (Archie Mayo) Fred Sersen, Roger Heman.
Nominated: *Air Force* (Howard Hawks) Hans Koenekamp, Rex Wimpy,
 Nathan Levinson.
Nominated: *Bombardier* (Richard Wallace) Vernon L. Walker, James G.
 Stewart, Roy Granville.
Nominated: *The North Star* (Lewis Milestone) Clarence Slifer, R. O. Binger,
 Thomas T. Moulton.
Nominated: *So Proudly We Hail* (Mark Sandrich) Farciot Edouart, Gordon
 Jennings, George Dutton.
Nominated: *Stand by for Action* (Robert Z. Leonard) A. Arnold Gillespie,
 Donald Jahraus, Michael Steinore.
 Special Award to George Pal for the development of novel
 methods and techniques in the production of short subjects
 known as Puppetoons.

1944
 Winner: *Thirty Seconds Over Tokyo* (Mervyn Leroy) A. Arnold Gillespie,
 Donald Jahraus, Warren Newcombe, Douglas Shearer.
Nominated: *The Adventures of Mark Twain* (Irving Rapper) Paul Detlefsen,
 John Crouse, Nathan Levinson.
Nominated: *Days of Glory* (Jacques Tourneur) Vernon L. Walker, James G.
 Stewart, Roy Granville.

Nominated: *Secret Command* (Eddie Sutherland) David Allen, Ray Cory, Robert Wright, Russell Malmgren, Harry Kusnick.
Nominated: *The Story of Dr Wassel* (Cecil B. DeMille) Farciot Edouart, Gordon Jennings, George Dutton.
Nominated: *Wilson* (Henry King) Fred Sersen, Roger Heman.

1945

Winner: *Wonder Man* (Bruce Humberstone) John P. Fulton, A. W. Johns.
Nominated: *Captain Eddie* (Lloyd Bacon) Fred Sersen, Sol Halprin, Roger Heman, Harry Leonard.
Nominated: *Spellbound* (Alfred Hitchcock) Jack Cosgrove.
Nominated: *They Were Expendable* (John Ford) A. Arnold Gillespie, Donald Jahraus, R. A. MacDonald, Michael Steinmore.
Nominated: *A Thousand and One Nights* (Alfred E. Green) Laurence Butler, Ray Bomba.

1946

Winner: *Blithe Spirit* (David Lean) (British) Tom Howard.
Nominated: *A Stolen Life* (Curtis Bernhardt) William McGann, Nathan Levinson.

1947

Winner: *Green Dolphin Street* (Victor Saville) A. Arnold Gillespie, Warren Newcombe, Douglas Shearer, Michael Steinmore.
Nominated: *Unconquered* (Cecil B. DeMille) Farciot Edouart, Gordon Jennings, Devereux Jennings, Wallace Kelley, Paul Lerpae, George Dutton.

1948

Winner: *Portrait of Jennie* (William Dieterle) Paul Eagler, J. McMillan Johnson, Russell Shearman, James C. Stewart, Clarence Slifer, Charles Freeman.

1949

Winner: *Mighty Joe Young* (Ernest B. Schoedsack) RKO Radio (Willis H. O'Brien).
Nominated: *Tulsa* (Stuart Heisler) Eagle Lion (John P. Fulton).

1950

Winner: *Destination Moon* (Irving Pichel) Eagle Lion (Lee Zavitz).
Nominated: *Samson and Delilah* (Cecil B. DeMille) Paramount (Gordon Jennings).

From 1951 to 1953 special effects were classified as 'another' Award – which meant that it would not necessarily be given each year; therefore there were no nominations during these years.

1951

Winner: *When Worlds Collide* (Rudolph Mate) Paramount (Gordon Jennings).

1952

Winner: *Plymouth Adventure* (Clarence Brown) MGM (A. Arnold Gillespie).

1953
 Winner: *War of the Worlds* (Byron Haskin) Paramount (Gordon Jennings).

1954
 Winner: *20,000 Leagues under the Sea* (Richard Fleischer) Walt Disney
 (Ub Iwerks).
Nominated: *Hell and High Water* (Samuel Fuller) 20th Century Fox (Ray
 Kellog).
Nominated: *Them!* (Gordon Douglas) Warner Brothers.

1955
 Winner: *The Bridges at Toko-Ri* (Mark Robson) Paramount (John P.
 Fulton).
Nominated: *The Dam Busters* (Michael Anderson) (British) Warner Bros.,
 (George Blackwell).
Nominated: *The Rains of Ranchipur* (Jean Negulesco) 20th Century Fox
 (Ray Kellog).

1956
 Winner: *The Ten Commandments* (Cecil B. DeMille) John P. Fulton.
Nominated: *Forbidden Planet* (Fred McLeod Wilcox) A. Arnold Gillespie,
 Irving Ries, Wesley C. Miller.

1957
 Winner: *The Enemy Below* (Dick Powell) Walter Rossi.
Nominated: *The Spirit of St Louis* (Harvey Roberts) Louis Lichtenfield.

1958
 Winner: *Tom Thumb* (George Pal) (British) Tom Howard.
Nominated: *Torpedo Run* (Joe Pevney) A. Arnold Gillespie, Harold Humbrock.

1959
 Winner: *Ben-Hur* (William Wyler) A. Arnold Gillespie, Robert
 MacDonald, Milo Lory.
Nominated: *Journey to the Centre of the Earth* (Henry Levin) L. B. Abbott,
 James B. Gordon, Carl Faulkner.

1960
 Winner: *The Time Machine* (George Pal) Gene Warren, Tim Baar.
Nominated: *The Last Voyage* (Andrew L. Stone) A. J. Lohman.

1961
 Winner: *The Guns of Navarone* (J. Lee Thompson) (British) Bill Warrington,
 Vivian C. Greenham.
Nominated: *The Absent-Minded Professor* (Robert Stevenson) Robert A.
 Mattey, Eustace Lycett.

1962
 Winner: *The Longest Day* (Ken Annakin, Andrew Marton) Robert
 MacDonald, Jaques Maumont.
Nominated: *Mutiny on the Bounty* (Lewis Milestone) A. Arnold Gillespie,
 Milo Lory.

1963
 Winner: *Cleopatra* (Joseph Mankiewicz) Emil Kosa Jr.
Nominated: *The Birds* (Alfred Hitchcock) Ub Iwerks.

1964
 'Visual Effects' (new category).
 Winner: *Mary Poppins* (Robert Stevenson) Peter Ellenshaw.
Nominated: *The Seven Faces of Dr Lao* (George Pal) Jim Danforth.

1965
 Winner: *Thunderball* (Terence Young) (British) John Stears.
Nominated: *The Greatest Story Ever Told* (George Stevens) J. McMillan
 Johnson.

1966
 Winner: *Fantastic Voyage* (Richard Fleischer) Art Cruickshank.
Nominated: *Hawaii* (George Roy Hill) Linwood G. Dunn.

1967
 Winner: *Dr Dolittle* (Richard Fleischer) L. B. Abbott.
Nominated: *Tobruk* (Arthur Hiller) Howard A. Anderson Jr., Albert
 Whitlock.

1968
 Winner: *2001 : A Space Odyssey* (Stanley Kubrick) Stanley Kubrick.
Nominated: *Ice Station Zebra* (John Sturges) Hal Millar, J. McMillan Johnson.

1969—70
 Winner: *Marooned* (John Sturges) Robie Robertson.
Nominated: *Krakatoa – East of Java* (Bernard Kowalski) Eugene Lourie,
 Alex Weldon.

1970—1
 Winner: *Tora, Tora, Tora* (Richard Fleischer) L. B. Abbott, A. D. Flowers.
Nominated: *Patton* (Franklin Schaffner) Alex Weldon.

1971—2
 Winner: *Bedknobs and Broomsticks* (Robert Stevenson) Danny Lee,
 Eustace Lycett, Alan Maley.
Nominated: *When Dinosaurs Ruled the Earth* (Val Guest) Jim Danforth,
 Roger Dicken.

1972—3
 Winner: *The Poseidon Adventure* (Ronald Neame) L. B. Abbott, A. D.
 Flowers.
No Nominations.

Reference Notes

1. *American Cinematographer*, March 1965.
2. *Los Angeles Herald Examiner*, 27 February 1972.
3. *Sight and Sound*, Summer 1938.
4. Kevin Brownlow, *The Parade's Gone By* . . . Secker and Warburg.
5. Ibid.
6. Leonard Maltin, *Behind the Camera*, New American Library.
7. Kevin Brownlow, *The Parade's Gone By* . . .
8. Ibid.
9. Ibid.
10. *Cecil B. DeMille – Autobiography*, W. H. Allen.
11. *American Cinematographer*, October 1946.
12. *American Cinematographer*, March 1933.
13. Reprinted from material in the possession of Mrs John Fulton.
14. *American Cinematographer*, March 1933.
15. Ibid.
16. Leonard Maltin, *Behind the Camera*.
17. *American Cinematographer*, June 1942.
18. Ibid.
19. *American Cinematographer*, March 1933.
20. From the BFI files, reviewer unknown.
21. *American Cinematographer*, December 1947.
22. *Cecil B. DeMille – Autobiography*.
23. Phil A. Koury, *Yes, Mr DeMille*, G. P. Putnam and Sons.
24. Kevin Brownlow, *The Parade's Gone By* . . .
25. *American Cinematographer*, December 1947.
26. *American Cinematographer*, June 1942.
27. *Popular Science Monthly*, November 1932.
28. A film review by Harrison Carroll, November 1932 (original publication unknown).
29. *Saturday Evening Post*, 6 December 1947.
30. *American Cinematographer*, December 1945.
31. *Spectator*, December 1940.
32. Leonard Maltin, *Behind the Camera*.
33. *Amateur Photographer*, August 1971.
34. Ibid.
35. Ibid.
36. Anthony Amaral, *Movie Horses: Their Treatment and Training*.
37. *Film Review*, December 1972.
38. Ibid.
39. *Los Angeles Herald Examiner*, February 1972
40. Ibid.
41. *Films and Filming*, December 1971.
42. Leonard Maltin, *Behind the Camera*.

43. *American Cinematographer*, March 1943.
44. Andrew Sarris, *Hollywood Voices*.
45. *American Cinematographer*, February 1971.
46. Ibid.
47. Ibid.
48. *Kine Weekly*, 5 March 1925.
49. *Cinefantastique*, Winter 1971.
50. *New York Times*, 21 September 1969.
51. *NBC Television* interview (date unknown).
52. *Cinefantastique*, Winter 1971.
53. Ibid.
54. *Photon Magazine* – reprinted from issue 20, copyright 1971 by Mark Frank, 801 Avenue 'C', Brooklyn, N.Y. 11218, USA.
55. Ibid.
56. Ibid.
57. Ibid.
58. Ibid.
59. Ibid.
60. Ibid.
61. *Astounding Science Fiction*, July 1950.
62. Ibid.
63. *Astounding Science Fiction*, October 1953.
64. Ibid.
65. Ibid.
66. *Famous Monsters of Filmland*, September 1964.
67. *American Cinematographer*, August 1960.
68. *Famous Monsters of Filmland*, September 1964.
69. *Cinefantastique*, Summer 1972.
70. Ibid.
71. Jerome Agel (editor), *The Making of Kubrick's 2001*, Signet Film Series.
72. *American Cinematographer*, June 1968.
73. Ibid.
74. *Cinefantastique*, Summer 1971.
75. Jerome Agel (editor), *The Making of Kubrick's 2001*.
76. *Egoboo*, August 1972.
77. John Gregory Dunne, *The Studio*, W. H. Allen.
78. René Gilson, *Jean Cocteau*, Crown Publishers, New York.
79. François Truffaut, *Hitchcock*, Secker and Warburg.

Bibliography

One of the most valuable aids in the writing of this book was Raymond Fielding's *The Technique of Special Effects Cinematography* (Focal Press, London and Hastings House, New York) and I recommend it to anyone who wishes to study the technical aspects of this subject more deeply. Another valuable source of information has been the back issues of the *American Cinematographer* magazine (edited by Herb A. Lightman, 1782 North Orange Drive, Hollywood, California), which contain a wealth of information concerning the development of the whole field of cinematography, including visual effects. Also of great help was *Cinefantastique* magazine (edited by Frederick S. Clarke, 7470 Diversey, Elmwood Park, Illinois), in particular the article on animation by Mark Wolf in the Winter 1971 issue, the interview with Douglas Trumbull by Kay Anderson and Shirley Meech and the article concerning *The Planet of the Apes* series of films by Dale Winogura, both of which were in the Summer 1972 issue, and the George Pal biography by Dennis S. Johnson in the Fall 1971 issue. The July 1950 and the October 1953 issues of *Astounding Science Fiction* (Now *Analog*, edited by Ben Bova, 420 Lexington Avenue, New York) contain information on the making of *Destination Moon* and *War of the Worlds* respectively, and another specialist magazine of great value was *Photon* (edited by Mark Frank, 801 Avenue 'C', Brooklyn, New York).

The following books have also been of assistance:

Agel, Jerome. *The Making of Kubrick's 2001*. Signet Film Series, New American Library, New York.

Baxter, John. *Science Fiction in the Cinema*. The Tantivy Press, London, and A. S. Barnes, New York.

Brownlow, Kevin. *The Parade's Gone By* . . . Secker and Warburg, London.

Clarens, Carlos. *Horror Movies*. Secker and Warburg, London.

DeMille, Cecil B., *Cecil B. DeMille – Autobiography*. W. H. Allen, London.

Dunne, John Gregory. *The Studio*. W. H. Allen, London.

Gilson, René. *Jean Cocteau*. Crown Publishers, New York.

Koury, Phil A. *Yes, Mr DeMille*. G. P. Putnam and Sons, New York.

Maltin, Leonard. *Behind the Camera*. New American Library, New York.

Osborne, Robert. *Academy Awards Illustrated*. ESE, California.

Robinson, David. *Buster Keaton*. Cinema One Series, Thames and Hudson, London.

Sarris, Andrew. *Hollywood Voices*. Secker and Warburg, London.

Schickel, Richard. *Walt Disney*. Weidenfeld and Nicolson, London.

Indexes of Personal Names, Film Titles, and Subjects and Techniques

Indexes

INDEX OF NAMES

Figures in italics refer to illustrations

INDEX OF FILM TITLES

Figures in italics refer to illustrations

INDEX OF SUBJECTS AND TECHNIQUES